ASTRONOMY
PHOTOGRAPHER
OF THE YEAR 2014

# ASTRONOMY PHOTOGRAPHER OF THE YEAR

**Collection 3**
Published by Collins
An imprint of HarperCollins Publishers
Westerhill Road
Bishopbriggs
Glasgow G64 2QT
www.collinsmaps.com

In association with
Royal Museums Greenwich, the group name for the National Maritime Museum,
Royal Observatory Greenwich, Queen's House and *Cutty Sark*
Greenwich
London SE10 9NF
www.rmg.co.uk

ISBN 978-0-00-759869-4

First edition (hardback) 2014 © HarperCollins Publishers
Text © National Maritime Museum, Greenwich, London 2014
Project management: Kara Green and Kevin Robbins
Editorial and proofing: Kris Martin, Louise Robb,
Steven Swaby and Pieter van der Merwe
Design and layout: Gordon MacGilp
Publisher: Jethro Lennox
Photographs © individual photographers see pages 194–198
FLICKR logo reproduced with permission of Yahoo! Inc. © 2014 Yahoo! Inc.
FLICKR and the Flickr logo are registered trademarks of Yahoo! Inc.
Map image: Courtesy of NASA/Earth Observatory

British Library Cataloguing in Publication Data
A catalogue record for this book is available from the British Library

# ASTRONOMY
# PHOTOGRAPHER
## OF THE YEAR 2014

ROYAL
OBSERVATORY
GREENWICH

# CONTENTS

# INTRODUCTION TO COMPETITION

## ASTRONOMY PHOTOGRAPHER OF THE YEAR

2014 is the sixth year of Astronomy Photographer of the Year, the competition to showcase the best celestial images taken from Planet Earth, organized by the Royal Observatory, Greenwich, and run in association with *BBC Sky at Night Magazine*, with the help of Flickr. Each year the competition continues to grow, and this year over 1700 entries were submitted from photographers all around the world in the categories of 'Earth and Space', 'Our Solar System', 'Deep Space' and 'Young Astronomy Photographer of the Year'.

In each category the competition's judges select a winner, a runner-up and three highly commended entries. The four winning images then go forward to compete for the title of Astronomy Photographer of the Year.

Three special prizes reflect the constantly evolving nature of astrophotography. 'People and Space' and 'Robotic Scope' celebrate the creativity and technological advances that photographers continue to bring to the field of astrophotography; while the Sir Patrick Moore Prize for Best Newcomer honours the man who did more than any other to engage the public with the wonders of the night sky.

This is the third volume of photographs from Astronomy Photographer of the Year. Collection 1 covered the first four years of the competition, including the winning images from 2009 to 2011 and all shortlisted and winning images from 2012. Collection 2 brought together over 100 winning and shortlisted images from 2013. This volume brings together all 120 winning and shortlisted images from the 2014 competition along with a gallery of the overall winners from the last six years.

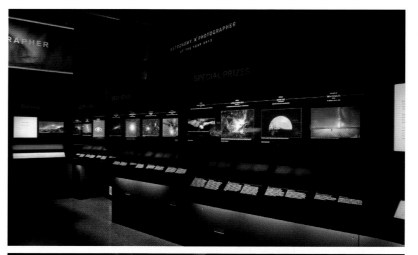

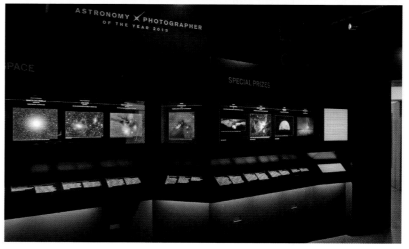

2013 Astronomy Photographer of the Year exhibition

## COMPETITION CATEGORIES

### EARTH AND SPACE
Photos that include landscapes, people and other 'Earthly' things alongside an astronomical subject.

Planet Earth is a special place; even powerful instruments like the Hubble Space Telescope have yet to find another planet with landscapes and environments as varied and beautiful as those of our own world. Photographs submitted in this category showcase the Earth's amazing scenery against the backdrop of the heavens, reflecting our planet's relationship with the wider Universe around us.

### OUR SOLAR SYSTEM
Photos of the Sun and its family of planets, moons, asteroids and comets.

We can see the Moon, the Sun and our local planets on a daily basis, even with the naked eye. But the photographs in this category present our cosmic neighbours in a new light, using equipment which reveals incredible levels of detail and by imaginative compositions which highlight their unique beauty.

### DEEP SPACE
Photos of anything beyond the Solar System, including stars, nebulae and galaxies.

Deep-space images give us a window into some of the most distant and exotic objects in the Universe; from the dark dust clouds where new stars are born to the glowing embers of supernova remnants, and far beyond to distant galaxies whose light set out towards us millions of years ago. These pictures take us to the depths of space and the furthest reaches of our imaginations.

### YOUNG ASTRONOMY PHOTOGRAPHER OF THE YEAR
Photos by people under 16 years of age.

The mission of the Royal Observatory, Greenwich, is to explain the wonder and excitement of astronomy and space science to the public. Inspiring young people and encouraging them to study science is an important part of this mission. The Young Astronomy Photographer category is a way to showcase the amazing skill and imagination of younger photographers, and to nurture their curiosity about the Universe.

## SPECIAL PRIZES

### PEOPLE AND SPACE
Photos that include people in a creative and original way.

At some time or another we have all experienced that moment when you look up at the vastness of the night sky and suddenly realize that you are a very small part of the Universe. This prize is awarded to pictures which juxtapose human and cosmic scales, with effects ranging from the profound to the humorous.

### THE SIR PATRICK MOORE PRIZE FOR BEST NEWCOMER
Photos by people who have taken up astrophotography in the last year and have not entered the competition before.

If the incredible skill and experience displayed by some of the winners of Astronomy Photographer of the Year can sometimes seem a bit intimidating, this special prize is a reminder that everyone was a beginner once upon a time. Indeed, imagination and an eye for the perfect shot can be just as important, and not every winning image was taken by an old hand.

### ROBOTIC SCOPE
Photos taken remotely using a robotic telescope and processed by the entrant.

Combining modern telescope technology with the power of the internet, robotic telescopes offer a new way for astronomy enthusiasts to experience the sky. Members of the public can sign up for time on state-of-the-art equipment in some of the best observing sites in the world, controlling the telescope remotely and downloading their images via the web. Robotic scopes give amateur astronomers access to equipment that previously only professional research observatories could afford.

## THE JUDGES

The judging panel is made up of individuals from the world of astronomy, photography, art and science:

**Maggie Aderin-Pocock**
Space scientist and co-presenter of the BBC television programme *The Sky at Night*

**Chris Bramley**
Editor of *BBC Sky at Night Magazine*, launched in 2005

**Will Gater**
Astrophotographer and one of the UK's best-known astronomy writers

**Melanie Grant**
Picture Editor of *Intelligent Life* magazine at *The Economist*

**Marek Kukula**
Public Astronomer at the Royal Observatory, Greenwich

**Pete Lawrence**
World-class astrophotographer, presenter on *The Sky at Night* programme and writer for *BBC Sky at Night Magazine*

**Chris Lintott**
Co-presenter of the BBC television programme *The Sky at Night* and an astronomy researcher at the University of Oxford

**Melanie Vandenbrouck**
Curator of Art (post-1800) at the National Maritime Museum

## PREVIOUS JUDGES HAVE INCLUDED:

**Rebekah Higgitt**
Former Curator of the History of Science and Technology at the National Maritime Museum

**Dan Holdsworth**
Photographic artist

**Olivia Johnson**
Astronomer, astronomy educator and former Astronomy Programmes Manager at the Royal Observatory, Greenwich

**Sir Patrick Moore**
Author, presenter of *The Sky at Night* on BBC television for over 50 years and a noted lunar observer, who passed away in 2012

**Damian Peach**
Astrophotographer and planetary observer

**Graham Southorn**
Former Editor of *BBC Sky at Night Magazine*

## FEELING INSPIRED?

You really do not need to have years of experience or expensive equipment to take a brilliant astrophoto, so why not have a go and enter your images into the Astronomy Photographer of the Year competition? There are great prizes to be won and you could see your photo on display at the Royal Observatory, Greenwich, part of Royal Museums Greenwich. Visit us online for more information about the competition and accompanying exhibition at rmg.co.uk/astrophoto

## JOIN THE ASTROPHOTO GROUP ON

Astronomy Photographer of the Year is powered by Flickr. Visit the Astronomy Photographer of the Year group to see hundreds of amazing astronomy photos, share astro-imaging tips with other enthusiasts and share your own photos of the night sky. Visit flickr.com/groups/astrophoto

**Sky at Night MAGAZINE**

*BBC Sky at Night Magazine* is the hands-on guide to astronomy for those who want to discover more about the wonders of the Universe from the world's leading astronomers ansd writers. Complementing *The Sky at Night* on BBC TV, the magazine features comment and analysis from its presenters Chris Lintott, Maggie Aderin-Pocock and Pete Lawrence, and covers the latest discoveries in astrophysics, monthly practical night-sky observing and astrophoto guides, plus in-depth equipment reviews. It is the definitive publication for astronomers of every level.

*BBC Sky at Night Magazine* is published by Immediate Media Co Ltd under licence from BBC Worldwide Ltd, the main commercial arm and a wholly owned subsidiary of the British Broadcasting Corporation (BBC). Visit skyatnightmagazine.com

## AUTHORS

**Background text for shortlisted entries was created by the following members of staff at Royal Museums Greenwich:**

**Edward Bloomer**, Planetarium Astronomer
**Tom Kerss**, Planetarium Astronomer
**Marek Kukula**, Public Astronomer
**Brendan Owens**, Astronomy Programmes Officer
**Elizabeth Roche**, Astronomy Education Manager
**Melanie Vandenbrouck**, Curator of Art (post-1800)

## ASTRONOMICAL PHOTOGRAPHY
## AT THE ROYAL OBSERVATORY, GREENWICH

Each year the winning images from Astronomy Photographer of the Year are displayed in a free exhibition at the Royal Observatory's Astronomy Centre. This elegant building was constructed in the 1890s as the 'New Physical Observatory', providing facilities for the Greenwich astronomers to develop new tools and observing techniques, including astrophotography.

Photography had become an increasingly important part of astronomy from the 1870s, with the arrival of technologies that allowed faster exposures, improved resolution and smoother tracking. A department devoted to photography and spectroscopy was founded at the Royal Observatory in 1873.

At Greenwich photography was used to record sunspots, study solar eclipses and measure the distance and motion of stars. The Observatory was also a partner in an international project to produce a photographic map of the sky, the *Carte du Ciel*, and the New Physical Observatory housed telescopes, cameras and photographic laboratories. More than a century later the building is a fitting home for the Astronomy Photographer of the Year exhibition.

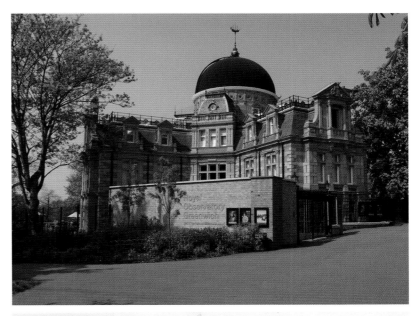

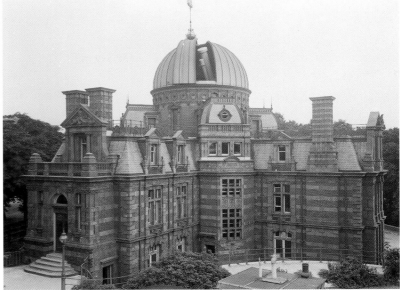

The New Physical Observatory, 1900–14

# FOREWORD

Dr Maggie Aderin-Pocock
*Space scientist & presenter of 'The Sky at Night' for BBC television.*

Looking up at the night sky has always been an inspiration for me. I got the astronomy bug as a young child growing up in London, which is perhaps a little surprising as I didn't get to see many clear skies. But reading about space and seeing amazing pictures of planets, stars and galaxies got me hooked. It drove me to find out more about what's out there and eventually led me to an exciting career in space science.

My original dream was to travel into space myself so that I could see some of the amazing objects out there from close quarters, I would still like to get out there, some dreams never die. In the meantime, technology has come to the rescue and today's scientific instruments allow us to look out into the furthest reaches of space without leaving the comfort of our own homes.

My first piece of scientific equipment was a 6-inch Cassegrain telescope which I made in an evening class while I was at school. This opened up new viewing opportunities for me and showed me the huge difference instrumentation makes to what we can see in space. I was hooked and, as an engineer, have since gone on to work on a wide range of instruments, from a spectrograph for the Gemini telescope in Chile to components for the James Webb Space Telescope, the successor to the Hubble.

But these days, seeing and photographing the heavens is not just the preserve of scientists in mountaintop observatories or using billion-dollar spacecraft. Digital cameras now allow anyone to have a go at astrophotography – and for many types of shot you don't even need a telescope. This is the sixth year of the Royal Observatory's Astronomy Photographer of the Year competition, with the highest number of entries ever, from 51 countries around the world.

As one of the judges, I'm particularly pleased to see how many new people are getting involved in astrophotography, and the quality of entries for the Sir Patrick Moore Prize for Best Newcomer really showcases the skill, passion and enthusiasm that astronomy inspires. The Young Astronomy Photographer of the Year category also continues to dazzle – it's hard to believe that these amazing photographers are all under 16 years old. As my own experience shows, astronomy is a powerful tool for inspiring the next generation of scientists and engineers, so it was exciting to see several group entries this year from whole classes of school pupils who had signed up with their teacher to use a robotic telescope and have the images sent direct to their classroom. It's also highly encouraging to see more and more girls and women entering the competition every year, shattering the old stereotype that astronomy is somehow just a 'boys' subject'. Space really is for everyone.

As the images in this book demonstrate, photographing the night sky can be an addictive pastime. I hope that it will encourage more people to look up at the stars and even have a go themselves. Perhaps some of the budding young photographers will also be inspired to pursue exciting careers in science and technology, just as I was all those years ago. There are so many beautiful sights out there to discover and explore – enough to keep anyone busy for a lifetime.

*Maggie Aderin-Pocock*

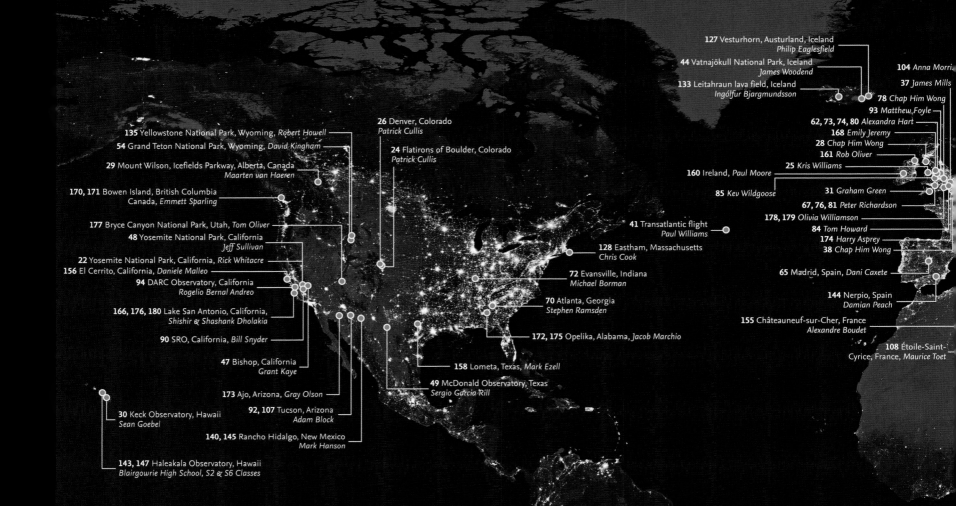

127 Vesturhorn, Austurland, Iceland
*Philip Eaglesfield*

44 Vatnajökull National Park, Iceland
*James Woodend*

133 Leitahraun lava field, Iceland
*Ingólfur Bjargmundsson*

104 *Anna Morri*

37 *James Mills*

78 *Chap Him Wong*

93 *Matthew Foyle*

62, 73, 74, 80 *Alexandra Hart*

168 *Emily Jeremy*

28 *Chap Him Wong*

161 *Rob Oliver*

25 *Kris Williams*

31 *Graham Green*

67, 76, 81 *Peter Richardson*

178, 179 *Olivia Williamson*

84 *Tom Howard*

174 *Harry Asprey*

38 *Chap Him Wong*

160 Ireland, *Paul Moore*

85 *Kev Wildgoose*

26 Denver, Colorado
*Patrick Cullis*

24 Flatirons of Boulder, Colorado
*Patrick Cullis*

135 Yellowstone National Park, Wyoming, *Robert Howell*

54 Grand Teton National Park, Wyoming, *David Kingham*

29 Mount Wilson, Icefields Parkway, Alberta, Canada
*Maarten van Haeren*

170, 171 Bowen Island, British Columbia
Canada, *Emmett Sparling*

177 Bryce Canyon National Park, Utah, *Tom Oliver*

48 Yosemite National Park, California
*Jeff Sullivan*

22 Yosemite National Park, California, *Rick Whitacre*

156 El Cerrito, California, *Daniele Malleo*

94 DARC Observatory, California
*Rogelio Bernal Andreo*

166, 176, 180 Lake San Antonio, California,
*Shishir & Shashank Dholakia*

90 SRO, California, *Bill Snyder*

47 Bishop, California
*Grant Kaye*

173 Ajo, Arizona, *Gray Olson*

92, 107 Tucson, Arizona
*Adam Block*

30 Keck Observatory, Hawaii
*Sean Goebel*

140, 145 Rancho Hidalgo, New Mexico
*Mark Hanson*

143, 147 Haleakala Observatory, Hawaii
*Blairgowrie High School, S2 & S6 Classes*

41 Transatlantic flight
*Paul Williams*

128 Eastham, Massachusetts
*Chris Cook*

72 Evansville, Indiana
*Michael Borman*

70 Atlanta, Georgia
*Stephen Ramsden*

172, 175 Opelika, Alabama, *Jacob Marchio*

158 Lometa, Texas, *Mark Ezell*

49 McDonald Observatory, Texas
*Sergio Garcia Rill*

65 Madrid, Spain, *Dani Caxete*

144 Nerpio, Spain
*Damian Peach*

155 Châteauneuf-sur-Cher, France
*Alexandre Boudet*

108 Étoile-Saint-
Cyrice, France, *Maurice Toet*

169 Rio Negrinho, Santa Catarina, Brazil
*Gabriel Tavares*

86 General Pacheco, Buenos Aires, Argentina
*Ignacio Diaz Bobillo*

82 Los Polvorines, Buenos Aires, Argentina
*Sebastián Guillermaz*

40 Mar de Ajo, Buenos Aires, Argentina
*Sebastián Guillermaz*

# IMAGE
# LOCATIONS

Map showing the origin of shortlisted
images in the 2014 competition.
Number on map relates to page number

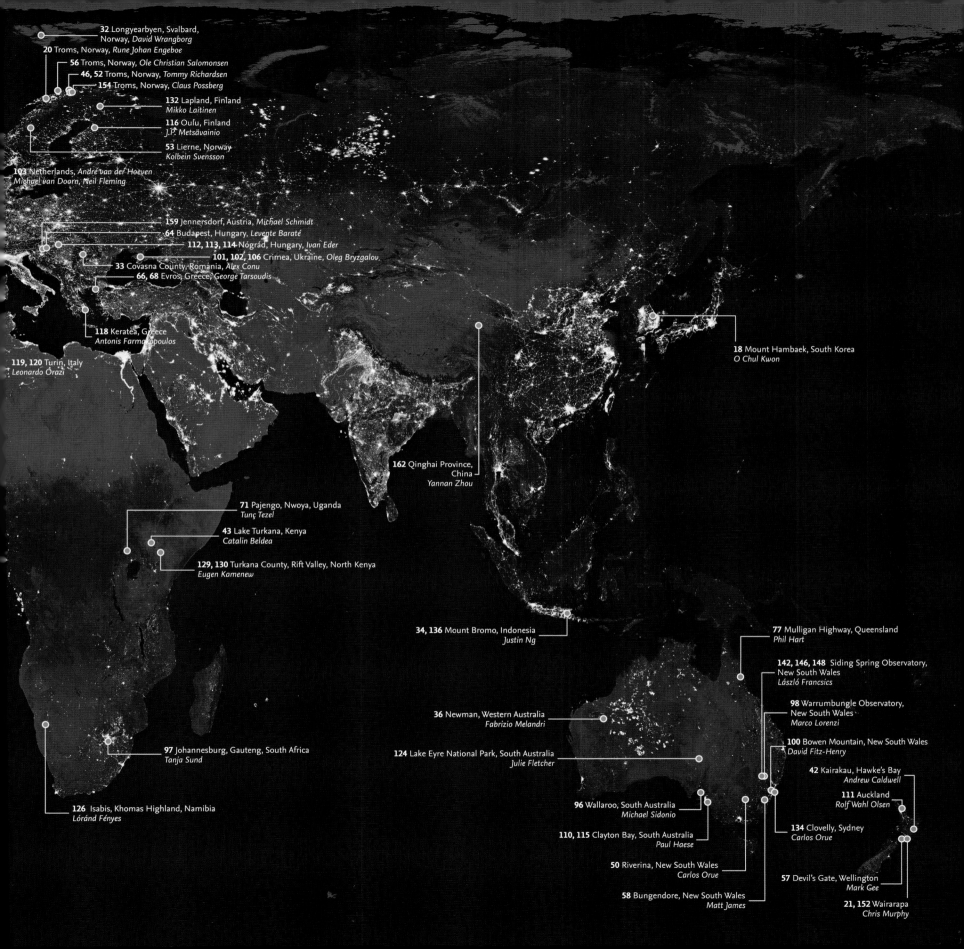

**32** Longyearbyen, Svalbard, Norway, *David Wrangborg*

**20** Troms, Norway, *Rune Johan Engeboe*

**56** Troms, Norway, *Ole Christian Salomonsen*

**46, 52** Troms, Norway, *Tommy Richardsen*

**154** Troms, Norway, *Claus Possberg*

**132** Lapland, Finland *Mikko Laitinen*

**116** Oulu, Finland *J.P. Metsävainio*

**53** Lierne, Norway *Kolbein Svensson*

**103** Netherlands, *André van der Hoeven, Michael van Doorn, Neil Fleming*

**159** Jennersdorf, Austria, *Michael Schmidt*

**64** Budapest, Hungary, *Levente Baraté*

**112, 113, 114** Nógrád, Hungary, *Ivan Eder*

**101, 102, 106** Crimea, Ukraine, *Oleg Bryzgalov*

**33** Covasna County, Romania, *Alex Conu*

**66, 68** Evros, Greece, *George Tarsoudis*

**118** Keratea, Greece *Antonis Farmakopoulos*

**119, 120** Turin, Italy *Leonardo Orazi*

**18** Mount Hambaek, South Korea *O Chul Kwon*

**162** Qinghai Province, China *Yannan Zhou*

**71** Pajengo, Nwoya, Uganda *Tunç Tezel*

**43** Lake Turkana, Kenya *Catalin Beldea*

**129, 130** Turkana County, Rift Valley, North Kenya *Eugen Kamenew*

**34, 136** Mount Bromo, Indonesia *Justin Ng*

**77** Mulligan Highway, Queensland *Phil Hart*

**142, 146, 148** Siding Spring Observatory, New South Wales *László Francsics*

**98** Warrumbungle Observatory, New South Wales *Marco Lorenzi*

**36** Newman, Western Australia *Fabrizio Melandri*

**100** Bowen Mountain, New South Wales *David Fitz-Henry*

**97** Johannesburg, Gauteng, South Africa *Tanja Sund*

**124** Lake Eyre National Park, South Australia *Julie Fletcher*

**42** Kairakau, Hawke's Bay *Andrew Caldwell*

**111** Auckland *Rolf Wahl Olsen*

**134** Clovelly, Sydney *Carlos Orue*

**126** Isabis, Khomas Highland, Namibia *Lóránd Fényes*

**96** Wallaroo, South Australia *Michael Sidonio*

**110, 115** Clayton Bay, South Australia *Paul Haese*

**50** Riverina, New South Wales *Carlos Orue*

**57** Devil's Gate, Wellington *Mark Gee*

**58** Bungendore, New South Wales *Matt James*

**21, 152** Wairarapa *Chris Murphy*

# ASTRONOMY PHOTOGRAPHER
## OF THE YEAR 2014

# EARTH
# AND SPACE

Photos that include landscapes,
people and other 'Earthly' things
alongside an astronomical subject

## O CHUL KWON *(South Korea)*

### Venus-Lunar Occultation
[*14 August 2012*]

**O CHUL KWON:** It was mid-August, before sunrise, when the rising Moon covered Venus. Originally, I took a time-lapse with three cameras, using my telescope and a wide angle lens. In this sequence, I picked ten-minute interval photos. The Moon was so bright that I took it with HDR. I have waited for this phenomenon since the 1989 Venus-Lunar occultation. At that time, I was young and had no camera. I finally succeeded in 2012. That night it was raining, but just before the occultation, it stopped and the clouds cleared.

*Mount Hambaek, Gangwon-do, South Korea*

**BACKGROUND:** Using High Dynamic Range (HDR) the photographer balances the brightness of the rising Moon and the much more distant planet Venus, to show us what happens when they come to the same apparent position in the sky. Venus is temporarily hidden from view by our nearest neighbour, only to re-emerge in less than one hour. This underscores the relatively quick apparent motion of the Moon through our skies as it makes its 27.3-day orbit around the Earth. Such spectacular occultations can be seen from somewhere on Earth several times a year, but careful planning is required to photograph them.

**Canon 5D Mk III camera; 24mm f/2.8–f/4 lens; ISO 1600–ISO 400; 1–1.3 second exposures**

*"A really interesting composition which rewards closer inspection. The atmospherically colour-adjusted red Moon is amazing!"*
PETE LAWRENCE

*"I love the atmospheric coloration of the lowest image of Venus."*
MAGGIE ADERIN-POCOCK

*"What attracted me with this picture is the way the celestial bodies in the pure night sky compete for attention with the bright city lights in the valley, reflected in the low-hanging clouds. This shot shows great technical accomplishment, but also a very strong artistic quality."*
MELANIE VANDENBROUCK

*"There's a lot to see in this beautifully framed photograph, which makes a stunning record of a celestial event."*
CHRIS LINTOTT

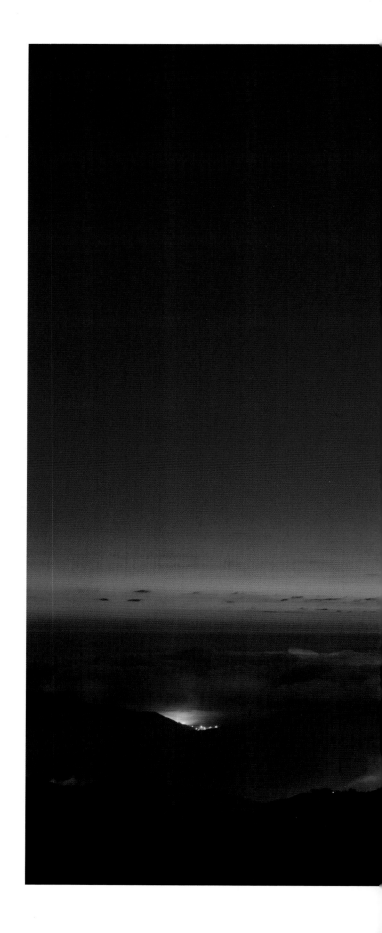

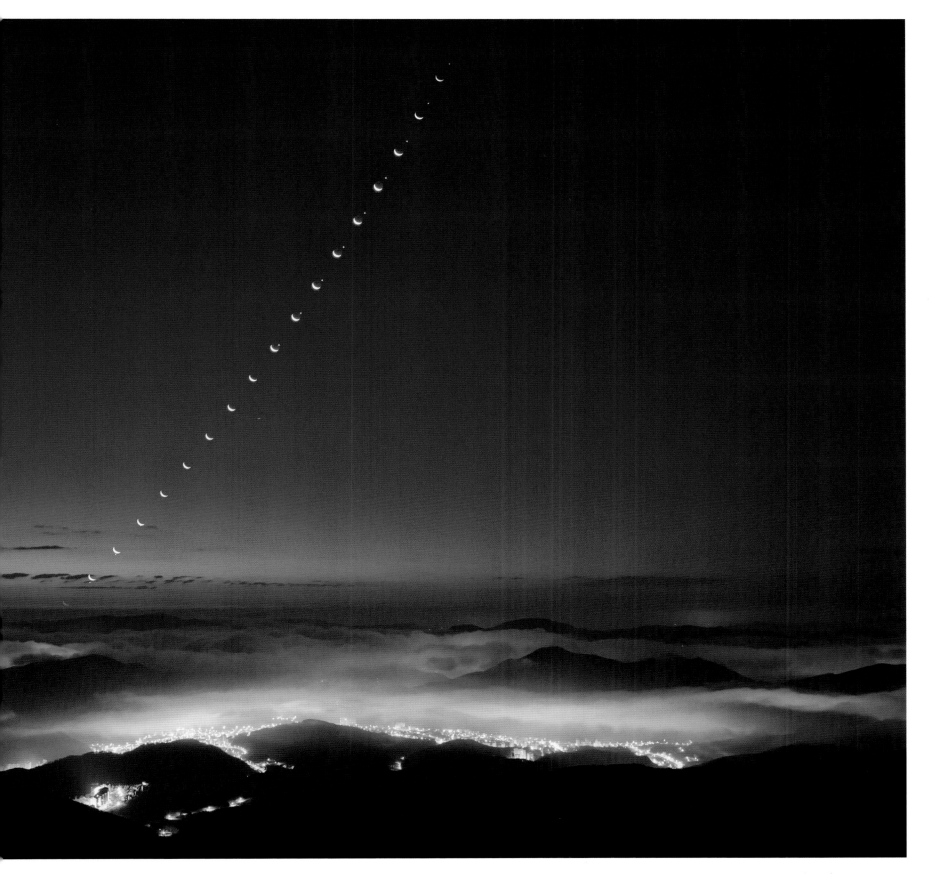

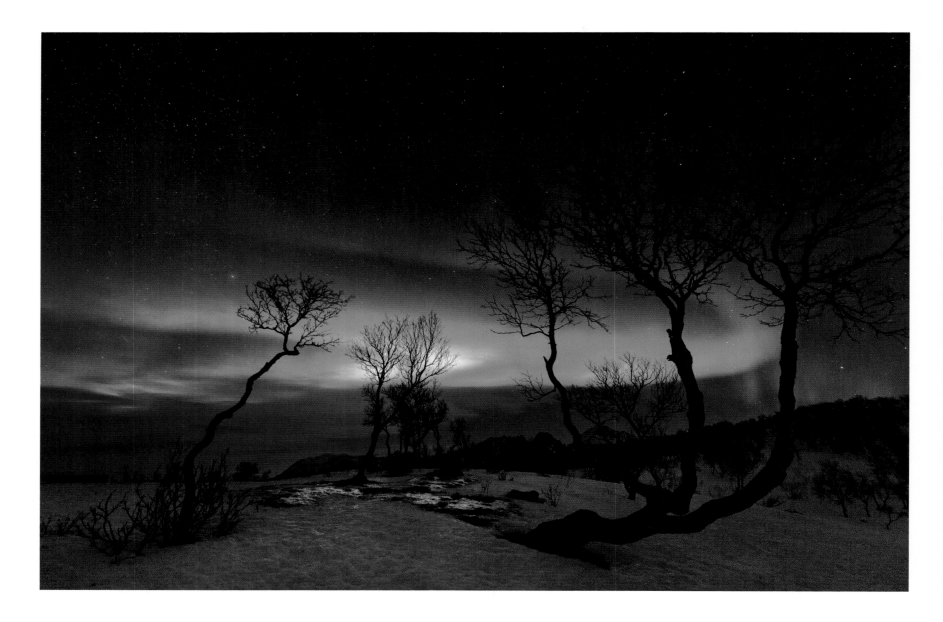

## RUNE JOHAN ENGEBOE (*Norway*)

### Flow
[*2 February 2014*]

**RUNE JOHAN ENGEBOE:** Green rivers in the sky, frozen rivers on the ground. A perfect moment.

*Harstad, Troms, Norway*

**BACKGROUND:** Triggered by bursts of subatomic particles fired out by the Sun, aurorae are most common close to the Earth's magnetic poles and can occur at any time of the day or night. However, these delicate atmospheric lights only become visible to us when the sky is dark. This makes the long, cold nights of the northern winter a particularly good time to see them.

**Nikon D800 camera**

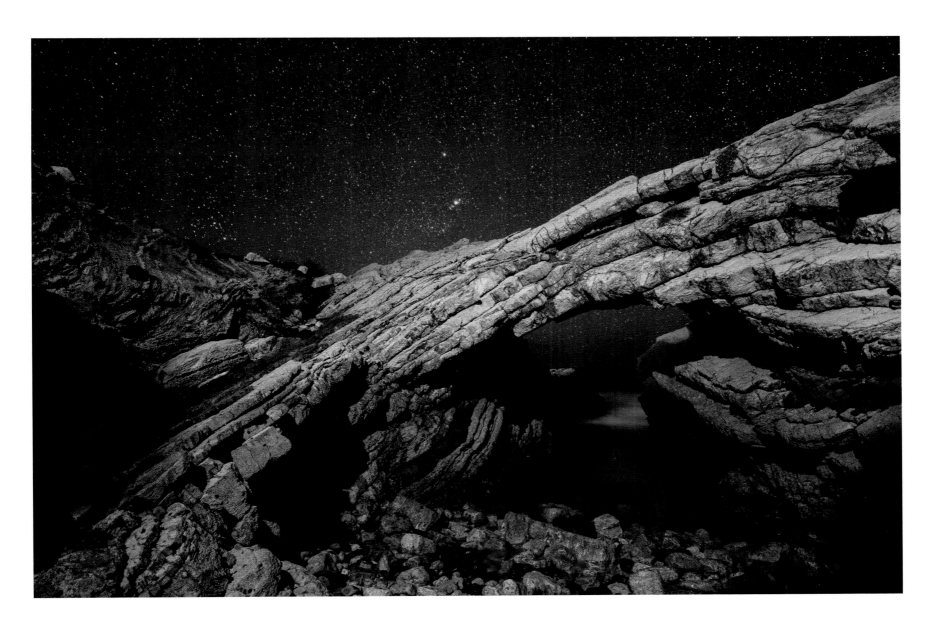

## CHRIS MURPHY (New Zealand)

### Sky Bridge
[1 November 2013]

**CHRIS MURPHY:** This was my first real attempt at astrophotography. I drove from Wellington, New Zealand, to the Wairarapa district. There are some amazing rock formations there and I knew they would make great foregrounds. Conditions were perfect with no light pollution and a super-clear crisp night.

*Wairarapa, New Zealand*

**BACKGROUND:** Geology and astronomy have always been closely allied subjects. They both speak to us of the immense age of the Universe and the physical processes that have shaped the world we now inhabit. Despite the apparent timelessness of this scene, the message of the rocks and stars is that the Universe is constantly changing, albeit on timescales far longer than a human lifespan.

**Nikon D600 camera; 19mm f/2.8 lens; ISO 3200; 20-second exposure**

## RICK WHITACRE (USA)

### 'Warp Factor 9, Mr Sulu' – 2013 Perseid Meteor Shower
[12 August 2013]

**RICK WHITACRE:** The northern arm of the Milky Way plays host to the Perseid meteor shower over Half Dome in Yosemite National Park. This is a time-shifted composite. The individual meteors were shot with a 14mm wide-angle lens. This image has 27 of the best meteors captured between 10pm and 4am on the same night.

*Glacier Point, Yosemite National Park, California, USA*

**BACKGROUND:** On a clear night under dark skies you can catch an infrequent shooting star but for a true celestial lightshow the Perseid shower cannot be beaten. Each year in August the Earth passes through the debris trail of comet Swift-Tuttle and our atmosphere deals with the harmless dust grains in spectacular fashion. Each one momentarily glows brightly as it pushes through the air at speeds of up to 70km per second.

**Canon 1D X camera; 14mm f/2.8 lens; ISO 12800; 15-second exposure**

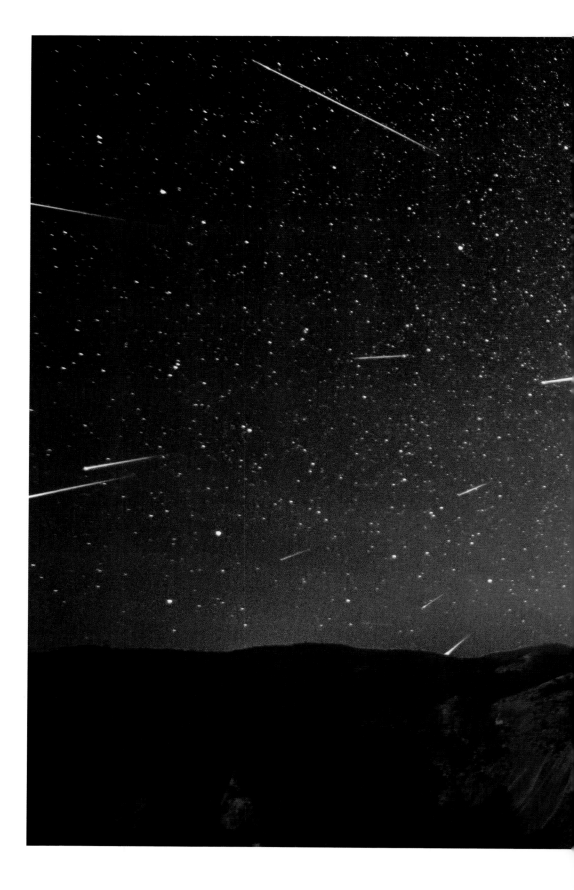

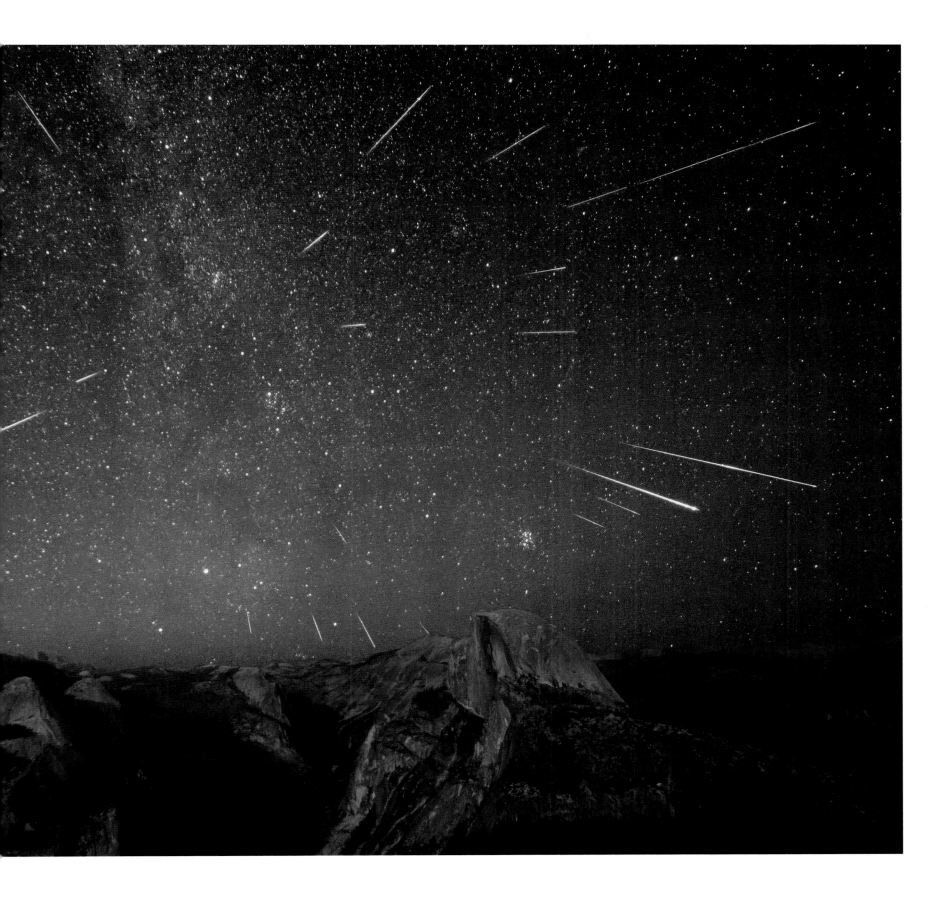

## PATRICK CULLIS *(USA)*

### Geminid Fireball
[*14 December 2012*]

**PATRICK CULLIS:** The Geminid meteor shower over the Flatirons of Boulder, Colorado, in December 2012. Orion marches across the sky toward the Pleiades and bright Jupiter inside the constellation Taurus.

*Flatirons of Boulder, Colorado, USA*

**BACKGROUND:** Like all meteor showers, the Geminids appear when small fragments of rock and ice, strewn across the Earth's orbit by a comet, burn up at hypersonic speeds in our atmosphere. Unlike other showers, however, the Geminids have a rather strange progenitor known as 3200 Phaethon. Technically an asteroid (a rocky body without the icy shell characteristic of a comet), Phaethon has become known informally as a 'rock comet'. The unusual composition of the Geminid particles results in bright, relatively slow-moving meteors – an ideal subject for a dazzling photo. In this example, a larger than usual fragment burns brightly enough to outshine all of the planets, producing what is commonly called a 'fireball'.

**Canon 5D Mk II camera; 16mm f/2.8 lens; ISO 1600; 15-second exposure**

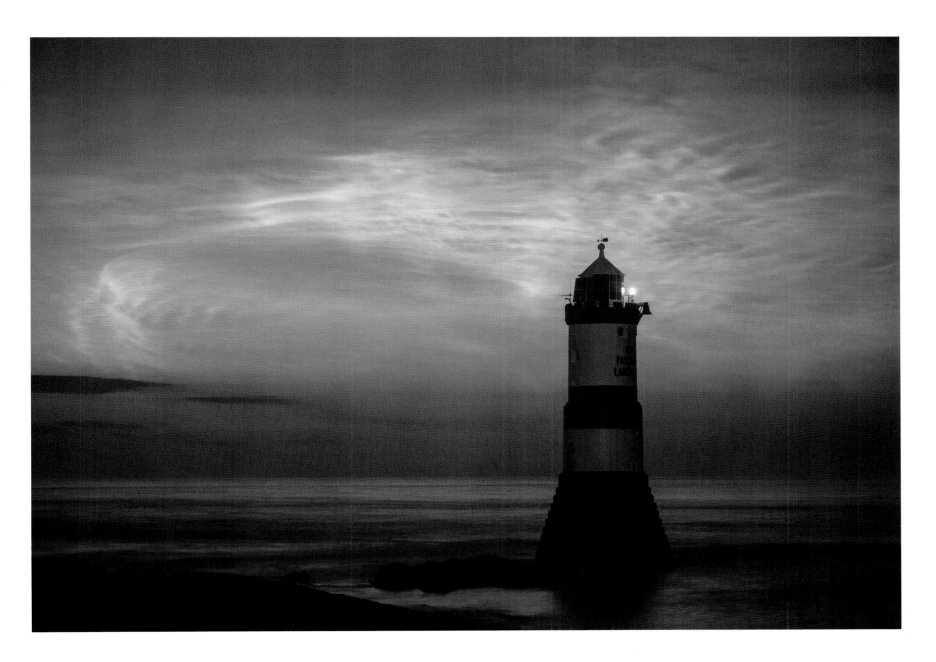

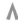

## KRIS WILLIAMS (UK)

### Shimmer – Black Point, Anglesey
[*30 May 2013*]

**KRIS WILLIAMS:** A bit of a rare treat on a flying visit to the local beach. While I was only going to test out a new camera body on some stars, I was lucky enough to catch these noctilucent clouds beyond the lighthouse. Sat around 50 miles above us in the mesosphere, they are illuminated once the Sun has dropped below the horizon substantially enough to leave the rest of the sky untouched by its light, only just catching the edge of the atmosphere.

*Black Point, Penmon, Anglesey, UK*

**BACKGROUND:** On a round planet like the Earth, height can sometimes be an advantage, allowing us to see or be seen over much larger distances. This lighthouse is tall enough for its beam to be clearly visible to ships that would otherwise be below the horizon. In a similar fashion, at a height of around 80km, these noctilucent clouds are still bathed in sunlight even though the Sun has already set for observers down on the ground.

**SLT-A99V camera; 100mm f/2.8 lens; ISO 400; 10-second exposure**

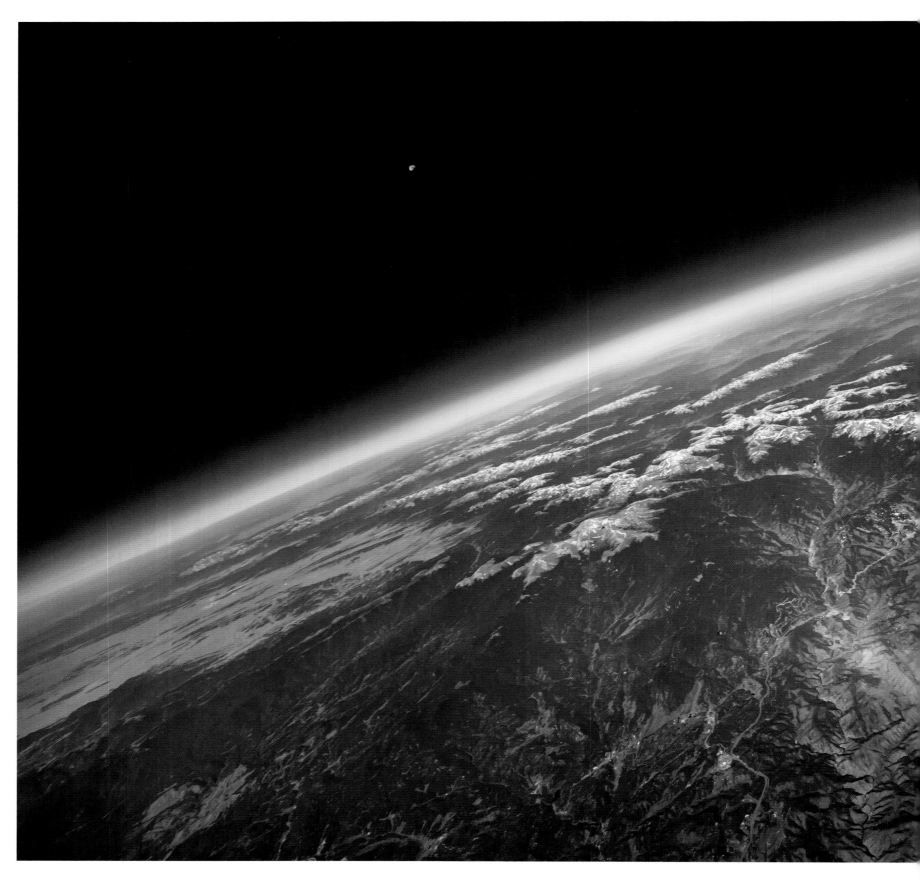

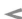

## PATRICK CULLIS (USA)                    *HIGHLY COMMENDED*

### Moon Balloon
[*27 June 2013*]

**PATRICK CULLIS:** This image was taken from a high altitude balloon, launched from Boulder, Colorado. The Moon only became visible when the balloon had cleared the bright haze of our atmosphere and entered the thin air of the stratosphere. Photographed from 26,500m above and west of Denver, Colorado.

*Denver, Colorado, USA*

**BACKGROUND:** Poised on the edge of space, this astonishing shot clearly shows the curvature of the Earth with the towering Rocky Mountains reduced to tiny wrinkles on the surface far below. Once the sole province of meteorologists and spies, high altitude balloons are increasingly being used by keen amateurs and even school pupils to carry out experiments – and to take spectacular pictures like this one. The tiny dot of the Moon serves to emphasize the vast distance between our planet and its nearest cosmic neighbour.

**Canon 5D camera; 17mm f/11 lens; ISO 200; 1/500-second exposure**

*"To capture the distant Moon and a dramatic Earthly landscape together like this using a remote camera strapped to a balloon is quite an achievement. Our first Earth and Space picture to be taken from the edge of space itself! High altitude balloons are becoming more accessible to amateur photographers, but it's still very difficult to take a really great shot like this."*

MAREK KUKULA

*"This picture shows just how far astrophotography has come in recent years. No longer are amateurs limited to imaging the Cosmos from the ground. From high up in Earth's atmosphere the rocky oasis we call home stands in stark contrast to the black of space and the tiny distant Moon lost in the darkness."*

WILL GATER

*"This is an impressive result from a high altitude balloon – space is no longer the preserve of expensive missions!"*

PETE LAWRENCE

*"Earth and space: does what it says on the tin. An image first taken by astronauts, now more accessible to us all."*

MAGGIE ADERIN-POCOCK

*"The detail in this entry is astounding."*

MELANIE GRANT

*"Balloon-borne astronomy has a long history, but I think this is the most beautiful such shot I've seen. The Moon looks tantalizingly out of reach above the thin atmosphere of the Earth."*

CHRIS LINTOTT

*"This shot encompasses it all: houses and valleys far below and the blackness of space looming above. Between the two is the thin delicate blueness of our atmosphere, which shields life on Earth from the endless hard vacuum beyond."*

CHRIS BRAMLEY

## CHAP HIM WONG (Hong Kong)

### Winter Constellations
*[25 December 2013]*

**CHAP HIM WONG:** The nebulae and dust structure can be seen within these winter constellations. I used a tracker to capture ten 240-second exposure shots for the sky, and one 30-second exposure shot for the foreground (the mountain edge). Then I overlaid the foreground image to the stacked one.

*Galloway Forest Park, Dumfries and Galloway, UK*

**BACKGROUND:** Certified as a Dark Sky Park in 2009, Galloway Forest Park in south-west Scotland has enviably low levels of light pollution. It also hosts the Scottish Dark Sky Observatory, which opened in 2012. This photographer has taken full advantage of the Park's exceptional conditions, using long exposures to capture the elusive red glow of hydrogen gas between the stars and dust clouds of the Milky Way.

**Canon 450D camera; Canon EF 17–40mm f/4 lens; HL-1 (DIY) mount; ISO 1600; 10 x 240-second exposures**

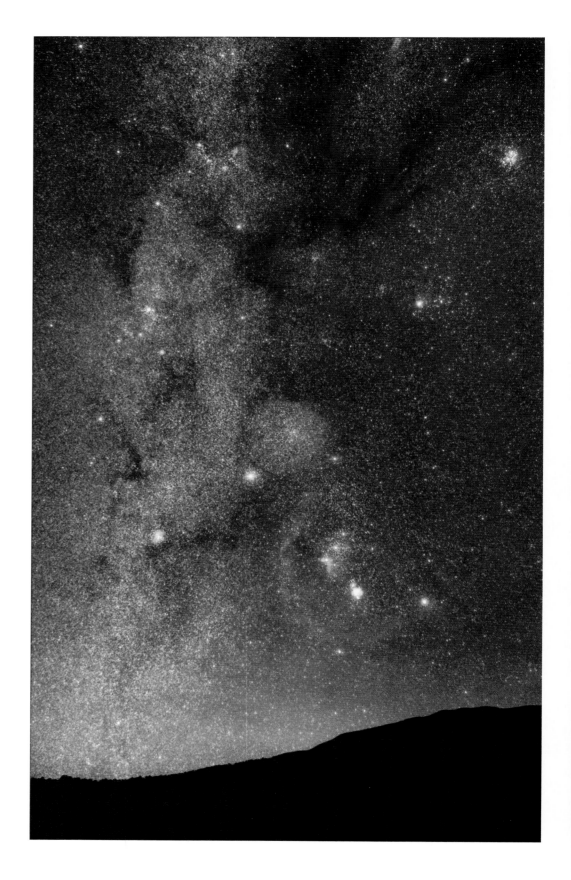

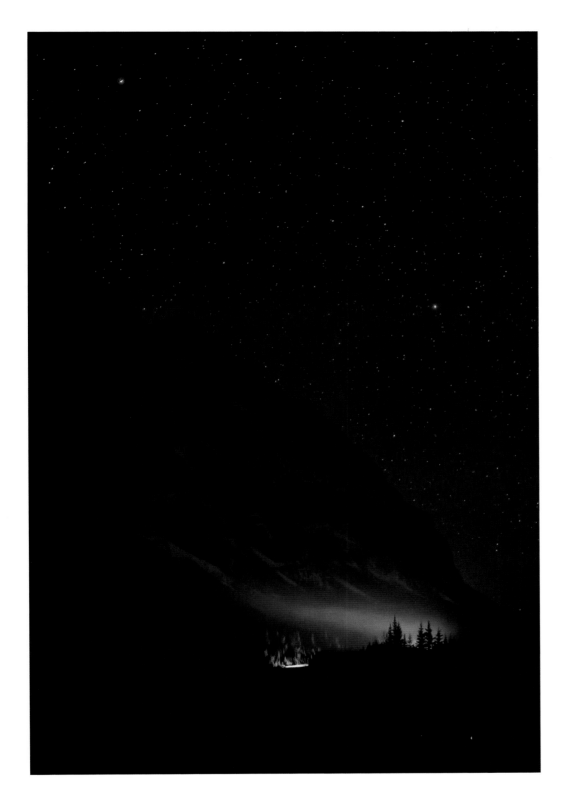

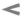

## MAARTEN VAN HAEREN *(Canada)*

### Mount Wilson
*[23 January 2014]*

**MAARTEN VAN HAEREN:** After a day of ice climbing on the Icefields Parkway we spent the night at Rampart Creek hostel, close to Mount Wilson. I opted to leave the warm cabin and step out into the -20°C evening for a few night shots. The cold Albertan air meant clear skies, which was promising for astronomy photography. The Parkway is a remote highway between Lake Louise and Jasper and sees very little traffic, especially on winter nights after midnight. When I heard a car coming, I knew I'd have only two or three attempts at getting the right shot, since the camera needs 30 seconds to cycle through an exposure. When I got this image, I knew I'd be very happy with the result! I've been using large-sensor mirrorless cameras for the last five years and have been taking advantage of the ability to use vintage lenses on the camera bodies.

*Mount Wilson, Icefields Parkway, Alberta, Canada*

**BACKGROUND:** The vastness of the sky is so overwhelming that it can be very hard to capture photographically. Earthly scenery, such as this imposing mountainside, gives us a familiar reference point from which to construct a sense of scale. Here, sky and landscape conspire to create a sense of awe and mystery, dwarfing the tiny pool of man-made light down among the trees.

**Sony NEX-5N camera; '80s-era Pentax 28mm f/2.8 lens; ISO 3200; 10-second exposure**

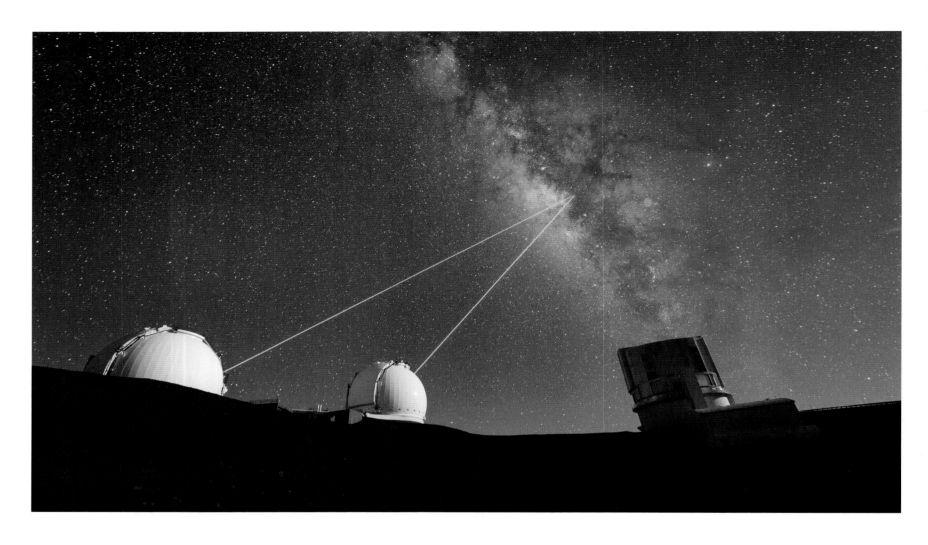

## SEAN GOEBEL *(USA)*

### Peering into the Milky Way
[*12 August 2013*]

**SEAN GOEBEL:** A team from UCLA uses the adaptive optics lasers of the twin Keck telescopes to observe stars as they orbit the black hole at the centre of the Milky Way Galaxy. I had flown back to Hawaii from California that day, but I thought that it would be horribly negligent if I didn't head up the mountain and film it. Fighting jet lag, exhaustion, and altitude sickness, I spent the night shooting time-lapse images of the lasers and Milky Way. It was the single most productive night of photography I've ever had.

*Keck Observatory, Mauna Kea, Hawaii, USA*

**BACKGROUND:** Even on completely cloud-free nights the Earth's turbulent atmosphere presents a series of obstacles for astronomers. Motion and temperature variations in the air distort the light passing through it, making the stars appear to twinkle and blur. 'Adaptive optics' are an ingenious way of getting round this familiar twinkling effect. Lasers fired from beside the telescopes cause a small pocket of air 90km above the ground to glow, forming an artificial 'guide star' in the same patch of sky as the astronomical objects of interest. Computers on the ground monitor the telescope images, tracking any changes in the guide star and applying corrections to the telescope in real time to adjust for the atmospheric distortion. In this way, large telescopes on the ground can now produce images as crisp and sharp as those of the Hubble Space Telescope.

**Canon 5D Mk II camera; 14mm f/2.8 lens; ISO 6400; 30-second exposure**

## GRAHAM GREEN (UK)

### Wistman's Wood
[*10 October 2013*]

**GRAHAM GREEN:** This small, stunted, ancient woodland appealed to me for its atmosphere, as it is said to be 'the most haunted place on Dartmoor'. I had intended to make this photograph during spring, to capture the Milky Way showing through the branches before the trees came into leaf. Due to poor weather I was forced to image the Milky Way on a separate night and returned later in the year to photograph the trees. I like how the Summer Triangle and nebulae work with the composition.

*Dartmoor National Park, Devon, UK*

**BACKGROUND:** The versatility of digital photography and the ingenuity of the dedicated astrophotographer combine in this atmospheric but deceptively simple shot. Bad weather is the nemesis of astronomers everywhere but here the photographer has refused to give up, combining frames shot at different times of year to recreate the perfect night, with leafless branches outlined against a crystal clear sky.

**Canon 5D Mk II camera**

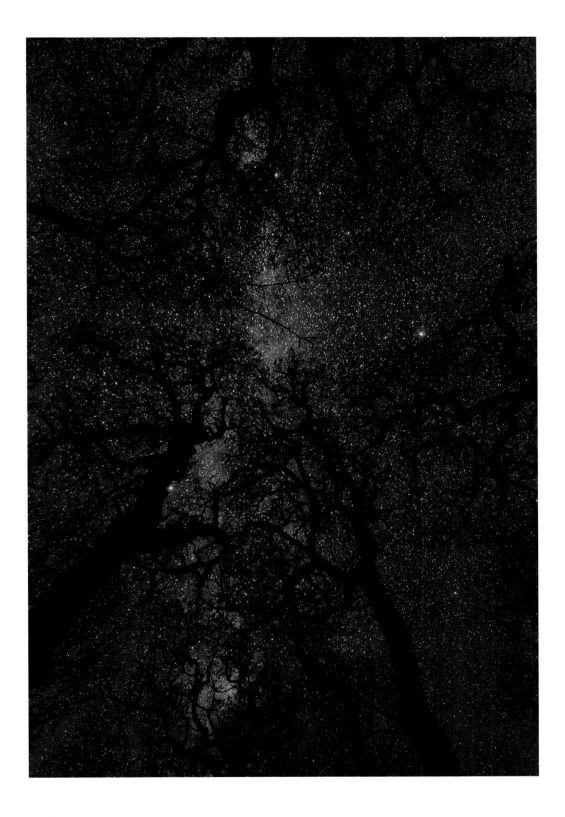

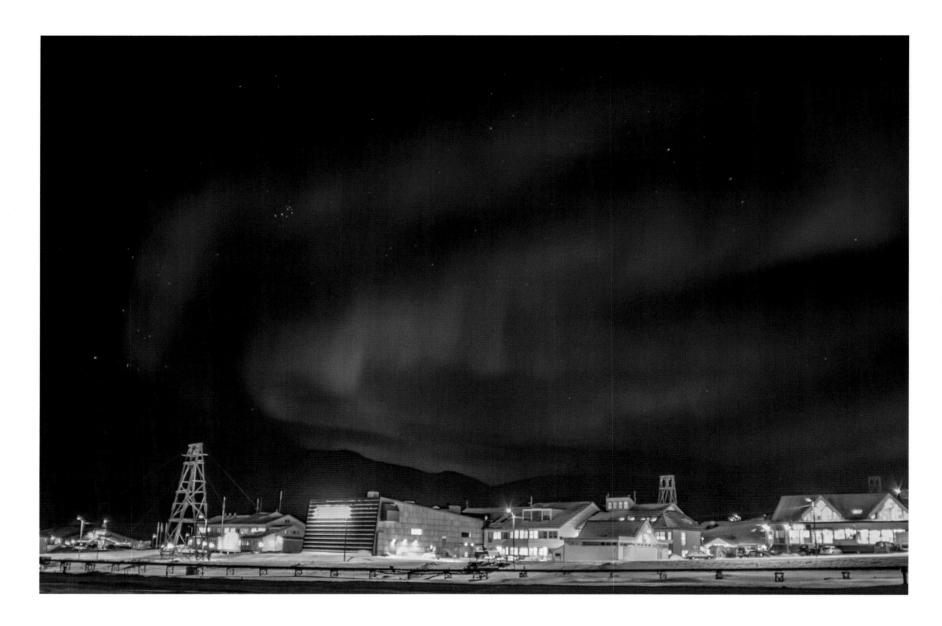

## DAVID WRANGBORG *(Norway)*

### Longyearbyen by Night
[*3 December 2013*]

**DAVID WRANGBORG:** The *Aurora Borealis* or Northern Lights are one of the exciting things about living in the polar region during the long winter. Usually the lights of the city of Longyearbyen are too bright to be able to properly enjoy the phenomena. Sometimes, however, the Northern Lights are strong enough to compete with man-made light sources. This was one of those occasions. Longyearbyen's town centre can be seen in the foreground.

*Longyearbyen, Svalbard, Norway*

**BACKGROUND:** The town of Longyearbyen's narrow band of pastel buildings is contrasted with the evanescent aurora and dark hills in the distance. Bright lights are blazing out of the windows, yet there is no sign of human life. Like the work of the American pioneer of colour photography William Eggleston, this picture shows the mundane beauty of an urban site, but here combined with the enchanting sight of the night sky.

**Pentax K-5 camera; 24mm f/3.2 lens; ISO 200; 5-second exposure**

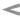

## ALEX CONU *(Romania)*

### Majestic Milky Way
*[12 August 2013]*

**ALEX CONU:** This image shows the majestic Milky Way stretching from east to west, above amateur astronomers at AstRomania Starparty. The Starparty has been held annually since 2009 at various dark sky locations around Romania. The photograph is composed of 51 images stitched together.

*Valea Frumoasei, Covasna County, Romania*

**BACKGROUND:** A panoramic view from horizon to horizon captures the full extent of the Milky Way and also the stargazers who have gathered with their telescope in order to observe it. Red lights help the astronomers to see what they are doing without spoiling their dark-adapted eyesight.

**Canon 6D camera; 35mm f/2 lens; ISO 4000; 13-second exposure**

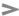

## JUSTIN NG *(Singapore)*

### Eta Aquarid Meteor Shower over Mount Bromo
[*5 May 2013*]

**JUSTIN NG:** A bright meteor streaked across the magnificent night sky over Mount Bromo just one day before the peak of the Eta Aquarid meteor shower, which is caused by Halley's Comet. Mount Bromo, visibly spewing smoke in this image, is one of the most well-known active volcanoes in East Java, Indonesia. The highest active volcano is called Mount Semeru (3676m), and the extinct volcano, Mount Batok, is located to the right of Mount Bromo.

*Mount Bromo, Bromo Tengger Semeru National Park, Indonesia*

**BACKGROUND:** Periodically the Earth passes through the trail of dust left behind by a comet, giving rise to a meteor shower that can last for several nights. But solitary meteors – like this bright example, caught over a misty volcanic landscape – can occur at any time of year, as particles of space dust or larger rocks burn up in the Earth's atmosphere.

**Canon 5D Mk II camera; 16mm f/2.8 lens; ISO 1600; 30-second exposure**

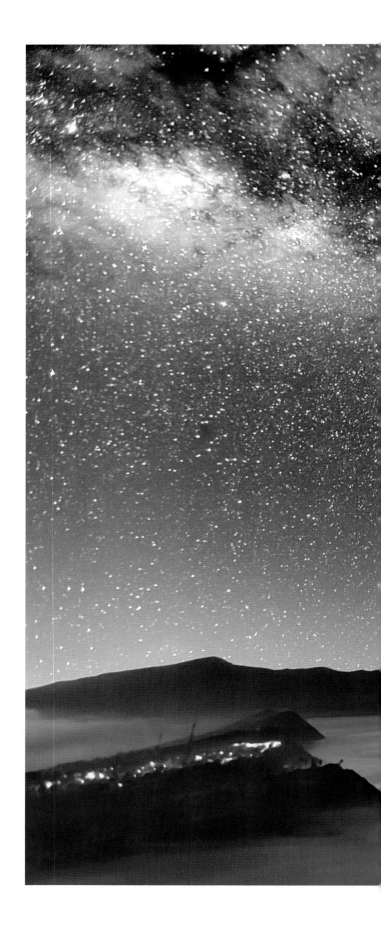

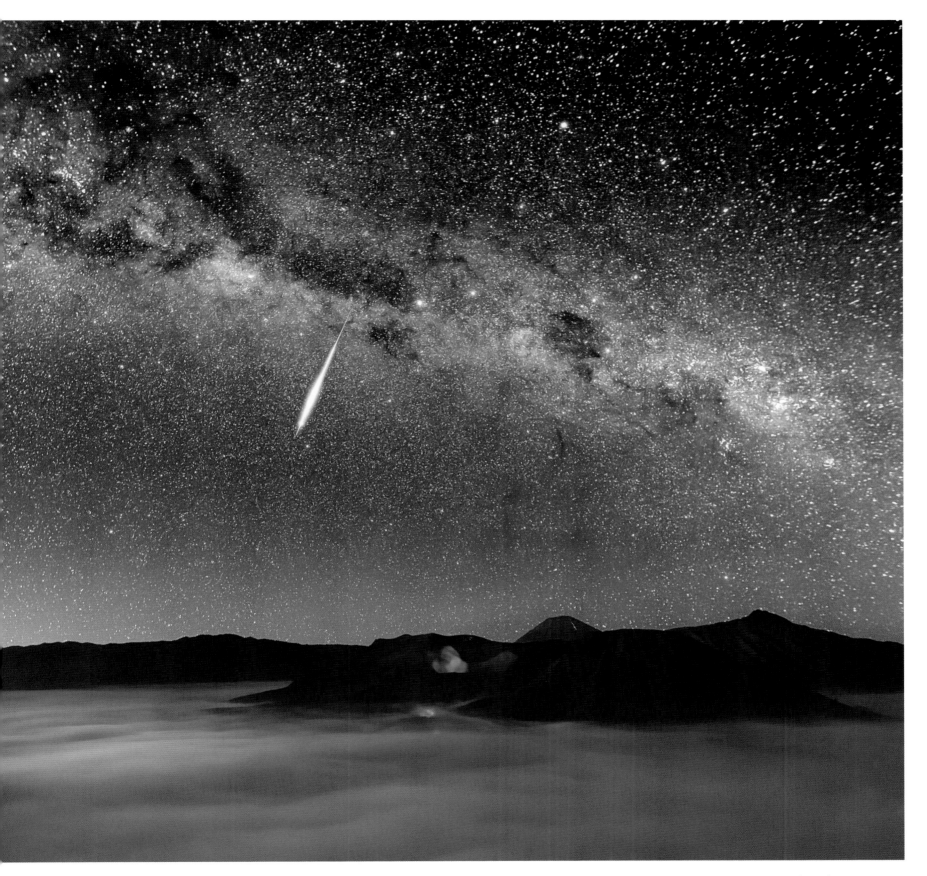

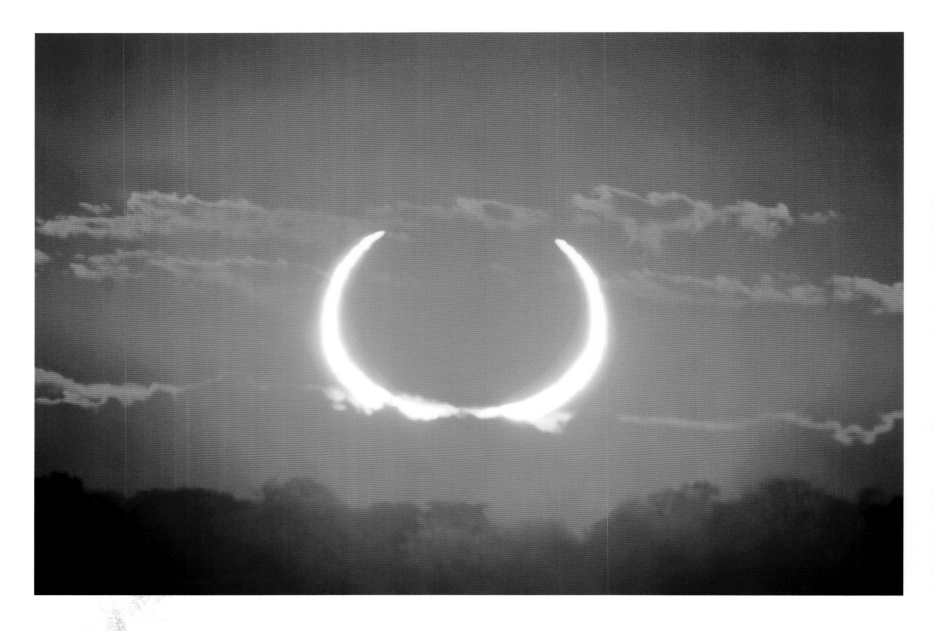

## FABRIZIO MELANDRI (Italy)

### Horns of Fire Sunrise
[10 May 2013]

**FABRIZIO MELANDRI:** Sunrise about 100km south of Newman, Western Australia, on a morning in May, with the annular eclipse in progress.

*Newman, Pilbara, Western Australia*

**BACKGROUND:** Here the distortion of the Sun and Moon as the light passes through the thickest part of our atmosphere provides a different perspective on this celestial event. During annular eclipses the Moon is too far away from the Earth to appear big enough to cover our distant star in the background. On the date this image was taken the Moon was about 400,000km away from us, while the Sun was around 150 million km away.

**Nikon D7000 camera; 700mm f/7 lens; ISO 100; 1/750-second exposure**

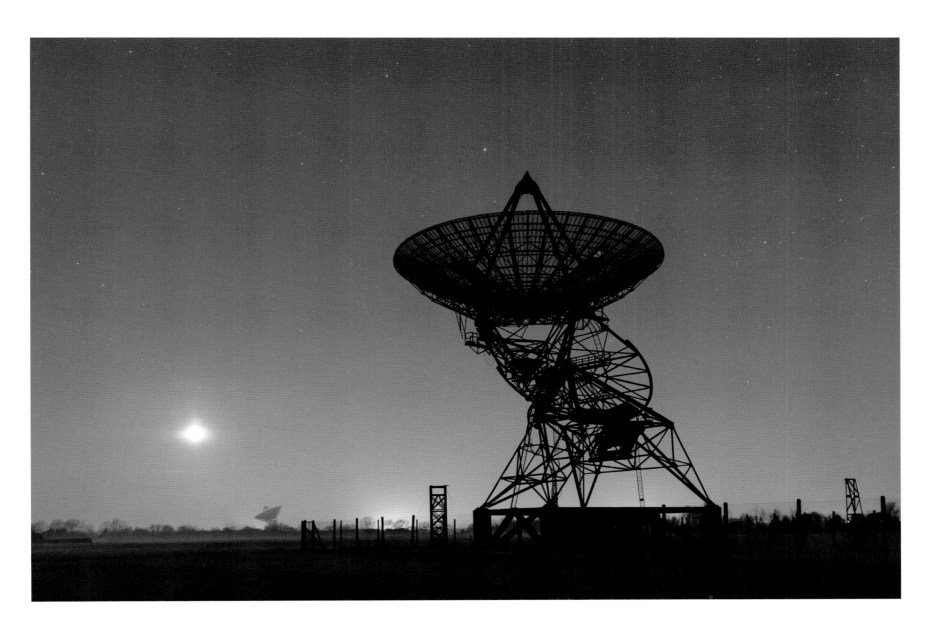

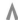

## JAMES MILLS *(UK)*

### Celestial Interactions
[*9 March 2014*]

**JAMES MILLS:** One of the MRAO (Mullard Radio Astronomy Observatory) one-mile telescope receiving dishes near Cambridge, just before moonset. At the horizon the MERLIN (Multi Element Radio Linked Interferometer Network) dish looks on up towards the Moon. The title came about with a couple of thoughts in mind … the obvious one of the main subjects, then also the meeting of cool blue moonlight against the Cambridgeshire light pollution.

*Lord's Bridge, Cambridge, UK*

**BACKGROUND:** Like our eyes, digital cameras are only sensitive to a very narrow range of the electromagnetic spectrum, leaving us blind to the many other types of radiation given off by objects in space. Here, however, the photographer is highlighting a technology that allows us to 'see' another form of radiation. These radio telescopes in Cambridge could also be thought of as 'radio cameras', capturing and recording the radio waves emitted by stars and galaxies and creating an image of their distribution across the sky.

**Nikon D800 camera; 32mm f/5 lens; ISO 4000; 10-second exposure**

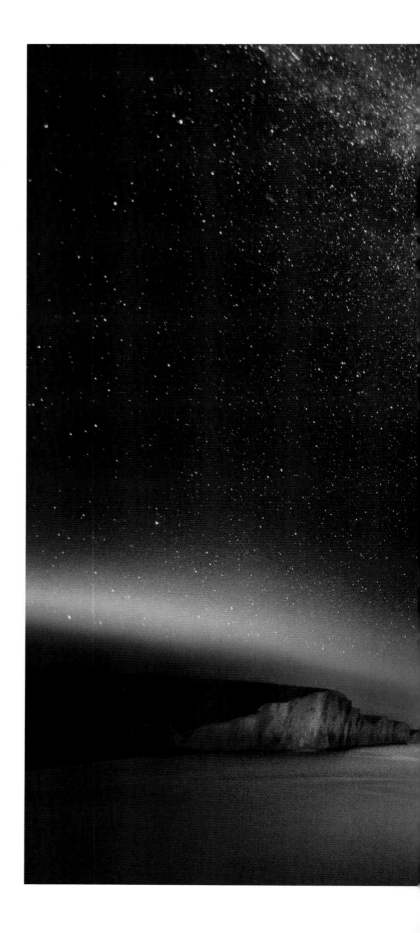

**CHAP HIM WONG** *(Hong Kong)*

### The Seven Sisters and the Milky Way
*[5 April 2014]*

**CHAP HIM WONG:** This was taken on Seven Sisters cliffs, Seaford, in April 2014. I have imagined this scene for years and I finally captured it here. I stacked four images of the Milky Way using a tracker, and then overlaid a static foreground image on top. All images were taken on the same day, at the same moment, with the same settings.

*Seven Sisters cliffs, Seaford, Sussex, UK*

**BACKGROUND:** One of the most familiar coastal cliffs in Britain, the Seven Sisters bear witness to an awe-inspiring spectacle, as the Milky Way seems to crash into the opaque sea. On the horizon, man-made light pollution timidly competes with the stars. There is an astronomical truth in the deep blue and golden glow of the sky, but the camera brings out colours that our eyes would otherwise be unable to see.

**Canon 6D camera; Canon EF 17–40mm f/4 lens; HL-1 (DIY) mount; ISO 1000; 5 x 180-second exposures**

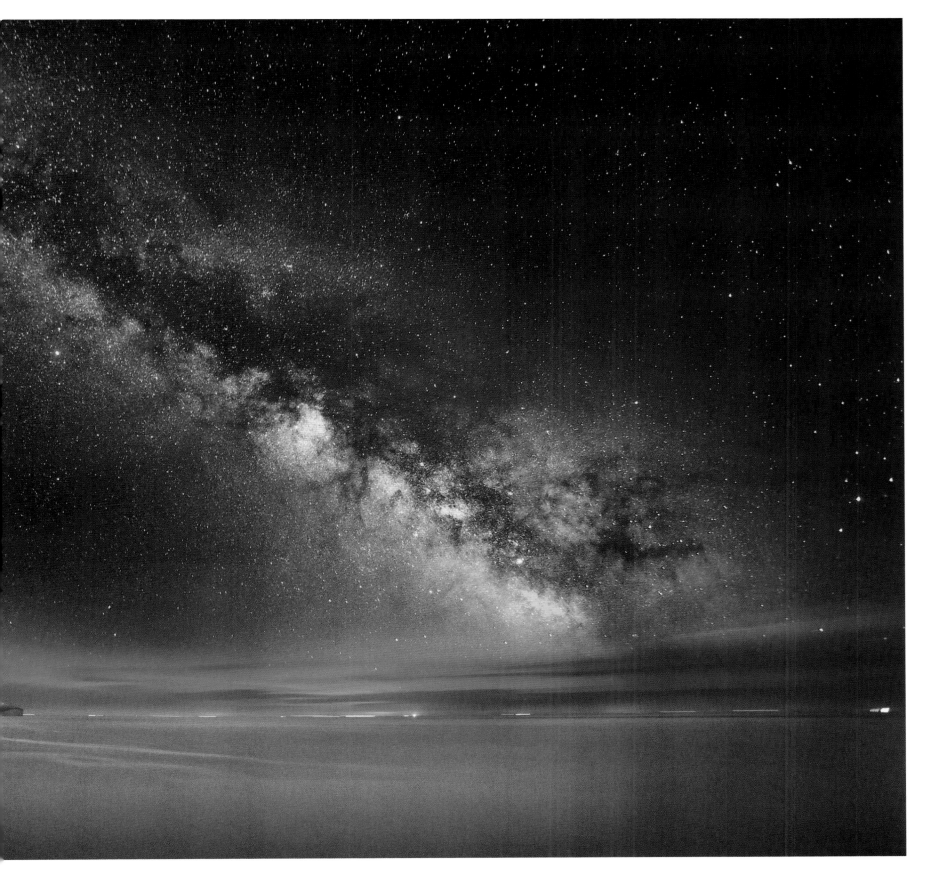

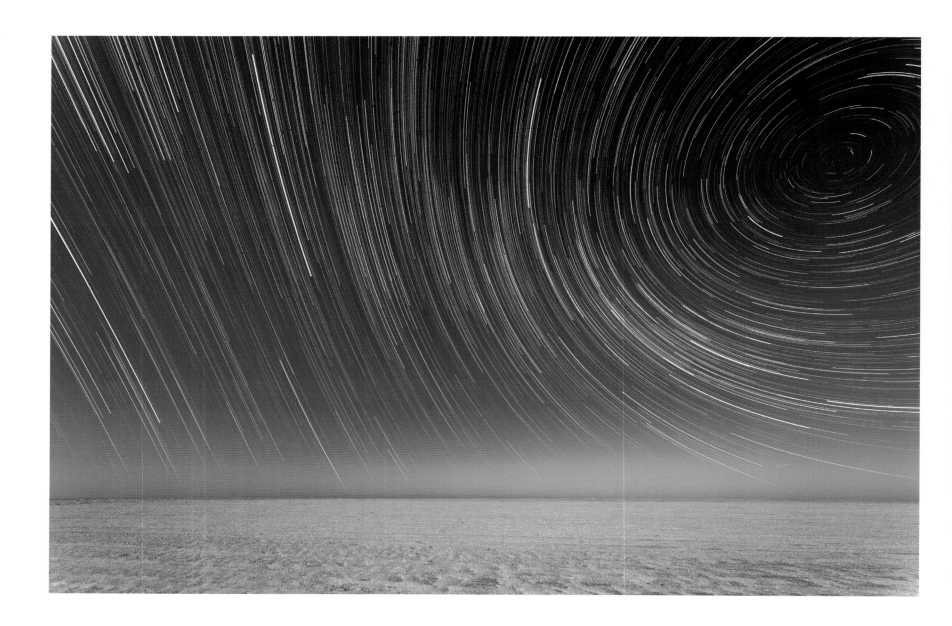

## SEBASTIÁN GUILLERMAZ (*Argentina*)

### Star Trails on the Beach
[*26 February 2014*]

**SEBASTIÁN GUILLERMAZ:** I stacked 268 photos to compose the star trail. The sky appears blue and bright by the light of the full Moon.

*Mar de Ajo, Buenos Aires Province, Argentina*

**BACKGROUND:** In this technically complex picture, multiple shots have been used to produce a time-lapse effect, as the Earth's rotation draws the light from the stars into long trails. Almost abstract in its block colours and strong linearity, this picture plays with contrasts, that of the sharp curves and obliques of the star trails against the warm plane of the beach.

**Canon 6D camera; Samyang 14mm f/4 lens; Manfrotto tripod**

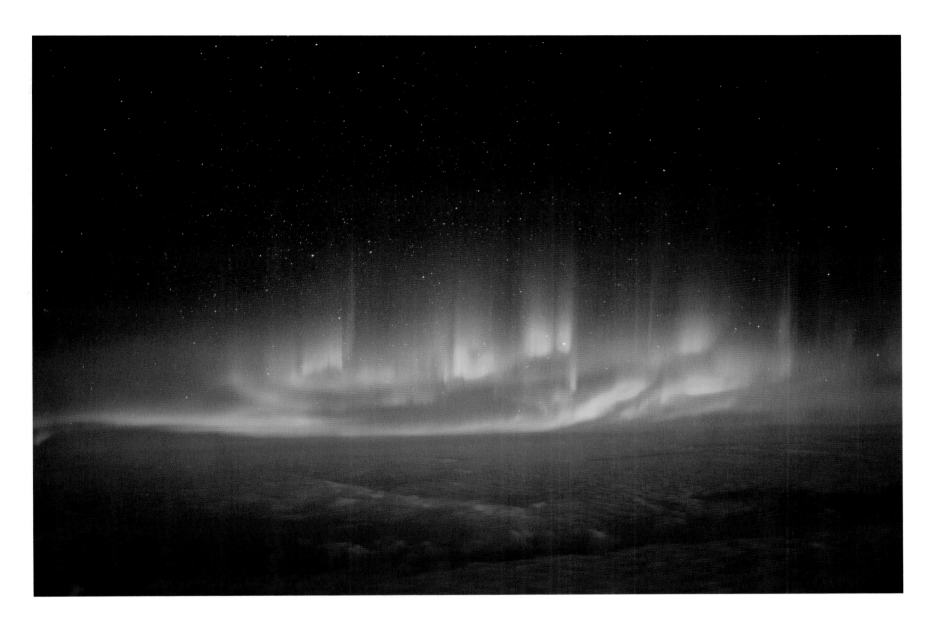

## PAUL WILLIAMS (UK)

### In-flight Entertainment
[*17 February 2014*]

**PAUL WILLIAMS:** Magnificent aurora seen from the window of a flight between London and New York in February 2014. The camera was balanced on my backpack; I was hoping for no turbulence.

*Mid-air between London and New York*

**BACKGROUND:** Transatlantic flights often pass close to the North Pole, where aurorae are more common, and being on the window seat can give you a view onto the greatest light show on Earth. Taken from above the clouds, this chance shot's unusual perspective highlights the vertical structure of the aurora.

**Canon 6D camera; 24mm f/1.4 lens; ISO 3200; 2.5-second exposure**

## ANDREW CALDWELL (New Zealand)

### Falling to Earth
[2 March 2014]

**ANDREW CALDWELL:** The International Space Station (ISS) traverses the galactic core, far above Hawke's Bay, New Zealand. This is a composite of eight consecutive frames; one used as the base image and seven others used only for the ISS trail. This image covers 100 seconds of the ISS trail.

*Kairakau, Hawke's Bay, New Zealand*

**BACKGROUND:** The careful image combinations for this final composition allow the scene to contain both the intense reflected sunlight from the space station and the faint glow of stars in the Milky Way galaxy. The ISS speeds around the Earth at approximately 28,000km per hour, but even at this fantastic speed it would take just over one billion years to reach the heart of our galaxy that is also captured in the backdrop.

**Nikon D800 camera; 17mm f/2.8 lens; ISO 1600; 13-second exposure**

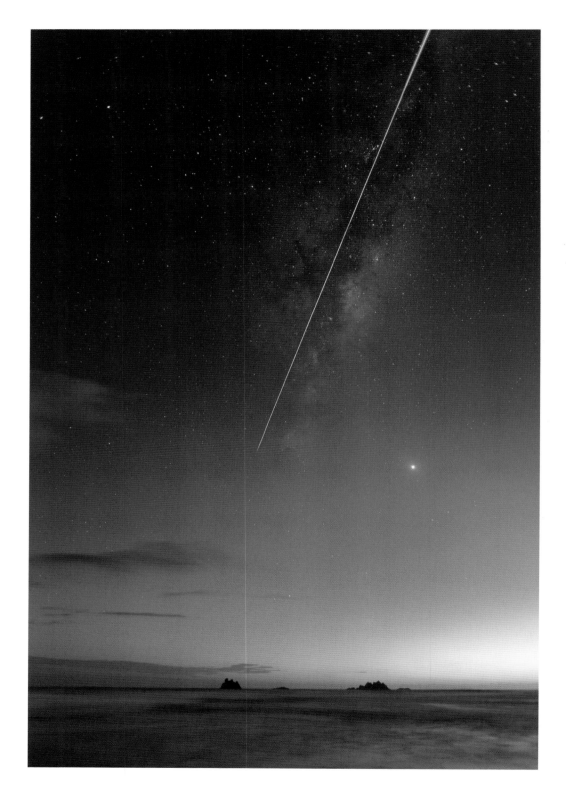

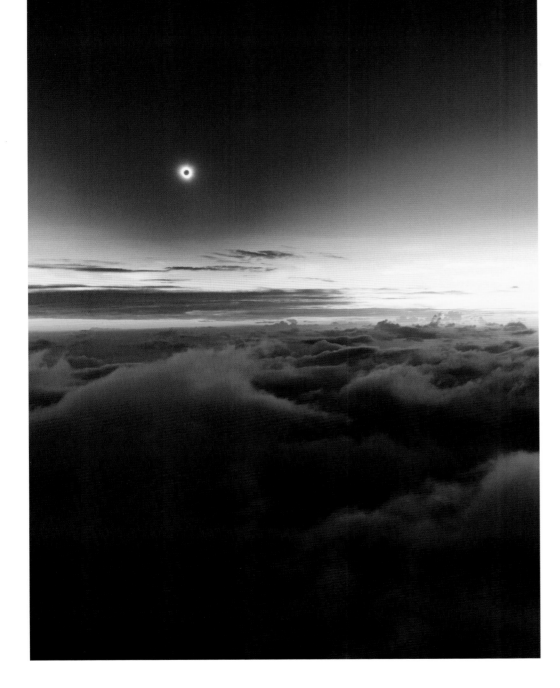

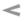

## Totality from above the Clouds
*[3 November 2013]*

**CATALIN BELDEA:** This is the view of the solar eclipse seen from 3200m. We were set to observe this rare total solar eclipse from the eastern shore of Lake Turkana, Kenya. Forty minutes before the totality we were hit by a huge sandstorm, and shortly after that by a thunderstorm. Fifteen minutes prior to totality our pilot decided to fly the plane to intercept this rare astronomical phenomenon. The duration of the eclipsed Sun was only ten seconds! The photo was shot through the open door of the small airplane.

*From an aeroplane, 3200m above Lake Turkana, Kenya*

**BACKGROUND:** A total solar eclipse is one of nature's greatest spectacles so it's no wonder that many people will go to extreme lengths just to experience one. Down on the ground the period of totality, when the Moon completely blocks the Sun, lasts for just a few minutes, so bad weather can completely wreck your chances of seeing it. This is where a plane can come in handy: you can fly above the clouds and chase the Moon's shadow as it races across the Earth.

**Nikon D7000 camera; 20mm lens; hand-held mount; ISO 800; 1/60-second exposure**

*"Catching a solar eclipse from the open door of a plane shows real dedication. An astonishing shot!"*
MAREK KUKULA

*"A fabulous image of a total solar eclipse. What I really like is the shadow of totality in Earth's atmosphere framing the eclipse."*
PETE LAWRENCE

*"What a magical moment captured from above the ground."*
MAGGIE ADERIN-POCOCK

*"This is an exceptional moment, captured in unique circumstances, with a powerful composition: deep blue sky, wispy clouds, beautiful light."*
MELANIE VANDENBROUCK

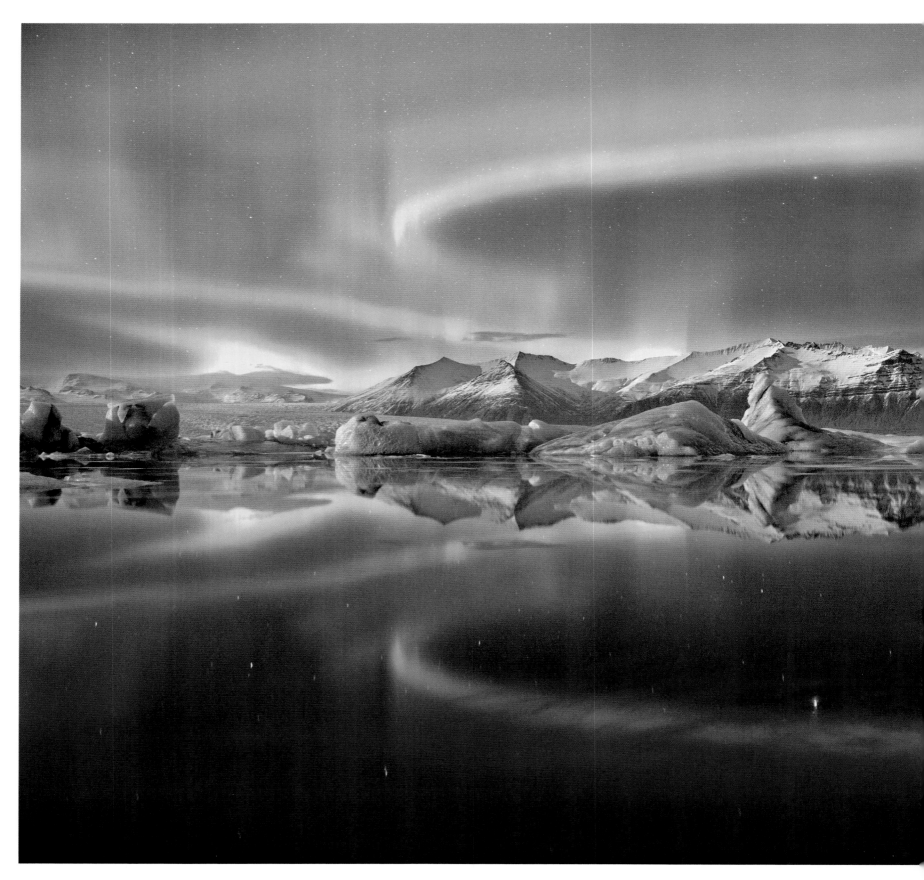

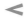

## JAMES WOODEND (UK)

### Aurora over a Glacier Lagoon
[9 January 2014]

**JAMES WOODEND:** Jökulsárlón Glacier lagoon with an overhead aurora reflected in the water. Although it is not a strong aurora, sometimes these make the best reflection shots. The water was very still – you can see the icebergs floating in the lagoon and their reflections. In the background is the Vatnajökull Glacier.

*Jökulsárlón, Vatnajökull National Park, Iceland*

**BACKGROUND:** A total lack of wind and current combine in this sheltered lagoon to produce a striking mirror effect, giving the scene a feeling of utter stillness. Even here, however, there is motion on a surprising scale: the loops and arcs of the aurora are shaped by the slowly shifting forces of the Earth's enveloping magnetic field.

**Canon 5D Mk III camera; 33mm f/3.2 lens; ISO 1000; 10-second exposure**

OVERALL WINNER 2014

*"Beautiful curves and symmetry! A wonderful, icy picture – I love the combination of whites and blue in the glacier with the chilly green of the aurora."*
MAREK KUKULA

*"I absolutely love the colours and auroral symmetry in this image as well as the contrast between the serene floating ice and the dramatic light display above. The blue ice is exquisite and the overall composition is mesmerizing. If you described this image on paper it would sound very alien indeed but the photographer has recorded the scene in a way that looks totally natural. The true beauty of planet Earth captured by camera: a worthy winner of the competition!"*
PETE LAWRENCE

*"Breathtaking shot! With its surreal colours and majestic aura it could be the landscape of a fairy-tale. I love the sense of depth, the sharpness of the turquoise ice, the structured symmetry, but, above all, its ethereal feel."*
MELANIE VANDENBROUCK

*"The lime greens and ice blues of this arctic landscape literally bounce off the page. A scenic dream of epic proportions."*
MELANIE GRANT

*"This beautiful image captures what it's really like to see a good aurora – the landscape, with the reflections which seem almost sharper than the shapes in the sky, is a terrific bonus, too! This is the first time an aurora image has won the overall prize; I think what captivated the judges was that it really looked like the aurora was right in front of the viewer – there's no need for exaggerated or stretched colour."*
CHRIS LINTOTT

*"This image is wonderful; it's a really natural portrayal of the aurora as diffuse and veil-like over the sparkling white landscape below."*
CHRIS BRAMLEY

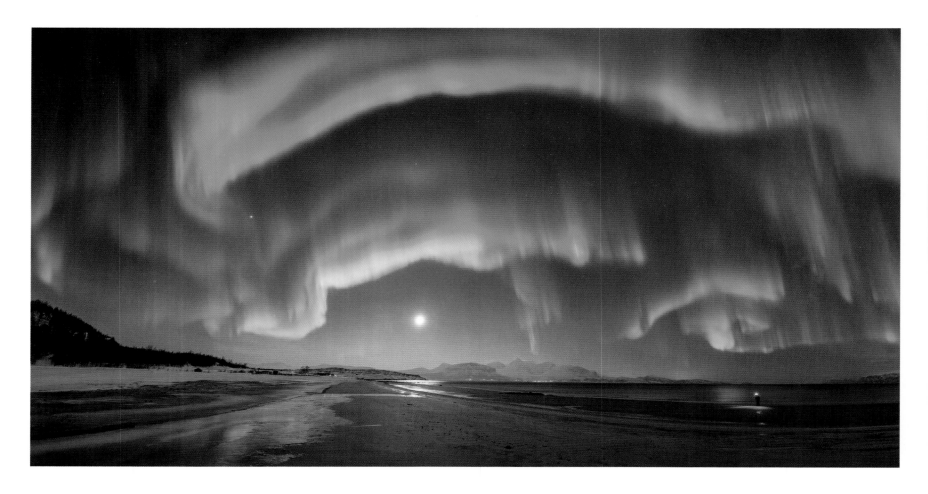

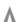

## TOMMY RICHARDSEN (*Norway*)

### What the ... !
[*8 February 2014*]

**TOMMY RICHARDSEN:** I was actually just about to leave to go shoot somewhere else when this massive aurora flared up. It lasted no more than ten minutes from start to finish but it lit up the entire sky. The figure on the right is my brother, furiously searching for his lens cap – he had just bought his new camera and lens the day before. It was hard not to laugh while moving my camera left to right capturing the panorama, but luckily he stood still long enough to make the final capture.

*Steinsvik beach, Nordreisa, Troms, Norway*

**BACKGROUND:** The unpredictable nature of the aurora means that photographers always need to be prepared to make the most of its fleeting appearances in order to capture the perfect shot. Here, even a bright Moon above the horizon cannot dampen the spectacular lightshow erupting across the winter sky.

**Nikon D800 camera; Zeiss 15mm f/2.8 Distagon lens; 3-second exposure**

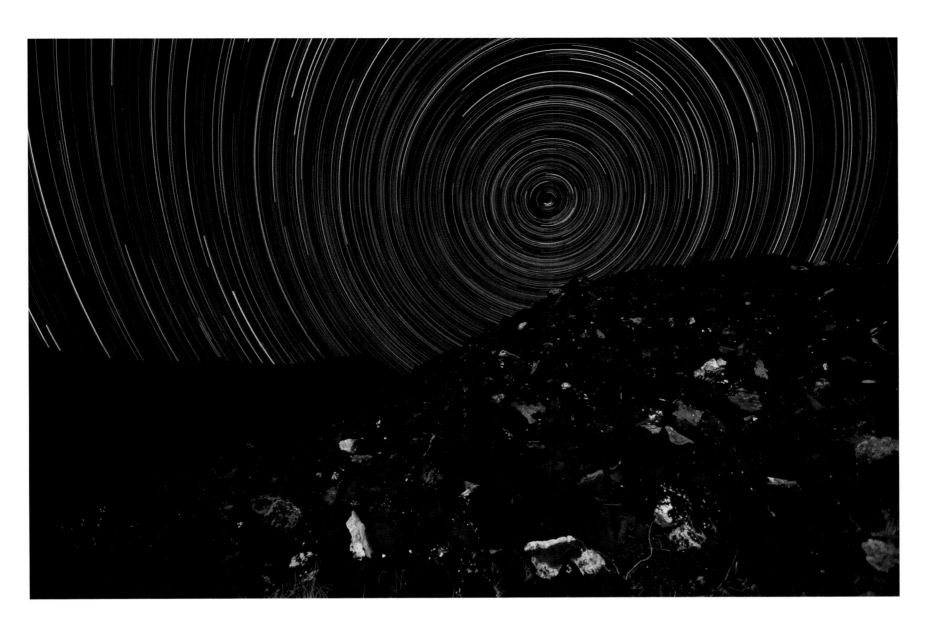

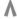

## GRANT KAYE *(USA)*

### Fluorescent Mine Tailings in the Tungsten Hills
*[13 April 2013]*

**GRANT KAYE:** This image combines one 30-second exposure (during which I illuminated a pile of mine tailings at an abandoned tungsten mine in the Eastern Sierra with shortwave ultraviolet light), with 55 six-minute exposures made at night to show the apparent motion of the stars, and one exposure made at the first light of dawn.

*Bishop, California, USA*

**BACKGROUND:** The stars are so far away that even the fastest spacecraft ever built would take thousands of years to reach our nearest stellar neighbour. And yet, by capturing their light, astronomers have been able to learn a great deal about these impossibly distant objects. Splitting starlight into its constituent colours is a particularly useful technique: by identifying the unique colours absorbed and given off by different chemical elements and compounds astronomers can work out what the stars are made of. Here the same principle is illustrated in a more Earthly context. The photographer has illuminated the mining waste in the foreground with ultraviolet radiation, energizing the metallic ores present in the rocks and causing them to glow with characteristic greens, blues and yellows.

**Canon 5D Mk III camera; 16mm f/5 lens; ISO 400; 360-second exposure**

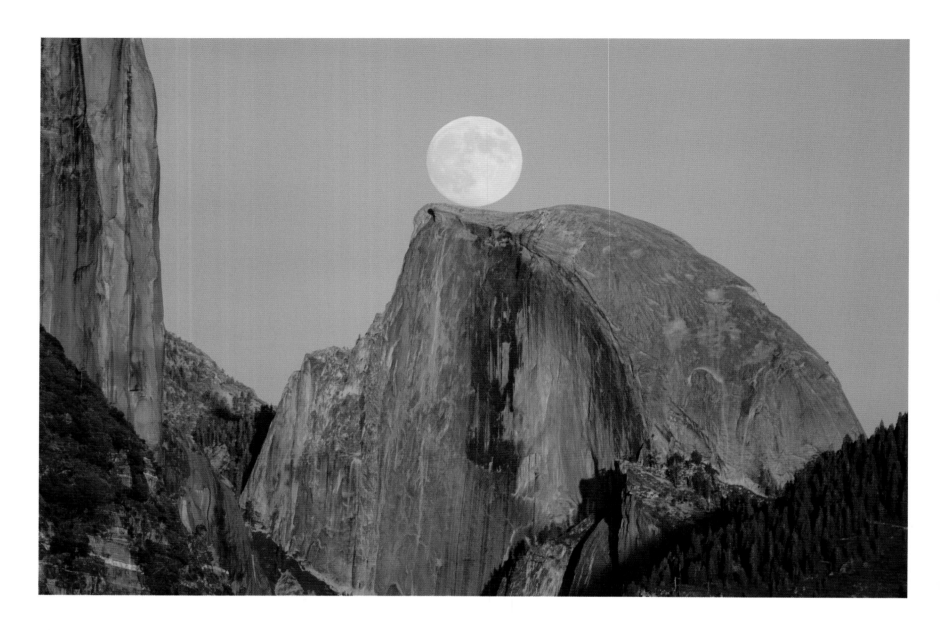

**JEFF SULLIVAN** *(USA)*

### Moonrise Behind Half Dome

*[28 October 2012]*

**JEFF SULLIVAN:** I've been pursuing this moonrise on and off since at least 2006. The weather doesn't always cooperate, but I've caught it from several different vantage points now, and I have a few more in mind for return trips.

*Yosemite National Park, California, USA*

**BACKGROUND:** The combination of moonrise and the dramatic landscape of the American West inevitably conjures associations with the great twentieth-century photographer Ansel Adams, for whom this was an iconic subject. Here the spectacular geologies of the Earth and Moon are juxtaposed, with our satellite apparently poised to roll down the granite slopes of Yosemite National Park's famous Half Dome rock formation.

**Canon 7D camera; 420mm f/8 lens; ISO 400; 1/1600-second exposure**

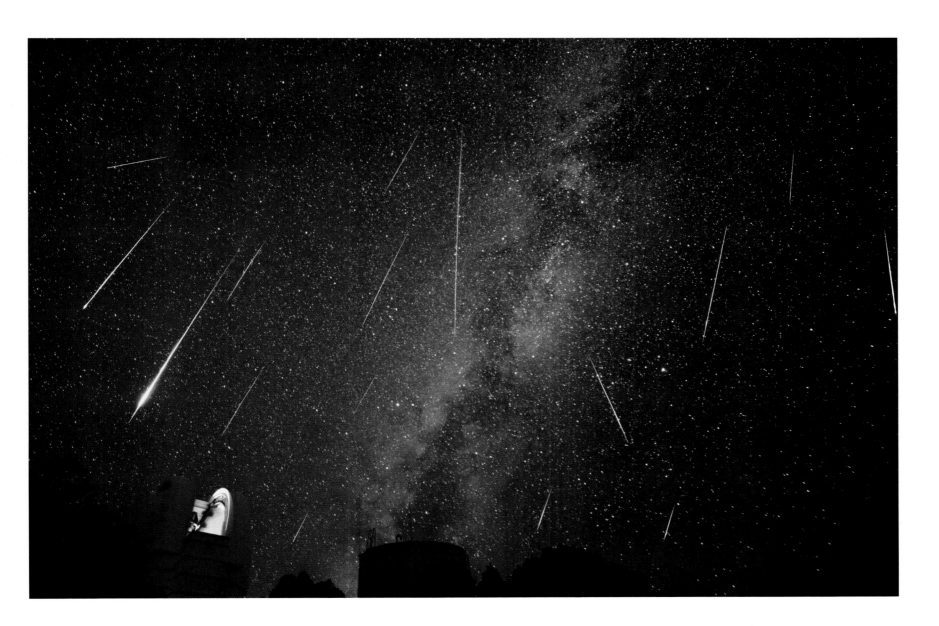

## SERGIO GARCIA RILL (USA)

### Perseids Composite
[12 August 2013]

**SERGIO GARCIA RILL:** This is a composite image of 17 different photos from the Perseid meteor shower in August 2013. It has 16 meteors that I captured during a three-hour period at the top of Mount Locke, looking towards the Otto Struve telescope of the McDonald Observatory.

*McDonald Observatory, Fort Davis, Texas, USA*

**BACKGROUND:** Small pieces of debris from the comet Swift-Tuttle collide with the Earth's atmosphere; heating and glowing, shedding material as they travel, these meteors create streaks that appear to radiate from the constellation Perseus. Individual meteors are usually short-lived, but in meteor showers such as the Perseids it is possible to see dozens per hour at the peak of activity.

**Nikon D600 camera; 14mm f/2.8 lens; ISO 5000; 30-second exposure**

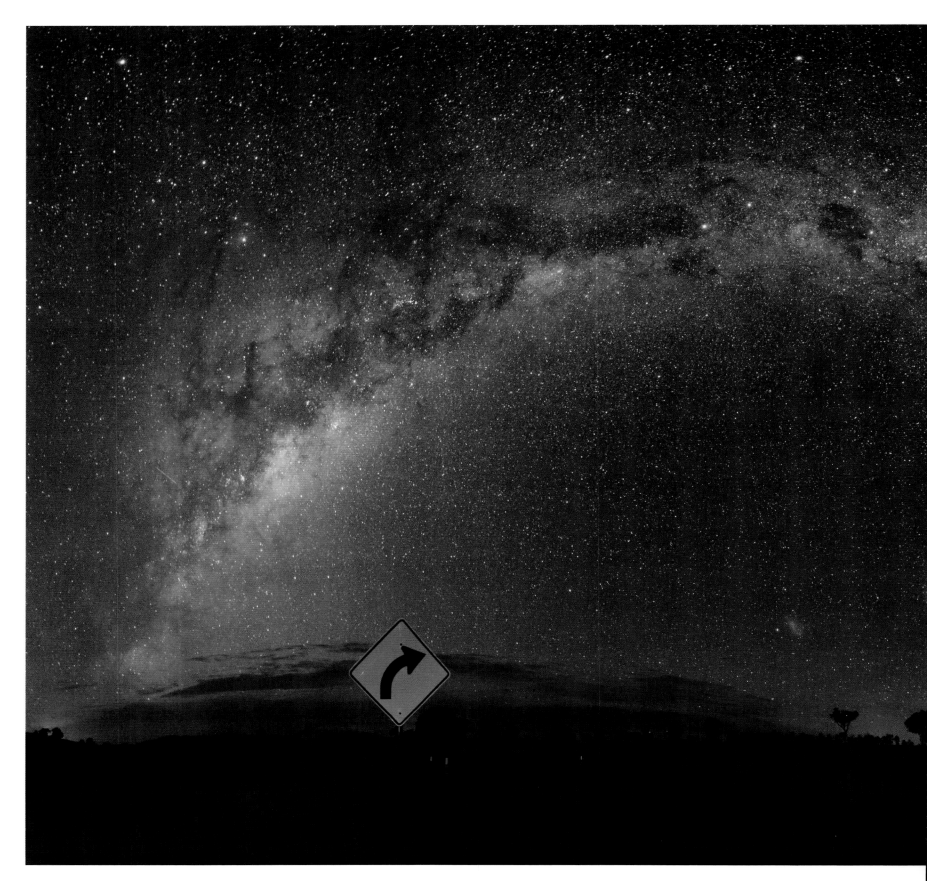

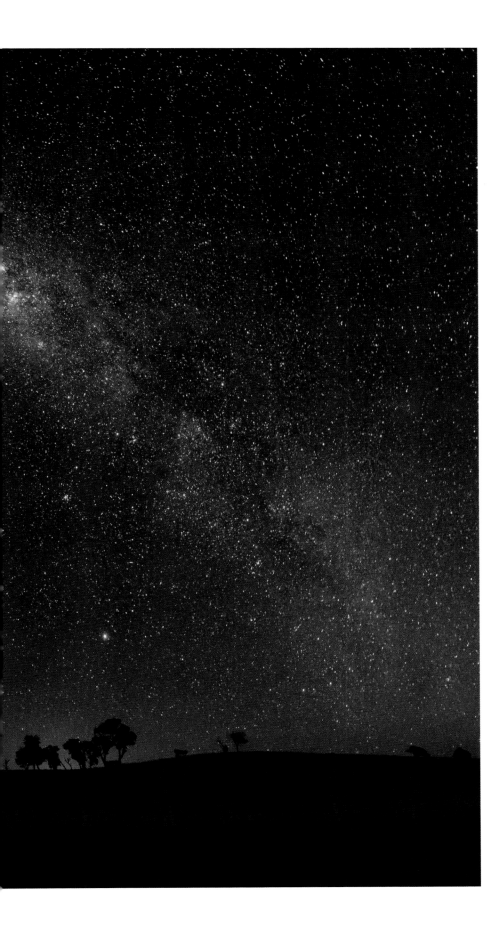

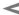

## CARLOS ORUE (*Australia*)

### Right Turn Ahead
[*9 March 2014*]

**CARLOS ORUE:** Milky Way season is upon us again. This 14-image panorama was taken under very dark skies in the heart of the Riverina, Australia. The Milky Way was so bright I almost needed sunglasses to turn down the glare! Lots of green airglow was visible, too. I had a lot of company along the way: kangaroos, wallabies, wombats, emus, rabbits and foxes. I'm proud to say that to date with all my driving around nightscaping, no creature has been harmed … well, except for a few bugs on my windscreen and grill.

*Riverina, New South Wales, Australia*

**BACKGROUND:** Our galaxy is vast; incredibly wide, but shallow. Embedded within this disc-like structure, we see the Milky Way as a band arching overhead: the diffuse light of billions of stars scattered, absorbed and re-emitted. Nearer the horizon are two irregular dwarf galaxies known as the Magellanic Clouds, which may orbit the Milky Way.

**Canon 5D Mk III camera; 15mm f/2.8 lens; ISO 4000; 25-second exposure**

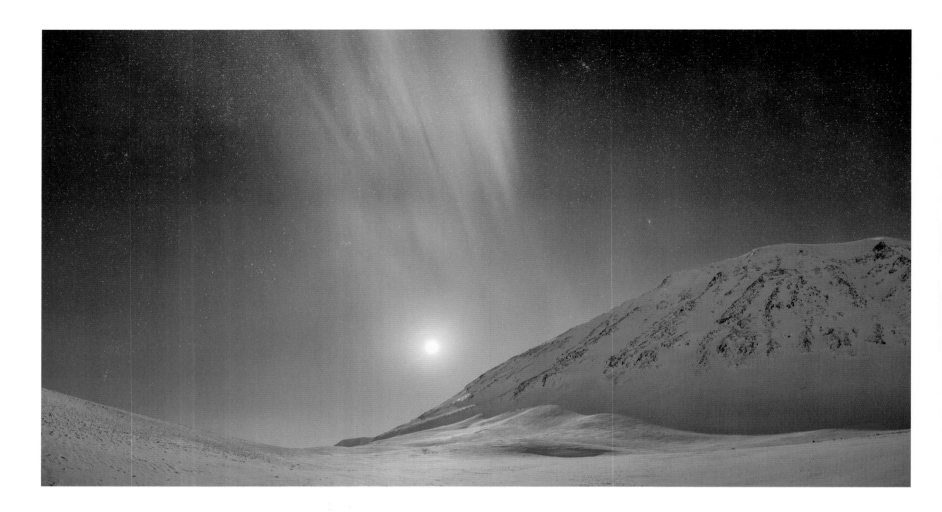

Λ

## TOMMY RICHARDSEN *(Norway)*

### Arctic Night
*[9 January 2014]*

**TOMMY RICHARDSEN:** With temperatures dipping as low as -18°C it was quite a cold night out shooting, but expectations were high with a reported X-flare incoming. It did not spark any bright auroras but the moonlight and the aurora that did appear made it all worthwhile. Looking at this image later, I felt it was my best capture of the season.

*Kvænangsfjellet, Troms, Norway*

**BACKGROUND:** In recent years the Sun has been going through the peak of its eleven-year cycle of activity, with sunspots mottling its face and vast solar flares exploding from its surface. Aurora watchers take a keen interest in this 'space weather', since a solar flare can send a blast of subatomic particles speeding towards the Earth. When they strike our planet's magnetic field the atmosphere around the poles is

energized, giving rise to the shimmering lights of the aurora. An X-class flare is among the most powerful, and often produces a spectacular auroral display. Alas, just like terrestrial weather, the aurora can defy all predictions, but even a more muted display can be very beautiful, especially when combined with a striking moonlit scene like this.

**Nikon D800 camera; Nikon 24mm f/1.4 lens; 6-second exposure**

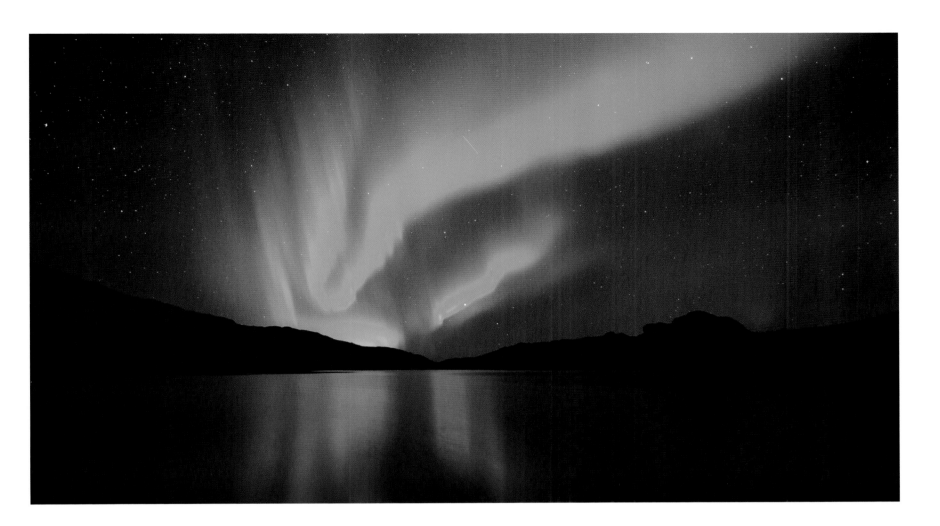

∧

**KOLBEIN SVENSSON** *(Norway)*

### Aurora
[*3 October 2013*]

**KOLBEIN SVENSSON:** I took this in October 2013. I was in the mountains, far away from any people, when this beautiful aurora appeared. It lasted a couple of hours. This shot is one of the best from that night.

*Lierne, Nord-Trøndelag, Norway*

**BACKGROUND:** Excited atomic oxygen emits this vibrant green light, while the lines of the Earth's magnetic field shape the aurora into wonderfully defined curtain-like structures (mirrored in the softer, reflected light beneath). The dark mountains seem empty and unchanging, a stark contrast to the dynamic auroral processes raging in the upper atmosphere.

**Nikon D7000 camera**

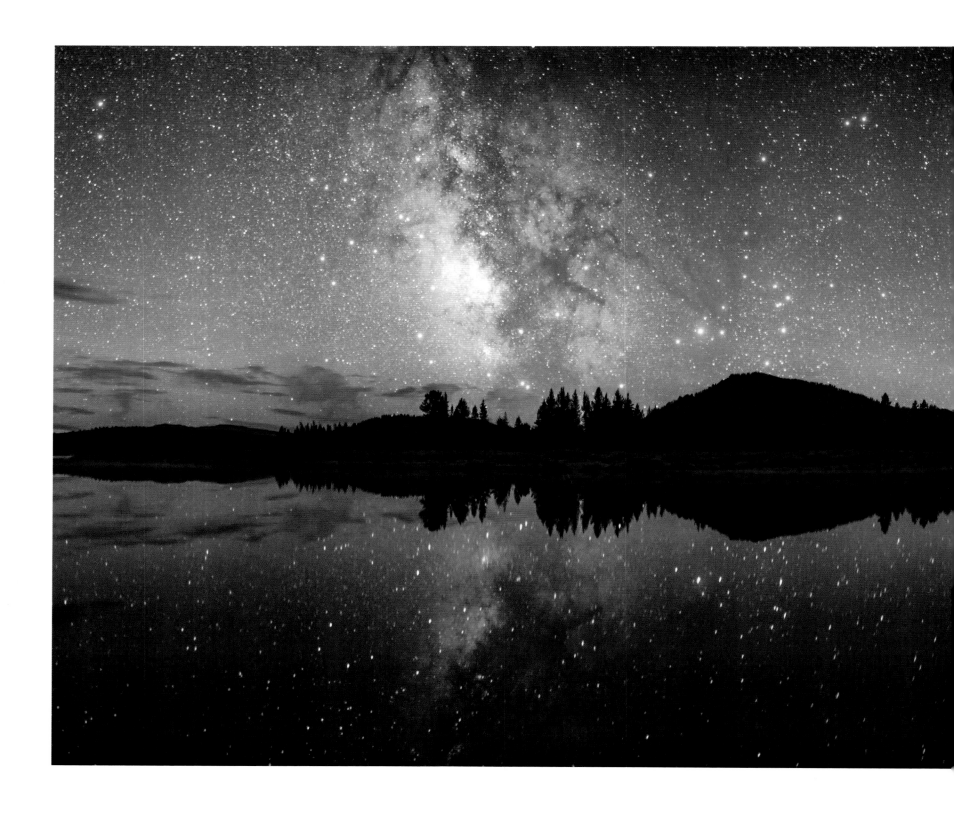

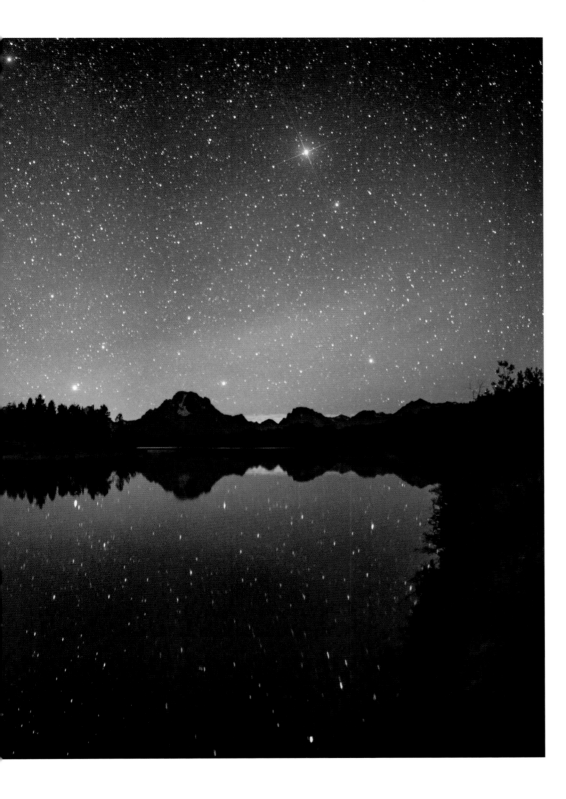

## DAVID KINGHAM *(USA)*

### Oxbow Bend Reflections
[*14 July 2013*]

**DAVID KINGHAM:** The Milky Way reflected in the Snake River at the famous Oxbow Bend in Grand Teton National Park. This is a nine-image panorama.

*Grand Teton National Park, Wyoming, USA*

**BACKGROUND:** The sensitive detector chip of the digital camera reveals a sky crowded with stars, many of them too faint for the unaided eye to see. The heart of our galaxy, the Milky Way, is poised just above the horizon like a glowing cloud. In this dense region the stars are packed so closely together that there would be no true night at all: instead even our weak eyes would see a dazzling vista of thousands upon thousands of stars crowding the heavens and rivalling the Sun for brightness.

**Nikon D700 camera; 24mm f/1.4 lens; ISO 6400; 20-second exposure**

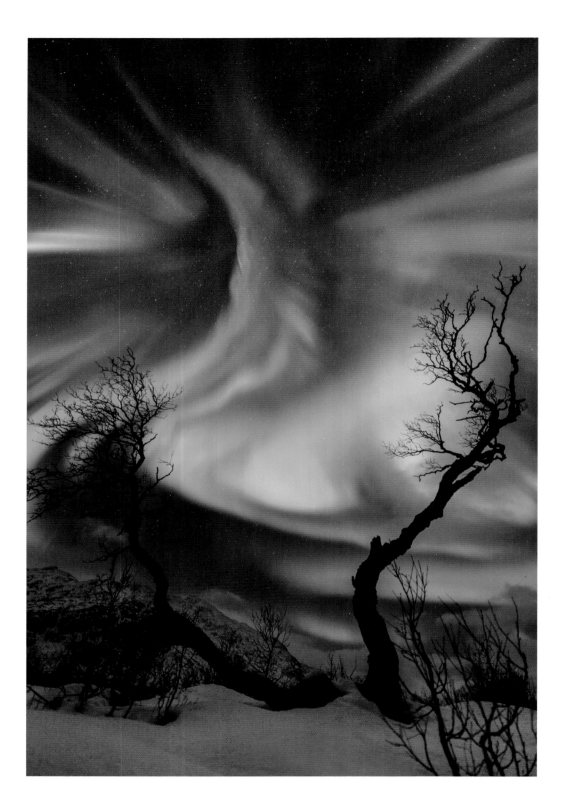

<

## OLE CHRISTIAN SALOMONSEN (*Norway*)

### Creature
[*31 October 2013*]

**OLE CHRISTIAN SALOMONSEN:** On 31 October a CME (Coronal Mass Ejection) hit Earth, giving us multi-coloured auroras across the sky for most of the night. My heart was beating fast as I did not want to miss this one. What is exciting about shooting a good aurora photo is that you are not in control of where the auroras are in the sky, so making a good composition is hard! These old birch trees worked well – arms reaching for the auroral corona – looking like some strange creature in the sky.

*Kattfjordeidet, Tromsø, Norway*

**BACKGROUND:** Often finding and losing form within a moment, the aurora is a dynamic and transient subject. In this photo, common auroral structures known as 'curtains' are brought into sharp relief, with the added element of stretching virtually overhead. The result is a colourful view of an auroral corona – the unique perspective of looking directly up through the rays of light, starting some 95km above the ground and extending a further 160km to the edge of space.

**Canon 5D Mk III camera; 14mm f/2.8 lens; ISO 6400; 2.5-second exposure**

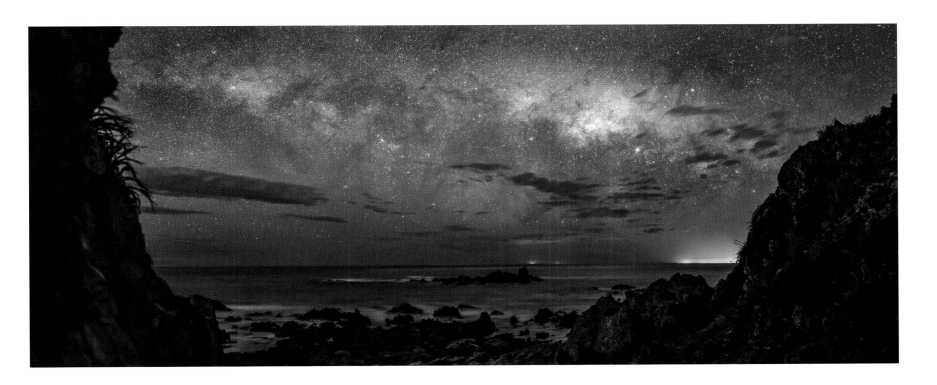

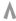

### MARK GEE *(New Zealand)*

### A Night at Devil's Gate
[*27 September 2013*]

**MARK GEE:** The south coast of Wellington, New Zealand, as the Milky Way hangs low just above the horizon. This view is from Devil's Gate, looking south across the Cook Strait to South Island.

*Devil's Gate, Wellington, New Zealand*

**BACKGROUND:** Scudding clouds and the lights of distant towns seem to emphasize the majesty of our home galaxy as it spans the sky in this scene from the Southern Hemisphere. The brightest regions of the Milky Way are the dense star fields in the direction of the Galactic Centre. The view would be even more dazzling if not for the intervening clouds of dark space dust, which blot out much of the central regions, hiding their stars from view.

**Canon 5D Mk III camera; 50mm f/2.5 lens; ISO 6400; 15-second exposure**

> 

## MATT JAMES (Australia)                    *RUNNER-UP*

### Wind Farm Star Trails
[*9 January 2014*]

**MATT JAMES:** This photograph shows the Capital Wind Farm on the shore of Lake George, near the town of Bungendore. The image was taken on a very pleasant summer evening during the new Moon in January 2014. Lake George is endorheic (a water body that does not drain into the sea) and is mostly dry at present. I had gone to this location to photograph a wide-field nightscape, which I did. But when I looked at the wind farm through my telephoto lens I noticed the lines and textures, and decided to make an image featuring the lake, the wind farm and star trails.

*Lake George, Bungendore, New South Wales, Australia*

**BACKGROUND:** A monochrome composition with striking graphic qualities, this is a picture of movement. It shows the power of the wind together with the apparent motion of the sky: the rotation of the Earth turns the trails into a shower of stars. Like a moment of stillness captured in the otherwise shifting surroundings, one of the wind turbines has remained static. Its sharply defined blades stand out among the dandelion-like shapes of the others.

**Sony A99 camera; Sony 70–200mm f/2.8 lens; RRS tripod; ISO 100; multiple exposures**

*"This is such a striking image. There's a real sense of motion and the monochrome palette makes the picture jump right out at you."*

MAREK KUKULA

*"A very different type of image. The glow of light around each of the turbine masts caused by the moving blades is incredible. The landscape below the masts reminds me of a lunar landscape. A wonderful result!"*

PETE LAWRENCE

*"A wonderful, desolate, artistic image that shows real bravery shot in black and white."*

MELANIE GRANT

*"Star trails are always popular, but this is so different from anything we normally see. I love the grainy feel, which sets the sky apart from the whirring turbines below."*

CHRIS LINTOTT

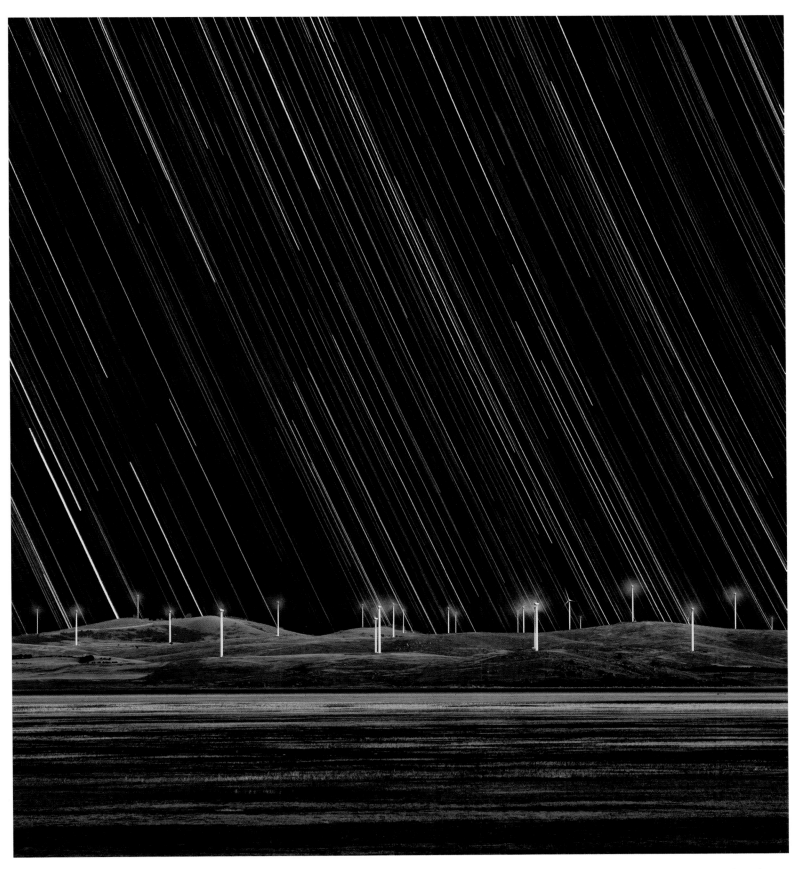

# ASTRONOMY ✦ PHOTOGRAPHER

## OF THE YEAR 2014

# OUR SOLAR SYSTEM

Photos of the Sun and its
family of planets, moons,
asteroids and comets

> 

## ALEXANDRA HART (UK)  *WINNER*

### Ripples in a Pond
*[16 February 2014]*

**ALEXANDRA HART:** Every moment I see the Sun through the telescope
a new scene takes my breath away. This day the view was exceptional
with a beautiful filament extending over the limb like a thin veil, together
with the massive active region AR11974. The active region resembled the
imprint created when stones hit the surface of a pond, with the magnetic
filaments as the ripples.

*Holmes Chapel, Cheshire, UK*

**BACKGROUND:** The Sun's boiling surface curves away beneath us in this
evocative shot, which powerfully conveys the scale and violence of our
parent star. The tortured region of solar activity on the left could swallow
up the Earth several times with room to spare. The photographer's
comparison with stones dropped into a pond is an apt one: the Sun's
outer layers do indeed behave as a fluid, but one that is constantly
twisted and warped by intense magnetic forces.

**TEC140 refractor; EQ6 Pro mount; Solarscope DSF 100mm f/18 lens;
PGR Grasshopper 3 camera**

*"You get a real sense of the Sun's seething, boiling surface in this photo.
A great reminder of the violent nature of our local star."*

MAREK KUKULA

*"The textures in this image are incredible. You really get a sense that there
are vast looping arcs of plasma leaping up and around the active region on
the left. I also love the way the patterns in the chromosphere draw your eye
towards the activity."*

WILL GATER

*"Amazingly detailed high resolution shot of the Sun's turbulent
chromosphere. The real achievement here is to show an active region
that looks three-dimensional. Brilliant image."*

PETE LAWRENCE

*"This image is unusual as it really gives a 3D impression of the Sun
in a 2D image. I feel we could jump in."*

MAGGIE ADERIN-POCOCK

*"There is a great texturing in this close-up view of the Sun, literally
sculpting the picture-plane of the photographic composition."*

MELANIE VANDENBROUCK

*"I love this swirling mass of fire and energy. A breathtaking example
of the Sun's power."*

MELANIE GRANT

*"This must be one of the most dramatic images we've ever had –
the turbulent magnetic forces that drive the Sun's activity are
almost visible here."*

CHRIS LINTOTT

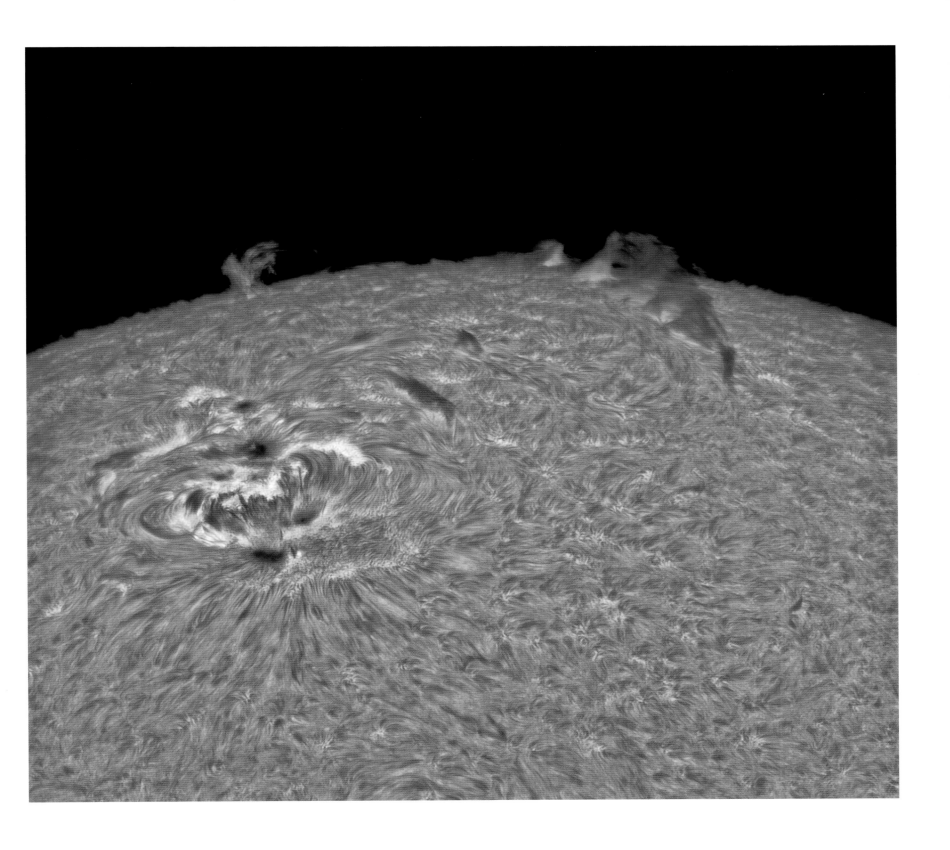

Λ

## LEVENTE BARATÉ *(Hungary)*

### Sun Whirlpools
[*31 August 2013*]

**LEVENTE BARATÉ:** I started doing astrophotography some ten years ago. As I live in a light polluted suburb of Budapest, my main targets are the Sun, the Moon and the planets. Three years ago I purchased a Lunt H-alpha solar filter, which drove my interest towards our constantly changing star. Every time I take pictures of it I 'discover' new spots and protuberances that capture my imagination.

*Budapest, Hungary*

**BACKGROUND:** Resembling a piece of abstract art, this close-up of the Sun uses a special filter to isolate the light given off by hydrogen atoms as they release their energy in the furnace-like conditions of the Sun's atmosphere. The solar surface seethes and roils like a pan of boiling water as superheated pockets of gas rise up from the interior. The darkest blotches are sunspots, where intense magnetic fields are supressing the rising gas. These slightly cooler regions rival the Earth's continents in scale.

**150/1800 home-made refractor; Sky-Watcher EQ6 mount; ASI120MM camera**

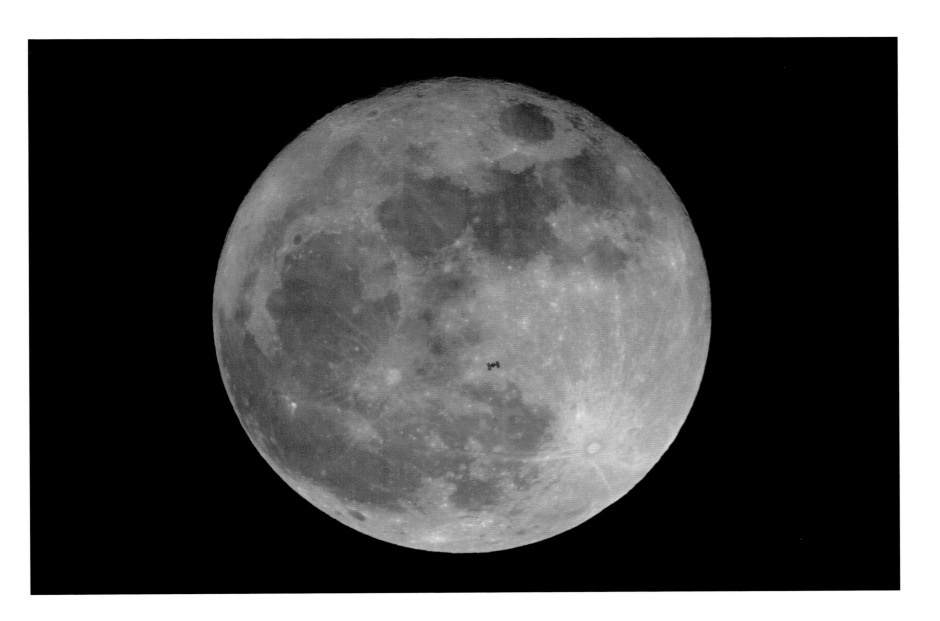

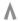

## DANI CAXETE *(Spain)*

### ISS Lunar Transit
[*17 December 2013*]

**DANI CAXETE:** This image captures the smallest full Moon of 2013, and in front of it is the International Space Station, orbiting at 28km per hour at a distance of 500km from the photographer.

*Madrid, Spain*

**BACKGROUND:** The Earth's two largest satellites, one artificial and the other natural, line up in this split-second shot as the International Space Station speeds across the face of the Moon. The idea of an artificial satellite orbiting the Earth with a human crew on board dates back to American author Edward Everett Hale's 1869 science fiction story 'The Brick Moon'. Today the ISS has a permanent crew of six, drawn from spacefaring nations around the world.

**Long Perng ED80 telescope; 550mm Barlow 2x lens; Nikon D7000 camera; ISO 1000; 1/1000-second exposure**

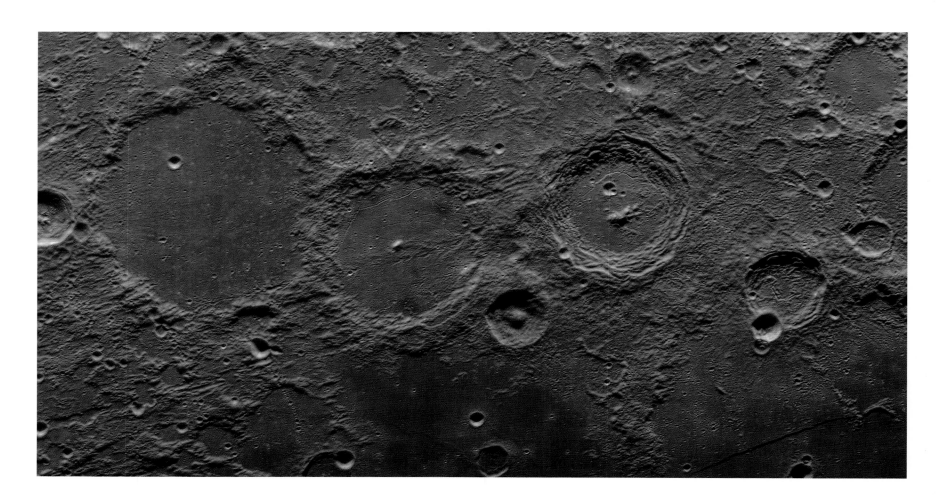

Λ

## GEORGE TARSOUDIS *(Greece)*

### Area of the Crater Ptolemaeus
*[13 October 2013]*

**GEORGE TARSOUDIS:** Craters Ptolemaeus, Alphonsus and Arzachel.
These three ancient large impact craters are among the most well-
known trilogy craters on the Moon. In my image you can see the 110km-
long Rupes Recta, or Straight Wall as it is more commonly known.

*Alexandroupolis, Evros, Greece*

**BACKGROUND:** As well as the three large craters, this image also
showcases several classic features of the Moon's rugged and varied
terrain. In the lower right-hand corner Rupes Recta is an escarpment
more than 200m high which stretches for over 100km along a geological
faultline. Meanwhile, two of the craters contain the meandering lines of
lunar 'rilles', thought to be the collapsed channels of subterranean lava
tubes formed long ago when the Moon was volcanically active.

**Sky-Watcher BK DOB 14-inch Collapsible 355mm f/4.5 telescope;**
**Sky-Watcher AZ EQ6 mount; Unibrain Fire-1 785 camera (monochrome)**

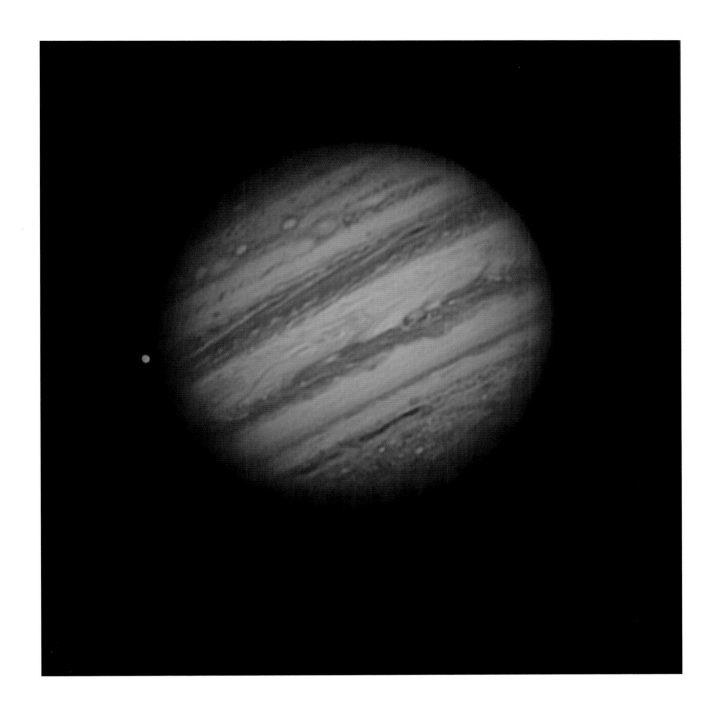

## PETER RICHARDSON (UK)

### Jupiter and Europa from Somerset, December 2013
[1 December 2013]

**PETER RICHARDSON:** This night was a constant battle with the clouds! It was the only capture of the session, but as it turned out, this image was probably my best of this stunning planet up to that point in time.

*Bleadon, Somerset, UK*

**BACKGROUND:** Jupiter has captured and held the interest of scientists for hundreds of years. Galileo Galilei discovered the largest of Jupiter's moons back in 1610 and since then spacecraft have been sent to Jupiter to try and find out more about it. Amongst these spacecraft is *Galileo* which was launched from the Space Shuttle *Atlantis* in 1989. The *Galileo* spacecraft found evidence of liquid water oceans underneath the icy crust of Europa's surface, which makes it a promising place to look for life beyond Earth.

**LX200ACF 12-inch telescope; ASI120MM camera**

## GEORGE TARSOUDIS (Greece)   *RUNNER-UP*

## Best of the Craters
[*13 October 2013*]

**GEORGE TARSOUDIS:** The king of the craters is maybe Tycho. Although it is not the biggest crater – it has a diameter of 86km – we can still see it easily on the Moon's surface.

*Alexandroupolis, Evros, Greece*

**BACKGROUND:** The word 'crater' was first coined in the seventeenth century by the Italian astronomer Galileo Galilei. He derived it from 'krater', the Ancient Greek term for a vessel used for mixing water and wine. Formed by meteorite impacts over billions of years, these bowl-shaped lunar features are typically named after scientists, artists and explorers. The central peak of the large crater featured here probably formed when the rocks of the crater floor rebounded immediately after it was formed.

**Sky-Watcher BK DOB 14-inch Collapsible 355mm f/4.5 telescope; Sky-Watcher AZ EQ6 mount; Unibrain Fire-1 785 camera (monochrome)**

*"This makes me feel as though I'm rushing over the lunar surface in a spacecraft. We're lucky to live in a time when we can see the Moon in such amazing detail."*

MAREK KUKULA

*"Such detail! The bright ray crater Tycho expertly captured when close to the terminator, showing intricate shadow relief detail. So many craters and craterlets caught here and processed to perfection. Makes you feel like you're looking down on Tycho from in orbit."*

PETE LAWRENCE

*"The detail on this image makes it seem like the view from a craft orbiting the Moon. There are a few good landing spots, too."*

CHRIS LINTOTT

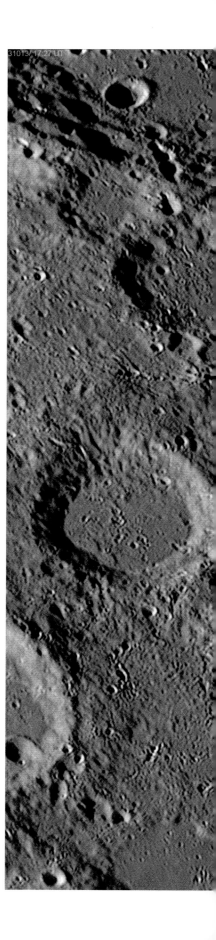

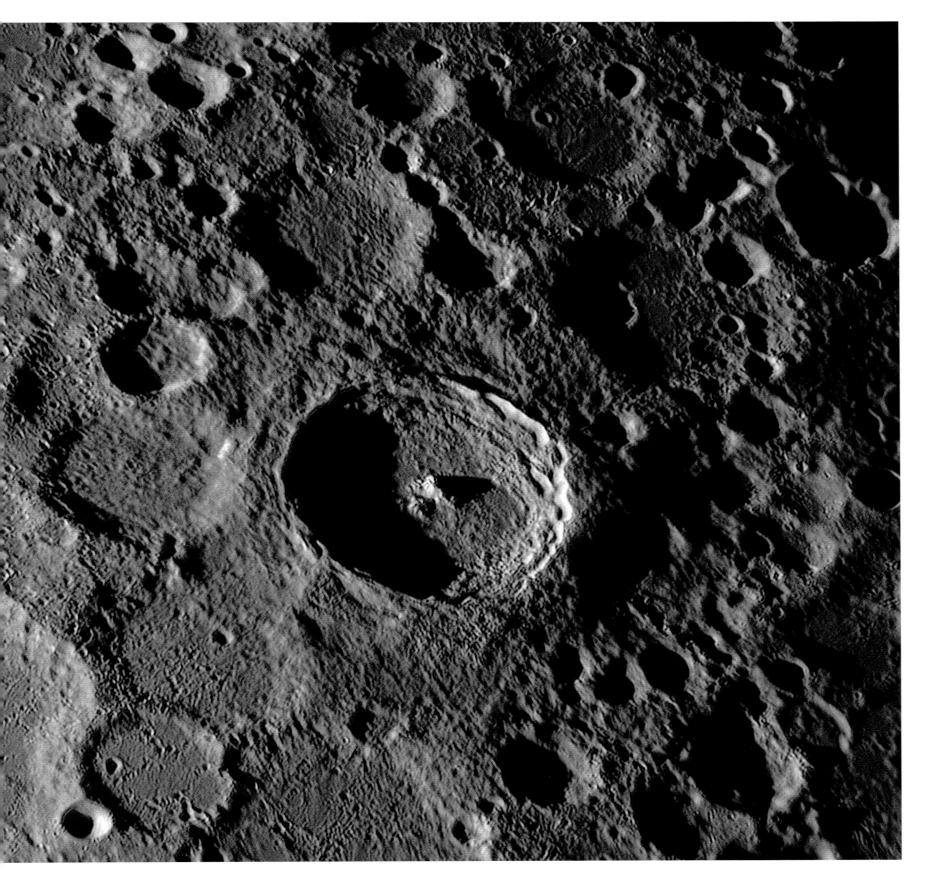

# STEPHEN RAMSDEN (USA)    HIGHLY COMMENDED

## Calcium K Eruption
[*31 August 2012*]

**STEPHEN RAMSDEN:** This is an image of an 800,000 mile (1.3 million km) dual branched solar prominence imaged at 393 nanometres taken during a solar astronomy outreach event in Atlanta, Georgia, using off-the-shelf consumer level solar viewing equipment. To my knowledge this is the longest prominence ever imaged by anyone on Earth and one of only a handful of Calcium K solar prominences ever captured.

*Atlanta, Georgia, USA*

**BACKGROUND:** 'Calcium K' refers to a very specific wavelength of violet light emitted by calcium ions in extreme environments such the Sun's atmosphere. By imaging the Sun only in this very narrow colour range astronomers can isolate evidence of extreme events, such as this colossal prominence rising off the solar surface.

**Explore Scientific 102mm APO/Lunt B1200 CaK wedge telescope; Celestron CGE mount; PGR Grasshopper 5.0MP camera; f/14 lens**

*"As well as being a record of a rare and explosive event, I love the way this photo perfectly conveys the Sun's dazzling brightness."*
MAREK KUKULA

*"Obtaining an image of a prominence through a Calcium K filter isn't the easiest thing to achieve, but to achieve one as dramatic and large as this is incredible."*
PETE LAWRENCE

*"The splash of violent colour complements the solar prominence beautifully."*
MAGGIE ADERIN-POCOCK

*"The use of a special filter has allowed the photographer to capture the full extent of this spectacular prominence, which stretches out into space. The Sun's complex magnetic fields are responsible for these dramatic events."*
CHRIS LINTOTT

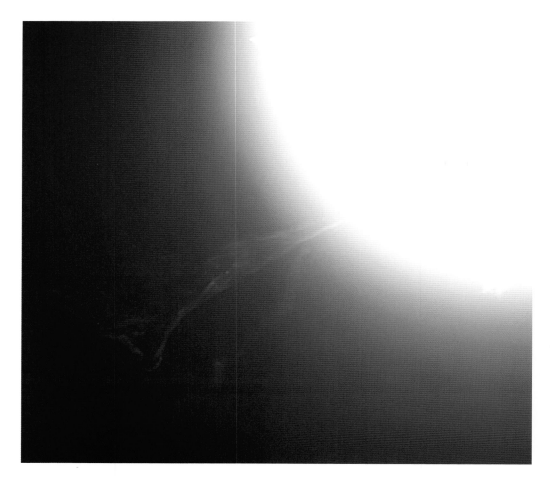

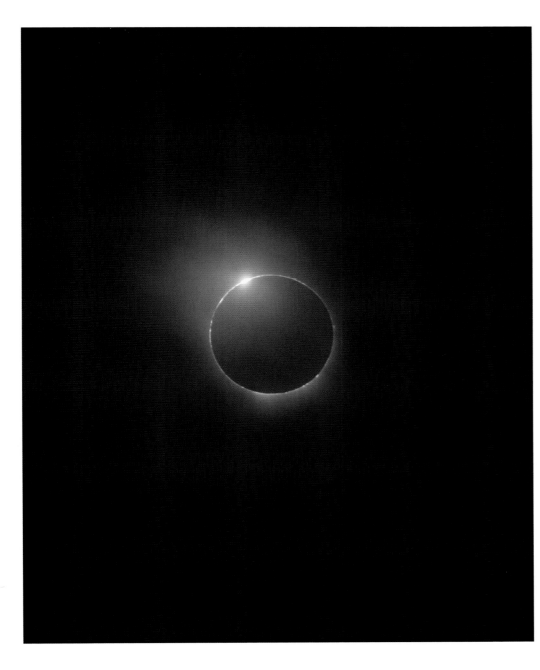

&lt;

**TUNÇ TEZEL** *(Turkey)*　　　　　　　*HIGHLY COMMENDED*

### Diamond and Rubies
[*3 November 2013*]

**TUNÇ TEZEL:** From our location at Pajengo village near Pakwach, Uganda, there was a lingering diamond ring before the beginning of the totality. There was also a thin layer of cloud, which diffused the lights of the diamond and red ring of chromosphere around the Moon. This view is a combination of two back-to-back exposures using my old Canon EOS 300D.

*Pajengo, Nwoya, Uganda*

**BACKGROUND:** Many features of the Sun only become apparent during a total eclipse, when the Moon blocks the dazzlingly bright solar disc from view. Here we see the Sun's outer atmosphere, or corona, as a diffuse white haze. Closer in, the layer of the Sun's atmosphere known as the chromosphere appears in the red light of hydrogen. The photographer has caught the moment when a tiny part of the Sun's disc shines out between the mountains on the edge of the Moon, creating an effect known as the 'diamond ring'

**Canon 300D camera; 400mm f/5.6 lens; ISO 200; 1/30- and 1/15-second exposures**

*"A fantastically eerie composition."*
MELANIE GRANT

*"This picture captures that magical moment during a total solar eclipse when the last (or first) rays of sunlight slip past the lunar disc. What I like most about this picture is the Sun's ruby-red chromosphere that is just peeking out from behind the Moon. Look closely and you can see many prominences – vast plasma clouds – leaping off the solar disc."*
WILL GATER

*"The moment of totality captured in all its glory here, and for a brief moment the Sun's outer atmosphere – the chromosphere – is visible as a red ring. It's the only time this layer of the Sun is not drowned out by the overwhelming brightness of our nearest star."*
CHRIS BRAMLEY

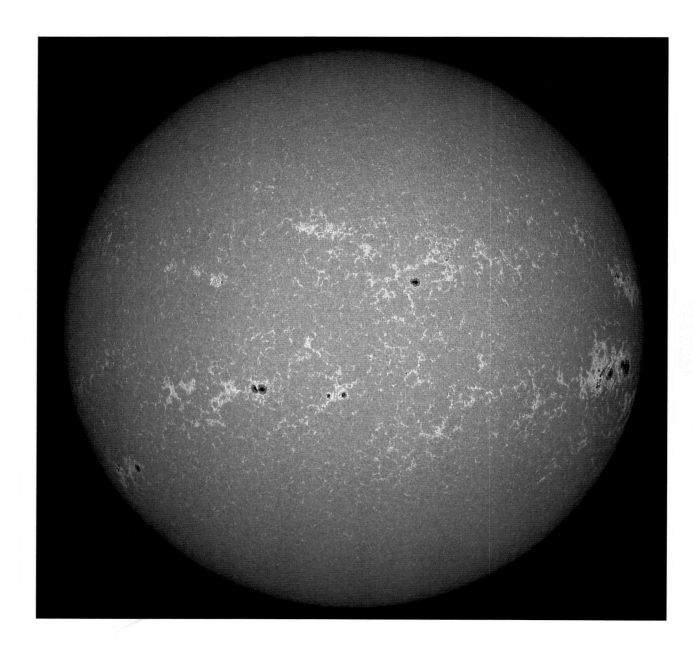

## MICHAEL BORMAN (*USA*)

### Solar Disc in Calcium K, January 2014
[*12 January 2014*]

**MICHAEL BORMAN:** I have been interested in imaging the Sun since the 1980s. I started out using film and a white light filter to take images of sunspots in the Sun's photosphere. In the 1990s I purchased my first H-alpha solar filter to take images of flares and prominences in the upper part of the Sun's chromosphere. Finally, when CaK solar filters became available to amateur astronomers, I purchased one to allow me to take images of the lower portion of the Sun's chromosphere. I now regularly take images in all three wavelengths, allowing me to see detail in all three 'levels' of the Sun's atmosphere.

*Evansville, Indiana, USA*

**BACKGROUND:** Light is a precious commodity for most astronomers, with every last scrap of electromagnetic radiation helping to reveal new detail in the faintest or most distant objects. But astronomers who study the Sun enjoy an embarrassment of riches, allowing them to pick and choose only the particular wavelengths of light which interest them, discarding the rest. Here, the photographer has used a filter to isolate the light from energized calcium atoms, revealing subtle detail in the Sun's upper layers.

**TeleVue 102iis refractor; Celestron CGE Pro German equatorial mount; 102mm lens; Point Grey Research Grasshopper 3 (monochrome) camera**

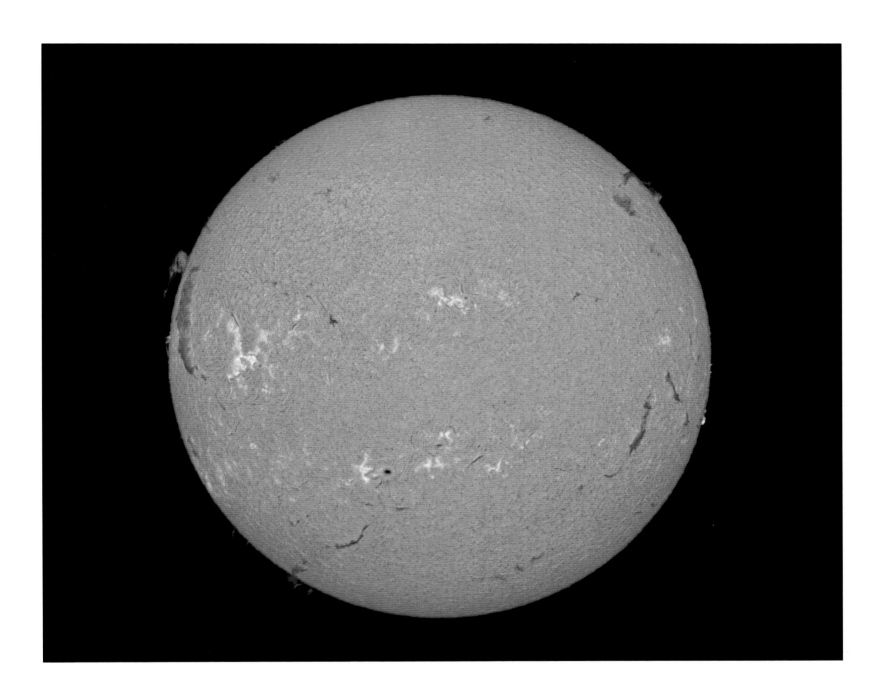

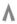

## ALEXANDRA HART (UK)

### Majesty
[22 September 2013]

**ALEXANDRA HART:** Certainly one is reminded of the majesty of our star, the life-giver of all, when encountering a sight such as this. The view through the eyepiece that day was the most beautiful I have ever seen, with many filaments extending over the limb. Who wouldn't want to share this with everybody?

*Holmes Chapel, Cheshire, UK*

**BACKGROUND:** The sight of the full disc of the Sun is put into perspective when realising that around 109 planets the size of Earth can be lined up across the Sun's equator. To be able to capture the detail seen here a H-alpha filter is needed to act like a very narrow light gate, allowing only a small fraction of the Sun's energy through the telescope to the camera.

**TEC140 refractor; EQ6 Pro mount; Solarscope DSF 100mm f/9 lens; PGR Grasshopper 3 camera**

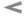

## ALEXANDRA HART (UK)

### Solar Nexus
[16 February 2014]

**ALEXANDRA HART:** The twisting and snaking of all the magnetically intertwined plasma between the active regions is pure solar joy: the Nexus.

*Holmes Chapel, Cheshire, UK*

**BACKGROUND:** The mesmerizing swirls of superheated gas in this image may induce a feeling of serenity, but this is far from a quiet scene for our star, the Sun. The dark strands, called filaments, that we see in this image more than likely have a ferocious destiny ahead. The magnetic chaperones that keep the filaments in place will eventually break down, unravelling to violently fling the stellar material off into space as a solar storm.

**TEC140 telescope; EQ6 Pro mount; Solarscope DSF 100mm f/18 lens; PGR Grasshopper 3 camera**

*"The Sun is such a complex object – after centuries of study we still don't fully understand how it works. It's amazing to think that all stars would look as chaotic as this if we could see their surfaces close up."*
**MAREK KUKULA**

*"The detail captured in this image of the roiling solar chromosphere is superb. The intricate textures in the plasma are especially well defined. Even in the extreme, and often violent, environment of the Sun's atmosphere there is great beauty it seems."*
**WILL GATER**

*"The dynamic nature of our nearest star is really captured here with the incredible sense of movement that seems to spring from the snaking dark filaments on the background granulation of the Sun's visible surface."*
**CHRIS BRAMLEY**

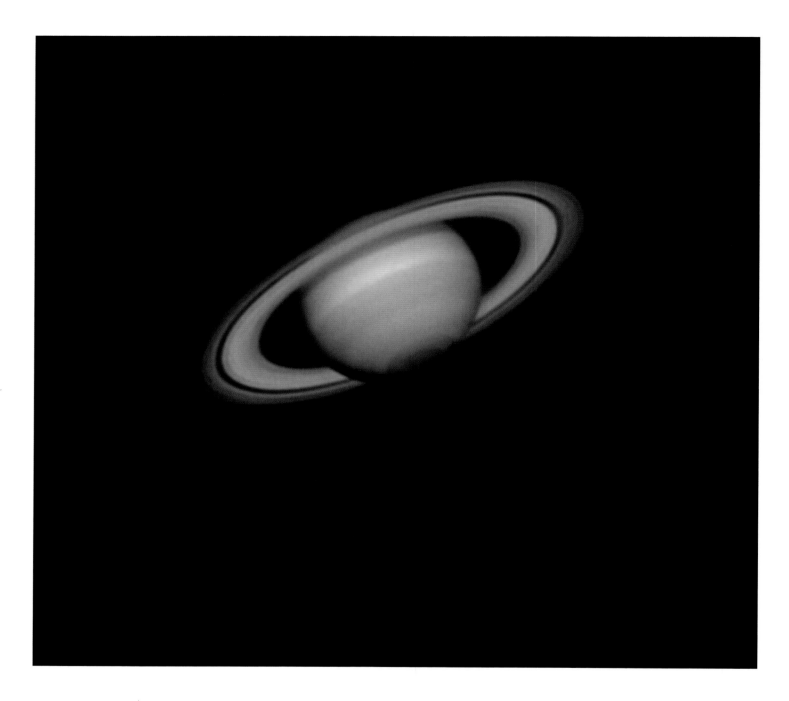

## Λ

### PETER RICHARDSON (UK)

#### Saturn from Somerset, April 2014
[10 April 2014]

**PETER RICHARDSON:** I love the planet Saturn. It was, like many others, my first view through a telescope and one of the main reasons I became hooked on imaging the heavens. This photo was especially pleasing to me due to the low altitude of 21° at time of capture.

*Bleadon, Somerset, UK*

**BACKGROUND:** This is a spectacular image of Saturn, particularly since it is incredibly challenging to photograph when it is so close to the horizon. The other gas giant planets in our solar system have rings similar to those of Saturn, made of ice and rock. However, as we can see from this beautiful image, there is definitely something extra-special about the complex rings of Saturn that make it an enchanting subject to photograph.

**LX200ACF 12-inch telescope; ASI120MM camera**

## Λ

**PHIL HART** (*Australia*)

### Close-up with Second Contact
[*14 November 2012*]

**PHIL HART:** A dramatic sequence of images at second contact in November 2012 during the Queensland total solar eclipse. Next time I wouldn't change the settings on the camera after a successful test run during the night, and three months of practising beforehand. I was still very lucky to get this shot!

*Mulligan Highway, Queensland, Australia*

**BACKGROUND:** A montage of images taken during a solar eclipse, in the final moments before 'totality', when the Moon completely covers the Sun. The dazzling white patch on the edge of the Moon is the famous 'diamond ring' effect – the last glimpse of the solar disc before it is entirely blocked from view. The red flame-like features are prominences – immense structures which tower above the Sun's surface – seen here in the red glow of hydrogen gas. The visibly uneven edge of the Moon's disc reveals its mountainous terrain.

**Takahashi FS-102 telescope; EQ6 Equatorial mount; Canon 5D Mk II camera; 1300mm f/13 lens; ISO 100; 1/1600-second exposure**

## CHAP HIM WONG *(Hong Kong)*

### Comet Panstarrs – Six Consecutive Days
*[6 April 2013]*

**CHAP HIM WONG:** Back in April 2013, Comet Panstarrs was visible in the Northern Hemisphere just after sunset. It was not an easy task to observe or capture it while the dusk sky was still bright. Surprisingly, Leicester had a week of good weather and I was very lucky to have six consecutive good days to capture the movement of this comet, alongside M31, the Andromeda Galaxy.

*Leicester, Leicestershire, UK*

**BACKGROUND:** Having passed within 50 million km of the Sun on 10 March 2013, Comet Panstarrs began a long journey back to the outer reaches of the Solar System. The comet's speed is vividly conveyed in this montage showing its changing position relative to the Andromeda Galaxy over six nights. As it moves further from the Sun's warming rays, the eruptions of gas and dust that form Panstarrs's tail will die away and the comet will return to a dormant state in which it will remain for thousands of years.

**Canon 500D camera; EF 200mm f/3.5 lens; HL-1 (DIY) mount; ISO 800; 60-second exposure**

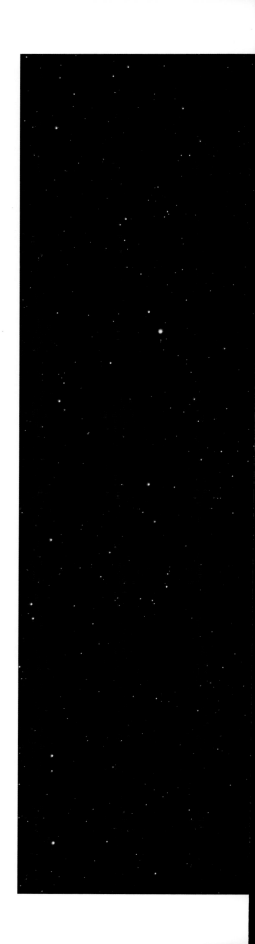

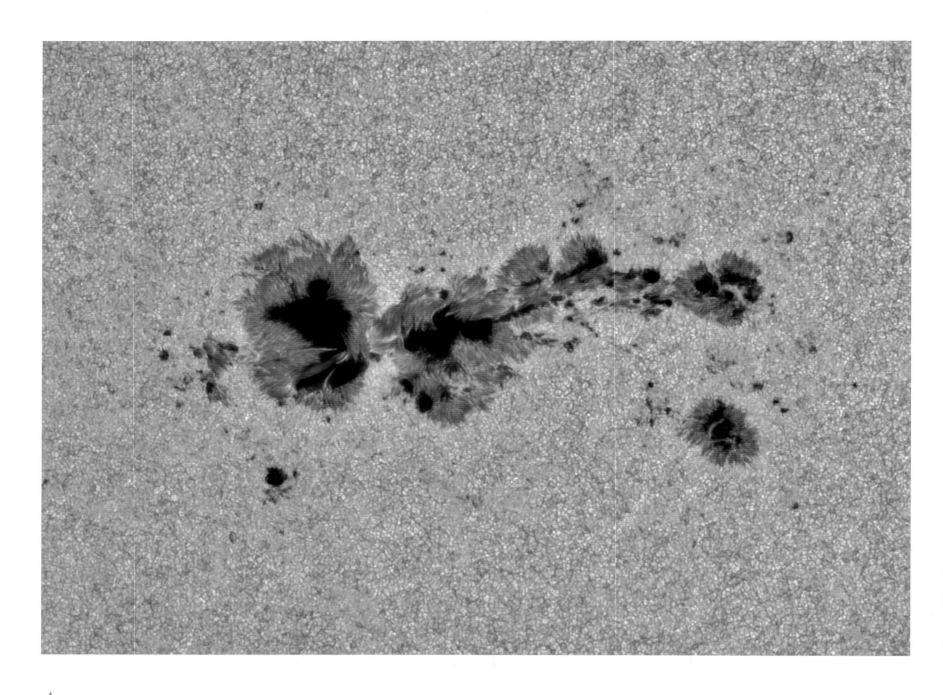

## ALEXANDRA HART (UK)

### Surfing the Sun
[2 February 2014]

**ALEXANDRA HART:** Not only is it exciting to watch and share the
Sun with others, it is also fun to use your imagination with a spot of
pareidolia ('the imagined perception of a pattern or meaning where it
does not actually exist'). Here I imagine the outline of a surfer riding the
waves of solar magnetism. For a hint, look at the main large spot group
on the left: what can you see?

*Holmes Chapel, Cheshire, UK*

**BACKGROUND:** This active region contains a grouping of sunspots.
These are areas of the Sun that are isolated from the main body by
magnetic fields so that they cool by a few thousand degrees and appear
dark. Studying the configuration of magnetic field patterns allows
solar physicists to predict the energy levels of potential flares and solar
storms. This 'space weather' forecasting can help safeguard the satellites
and power networks which we rely on back here on Earth.

**TEC140 refractor; EQ6 Pro mount; 140mm f/21 lens; PGR Grasshopper 3 camera**

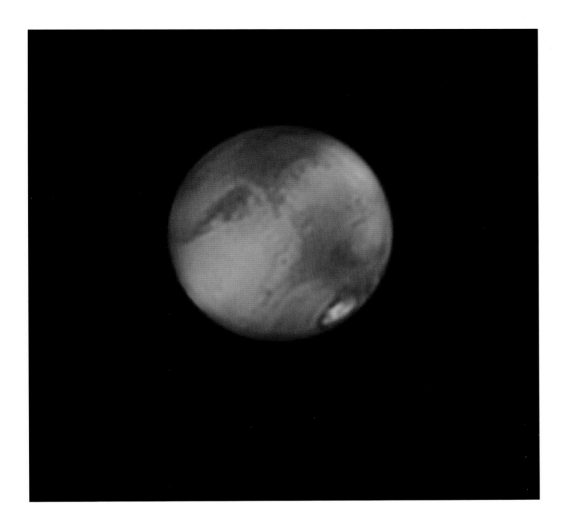

<

## PETER RICHARDSON (UK)

### Mars from Somerset, April 2014
[*15 April 2014*]

**PETER RICHARDSON:** Up to this point I hadn't had much luck with Mars due to the good old British weather! But then there was a period of a couple of weeks where conditions were good, enabling me to capture this image of the Red Planet.

*Bleadon, Somerset, UK*

**BACKGROUND:** To think of Mars as simply 'the Red Planet' belies the varied tones and shades of the planetary surface: from bright dust-covered regions, to areas where the dust has been swept away to reveal darker rocky material. The lower-right part of the image shows the white ice of the northern Martian polar cap, which mainly consists of water ice and a thin layer of frozen carbon dioxide.

**LX200ACF 12-inch telescope; ASI120MM camera**

## SEBASTIÁN GUILLERMAZ *(Argentina)*

### Occultation of Jupiter
*[25 December 2012]*

**SEBASTIÁN GUILLERMAZ:** From my backyard I saw the full Moon over the clouds. Immediately I remembered that the occultation of Jupiter was due to take place that day. I was surprised how visible Jupiter was despite the sunlight.

*Los Polvorines, Buenos Aires, Argentina*

**BACKGROUND:** An unusual daytime view of an astronomical alignment, taken just before the planet Jupiter is blocked from view by the Moon on Christmas Day 2012. Jupiter can be seen as a pale dot to the right of the Moon's disc. Such events are known as 'occultations', from the Latin word for 'hidden'.

**Canon 7D camera; 420mm f/8 lens; ISO 400; 1/1600-second exposure**

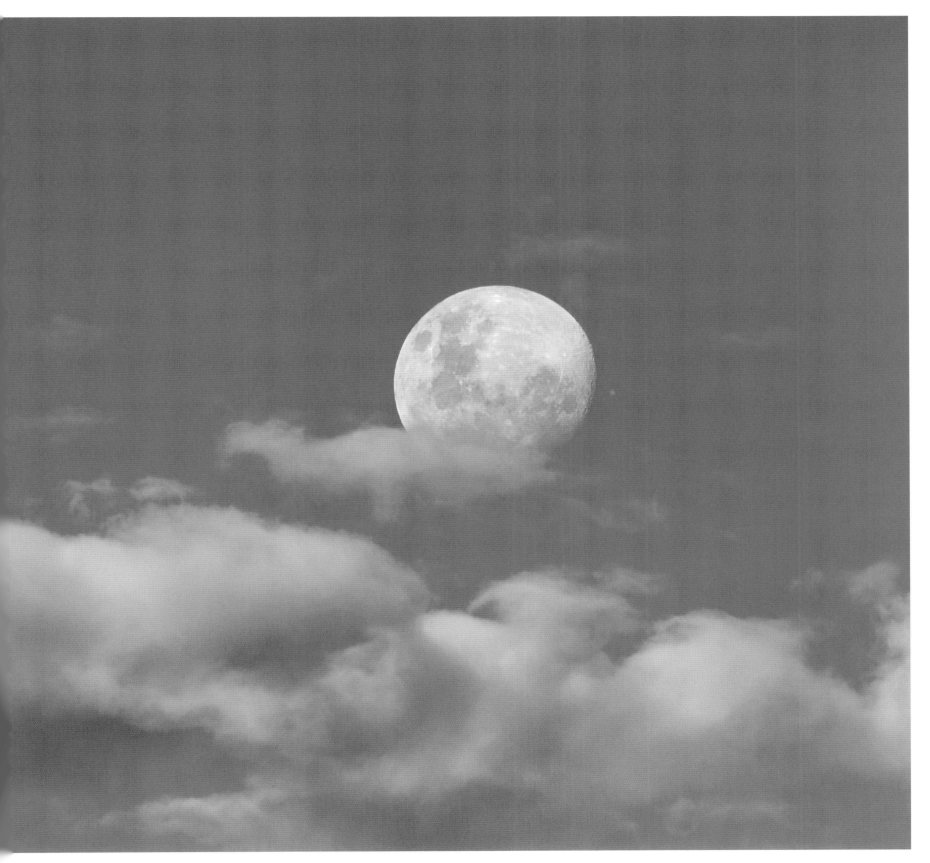

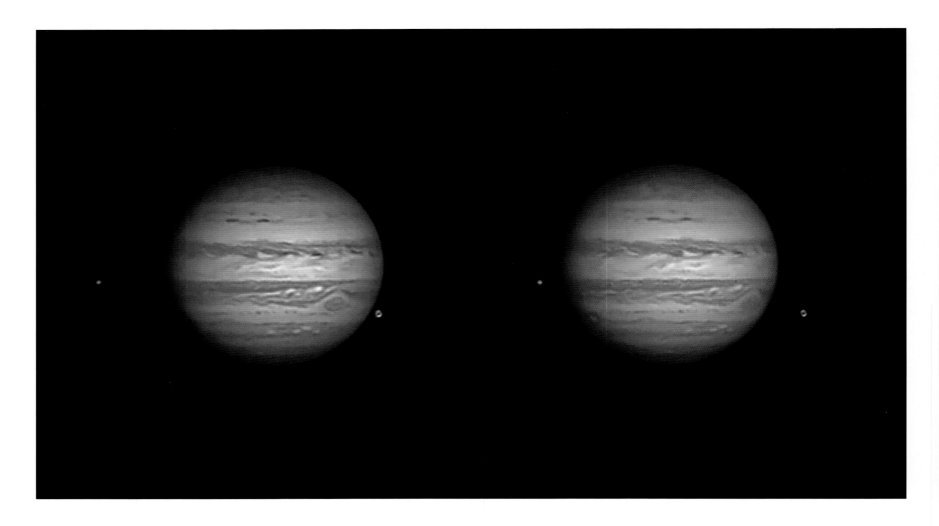

∧

## TOM HOWARD (UK)

### Thirty Minutes
[*16 March 2014*]

**TOM HOWARD:** I took the two images in this presentation exactly 30 minutes apart. In that time, Jupiter's Great Red Spot began to rotate out of view while Oval BA, its smaller cousin, made an appearance on the left side of the planet. The movements of the two moons, Io and Ganymede, also serve to demonstrate the dynamism of our largest neighbour and its system. It is this constant change – minute on minute, year on year – that makes Solar System imaging so rewarding for me.

*Crawley, Sussex, UK*

**BACKGROUND:** Despite having a diameter eleven times larger than the Earth, Jupiter spins on its axis every ten hours, more than twice as fast as our own world's daily revolution. Meanwhile, locked in the grip of the giant planet's gravity, Jupiter's moons hurtle around their parent at a dizzying rate. Placed side by side these two views of Jupiter, taken only 30 minutes apart, make this hectic motion apparent as cloud features slide around the planet and two of its moons visibly change their positions.

**Celestron Skyris 618C CCD camera**

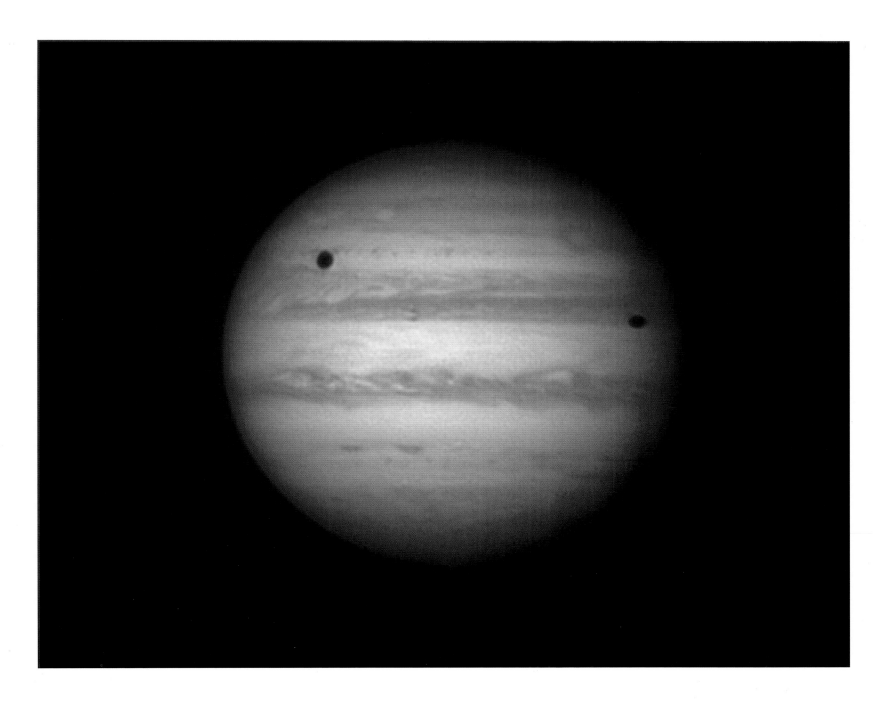

 **KEV WILDGOOSE** (*UK*)

### Jupiter and the Shadows of Io and Ganymede
[*9 March 2014*]

**KEV WILDGOOSE:** Jupiter with Io in transit, plus two shadows (from Io and Ganymede). I managed to time this just right to allow the Great Red Spot and Red Spot Junior to both be visible. An average of 9000 frames were stacked from the 14,000 captured for this image.

*Shropshire, UK*

**BACKGROUND:** With over 60 moons orbiting around it, it is perhaps not surprising that Jupiter experiences many more solar eclipses than the Earth. Here, the giant planet enjoys two eclipses at once, as the moons Io and Ganymede cast their shadows onto the cloud tops. The shadow on the right is striking the planet at an oblique angle, giving it an elongated shape, while the moon which is casting it, orange-brown Io, can just be seen near the centre of Jupiter's disc, camouflaged against a band of pastel-coloured cloud.

**Celestron C14 Edge HD telescope; CGE PRO mount;
Carl Zeiss 2.2x Barlow lens; ZWO ASI120MC camera**

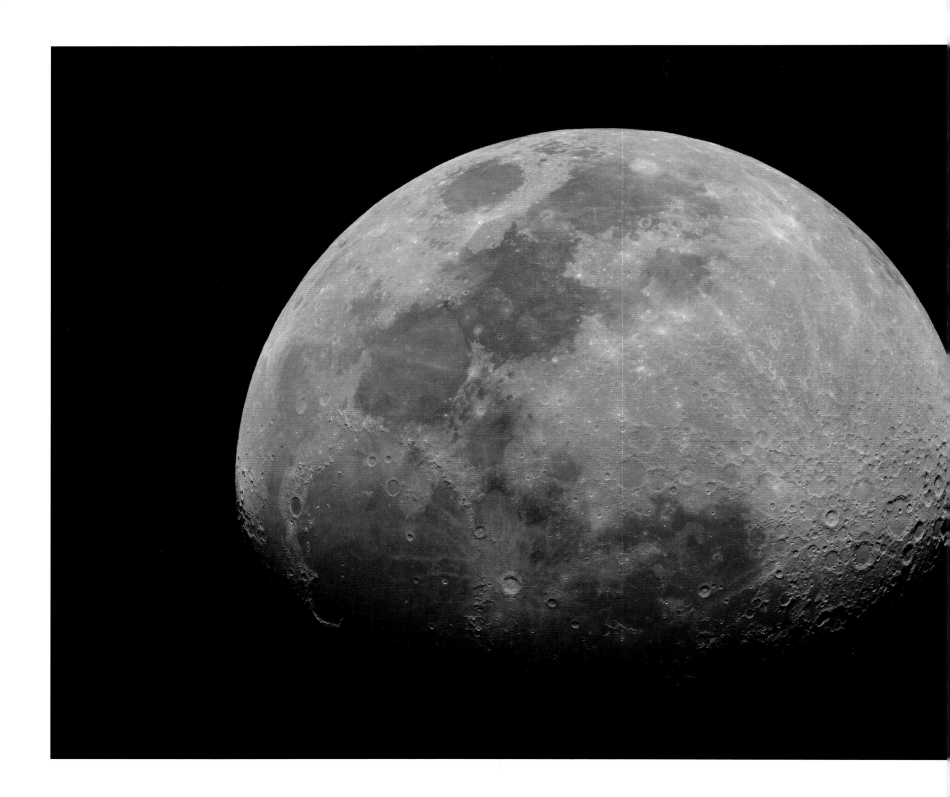

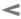

## IGNACIO DIAZ BOBILLO *(Argentina)*

### Zenithal Colour Moon
[*16 August 2013*]

**IGNACIO DIAZ BOBILLO:** This image of the Moon is unusual, not only because of its emphasized natural colours, but also by the way the acquired data was processed. Following the workflow of a typical deep space image, the 100 RAW snapshots were calibrated, registered, stacked, and post-processed, using powerful deep-space processing software. By exploiting the high contrast features of the lunar surface, the stack was precisely aligned from the 'skyline' of the limb, to the terminator.

*General Pacheco, Buenos Aires, Argentina*

**BACKGROUND:** Stacking multiple exposures allows a clear view of the Moon's surface, with highly defined craters. Our naked eye sees the Moon in shades of grey; the enhanced saturation (commonly used by astrophysicists) brings out vividly its muted natural colours to give clues about its geology. The light orange shows areas rich in iron, while the blue indicates the presence of titanium. Fresh impacts from meteors and asteroids are shining white. In this beautifully balanced picture, the crispness of the Moon's upper edge (or limb) is juxtaposed with the softly waning terminator, the boundary between day and night, where the Sun rises or sets.

**AP130GT with 1.8x Barlow telescope; Losmandy G11 mount; Canon 1000D camera; 1500 mm f/11.5 lens; ISO 400; 100 x 1/160-second exposures**

# ASTRONOMY
# PHOTOGRAPHER
## OF THE YEAR 2014

# DEEP SPACE

Photos of anything beyond the
Solar System, including stars,
nebulae and galaxies

## BILL SNYDER (USA) — *WINNER*

## Horsehead Nebula (IC 434)
[10 January 2014]

**BILL SNYDER:** This was captured with a Planewave 17-inch scope in the Sierra Nevada Mountains, California. The CCD camera used was an Apogee U16 with Astrodon filters. The exposure times were 1.5 hours each of red, green and blue, plus 8.3 hours of H-alpha, making the total amount of exposure time for this image nearly 13 hours.

*Heaven's Mirror Observatory, SRO, California, USA*

**BACKGROUND:** The Horsehead Nebula is one of the most photographed objects in the night sky, but this astonishing image succeeds in showing it in a brand new light. Rather than focussing solely on the black silhouette of the horsehead itself the photographer draws the eye down to the creased and folded landscape of gas and dust at its base, and across to the glowing cavity surrounding a bright star. By pushing the compositional boundaries of astrophotography this image expands our view and tells a new story about a familiar object.

**Planewave 17-inch telescope; Paramount mount; Apogee U16 camera; f/6.8 lens**

*"It's so unusual to see the complex structure below the 'neck' of the horsehead. You get a real sense of a wrinkled landscape of dust and gas and a hollow carved out by the bright blue star. A novel view of a familiar object. The photographer has really thought outside the astronomical box."*
MAREK KUKULA

*"The detail beneath the horse's head in this image is astounding. This region is often lost in darkness in most astrophotos, but Bill's image reveals the billowing, almost fluffy, texture of the gas and dust there superbly."*
WILL GATER

*"Wow, what a deep image of the Horsehead Nebula. It looks as if the horse is rising out of a pink, slim mist – very beautiful indeed. What's amazing in this image is the fact that there's no dark space visible, the whole frame being covered in glowing gas or dark dust."*
PETE LAWRENCE

*"The silky folds captured in the image gave us a real insight into the area."*
MAGGIE ADERIN-POCOCK

*"The velvety texture and detail of this Horsehead Nebula is stunning."*
MELANIE GRANT

*"A really unusual view of a famous object; the swirling structure at the base of the head is unusually well seen here."*
CHRIS LINTOTT

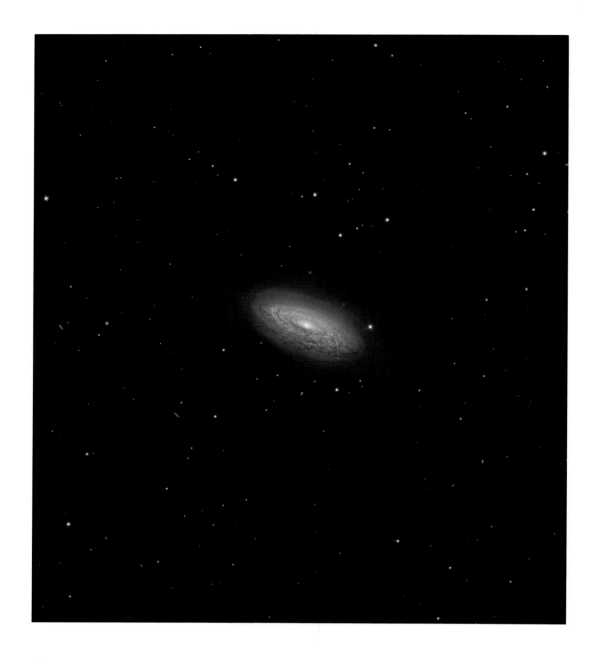

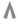

**ADAM BLOCK** *(USA)*

### Rapt with Spiral Arms
*[25 March 2014]*

**ADAM BLOCK:** I always enjoy highlighting objects that I feel do not receive enough attention. This is a spectacular galaxy which features a wealth of small details. I am especially fond of the dust lanes that circumscribe the galaxy within its extended halo. This data was collected on a few clear nights between winter storms. Since the time was limited, I carefully monitored the data acquisition so that each available second of time was used collecting light.

*Mount Lemmon SkyCenter, Tucson, Arizona, USA*

**BACKGROUND:** Despite the immense size of this galaxy, which is around 100,000 light years across and contains hundreds of billions of individual stars, the framing of the image emphasizes its isolation on the even vaster scales of intergalactic space. The typical distances between galaxies are so large that in the early twentieth century they were sometimes referred to as 'island universes'.

**0.8m reflector; equatorial mount; SBIG STX-16803 camera; f/7 lens; 9-hour exposure (L), 4-hour exposures (RGB)**

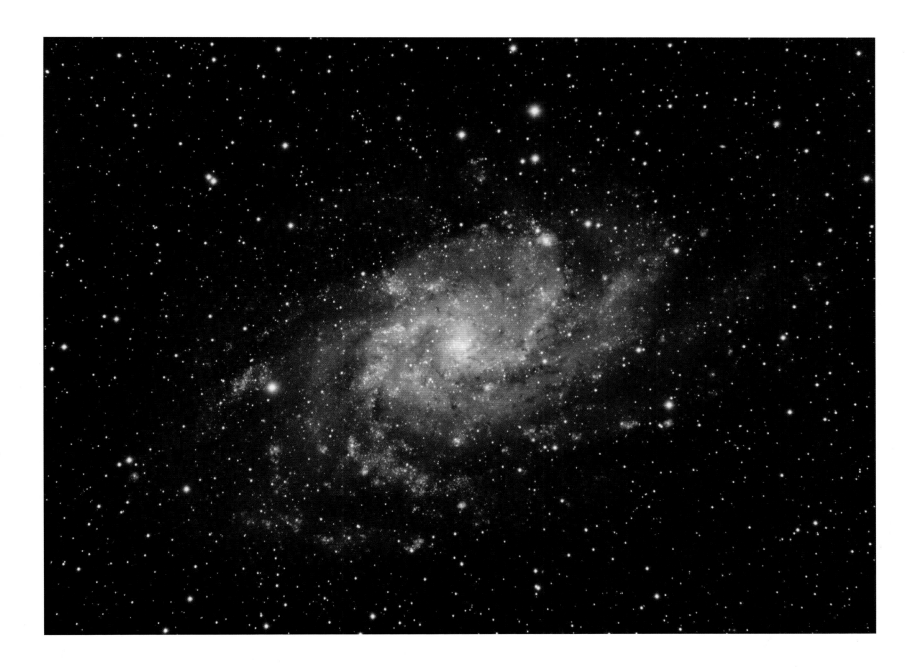

Λ

**MATTHEW FOYLE** (*UK*)

## The Triangulum Galaxy (M33)
[*7 September 2013*]

**MATTHEW FOYLE:** I could get no more than 13 hours of data for this image due to the bad UK winter weather. I have become fond of M33 in the short time I have been imaging because of its large hydrogen alpha regions and the size and scale of some of them. It also has some nice background galaxies. I feel it is often overlooked for the more famous Andromeda Galaxy. I have spent many hours trying to get some good data under reasonable skies.

*Bakewell, Derbyshire, England*

**BACKGROUND:** At a distance of just three million light years Messier 33, in the constellation of Triangulum, is one of our nearest and most photographed galactic neighbours. Along with the Andromeda Galaxy and our own Milky Way it is a member of the Local Group of galaxies and is one of the few galaxies that can be seen with the naked eye, although this requires excellent eyesight and extremely dark viewing conditions. Photography is able to reveal the full splendour of the galaxy's spiral structure, along with its prominent hydrogen alpha regions – clouds of hydrogen gas which glow with a characteristic red/pink light.

**Takahashi FSQ-106ED telescope; NEQ6 Pro mount; QHY9M camera; 848mm f/8 lens; 10- and 20-minute exposures**

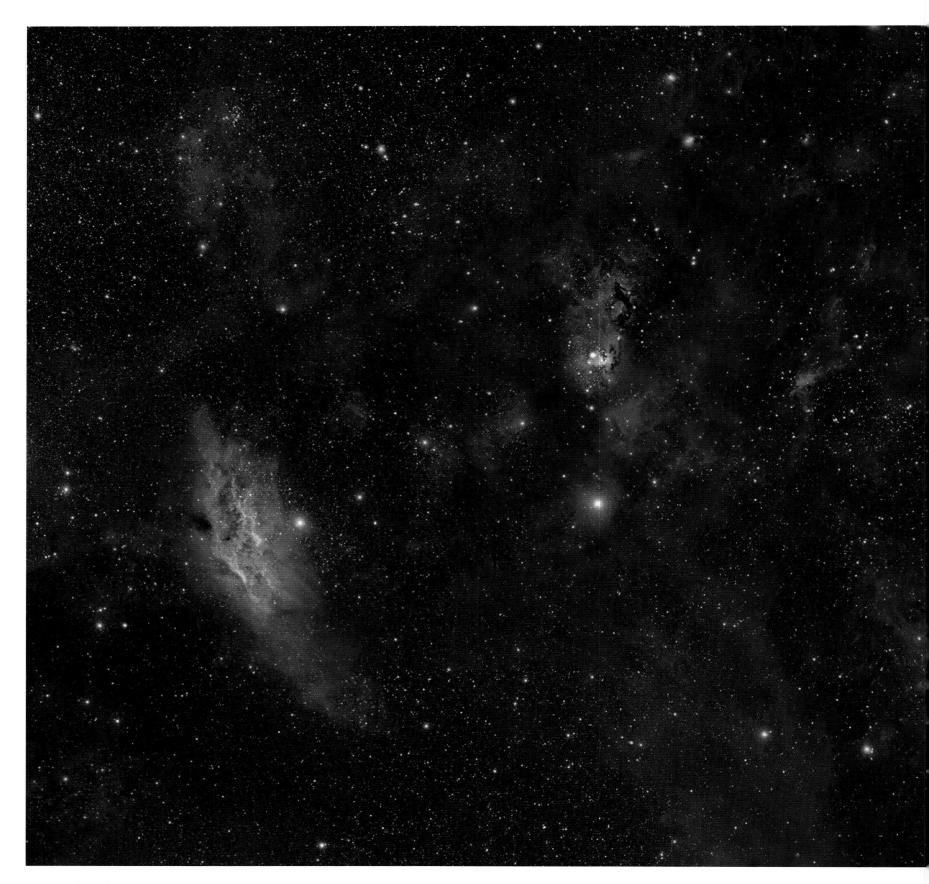

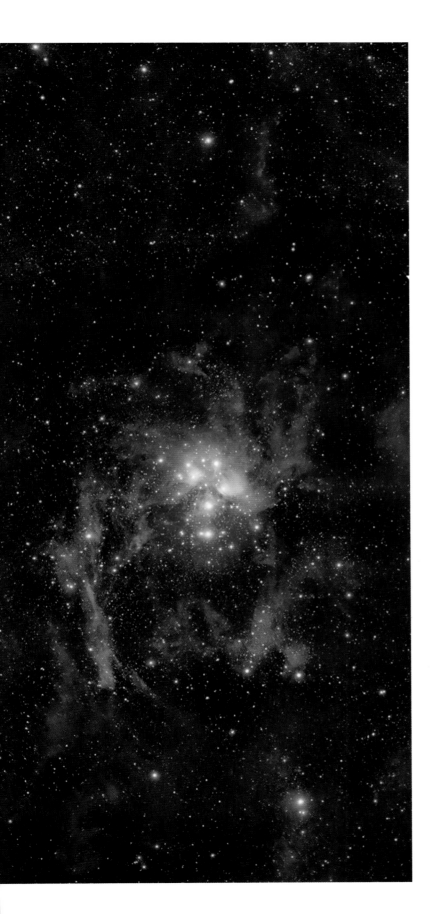

<

## ROGELIO BERNAL ANDREO *(USA)*     *HIGHLY COMMENDED*

### California vs Pleiades
[*20 November 2013*]

**ROGELIO BERNAL ANDREO:** A vast field featuring the California Nebula, the famous Pleiades and other lesser-known objects. My interest was not only the main characters but also anything else that might be there. In this case, numerous molecular clouds of dust remind us that the night sky is often filled with structures that escape the eye, and even the camera.

*DARC Observatory, Los Baños, California, USA*

**BACKGROUND:** Known since ancient times as the Seven Sisters, the Pleiades Cluster, to the right of this image, actually consists of around a thousand stars which formed together about 100 million years ago. The Pleiades are a perennial favourite of amateur astronomers and astrophotographers, but this unusual view shows the cluster in the broader context of its local environment, drifting through a chaotic region of dark dust. The California Nebula, named for its resemblance to the US state, is the cloud of glowing hydrogen gas to the left of the image.

**Takahashi FSQ-106 telescope; Takahashi EM-400 mount; SBIG STL-11000 camera; 385mm f/3.7 lens; 57-hour exposure**

*"It's great to see the Pleiades set in the wider context of dust clouds and glowing emission nebulae. I love how chaotic this familiar corner of the sky appears in this shot."*
MAREK KUKULA

*"Beautiful, complex; enigmatic too. The bright clusters draw your eye in."*
MELANIE VANDENBROUCK

*"This sort of extreme wide-field photography needs skill and patience to work – and here both have paid off wonderfully."*
CHRIS LINTOTT

*"Gazing up at the Pleiades on a clear night, you'd have no idea that this part of space is so full of delicate veils of dust."*
CHRIS BRAMLEY

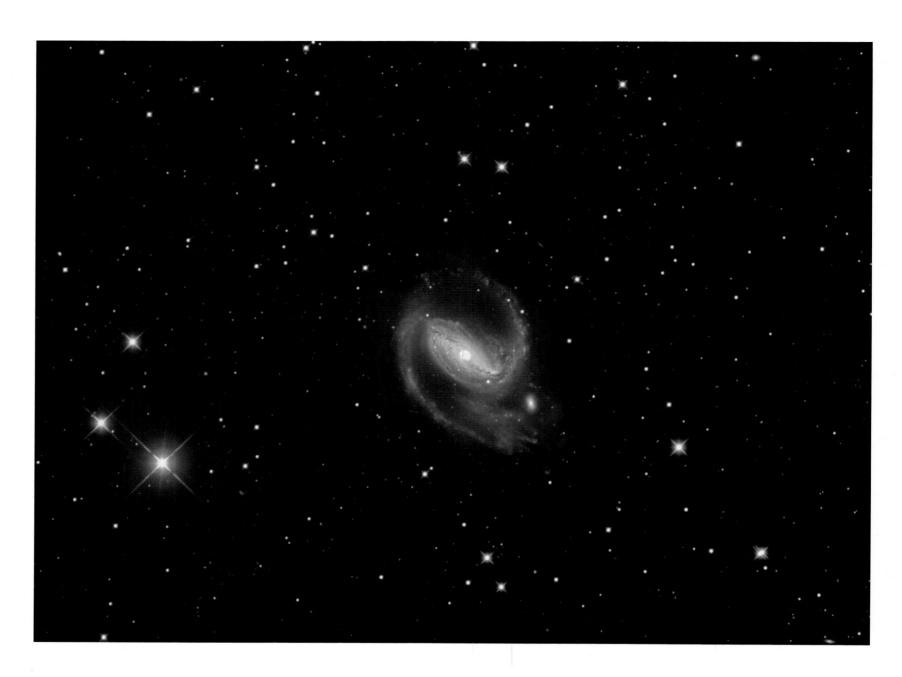

**MICHAEL SIDONIO** (*Australia*)

### The Jets of NGC 1097
[*5 October 2013*]

**MICHAEL SIDONIO:** Looking like antennae, very faint structures or jets associated with NGC 1097 in Fornax can be seen emanating above right and to the left of the galaxy in this image. These structures are thought to be streams of stars left after a smaller galaxy passed through the larger galaxy billions of years ago. The surface brightness of these jets is as faint as 27 magnitudes per square arcsecond.

*Wallaroo, Yorke Peninsula, South Australia*

**BACKGROUND:** To understand the Universe astronomers often have to take on the role of detectives, piecing together the history of an object from subtle clues. NGC 1097 is a good example of this. At first glance it looks like just an ordinary spiral galaxy drifting serenely through space, but a closer inspection reveals hints of a more turbulent past. Faint trails of stars may be the debris of a smaller galaxy, cannibalized by NGC 1097 long ago, while the galaxy's brilliant core contains a region of violent star-formation surrounding a supermassive black hole.

**Orion Optics AG12 f/3.8 Astrograph telescope; Astronomik filters; Starlight Xpress SXVR-H694 camera**

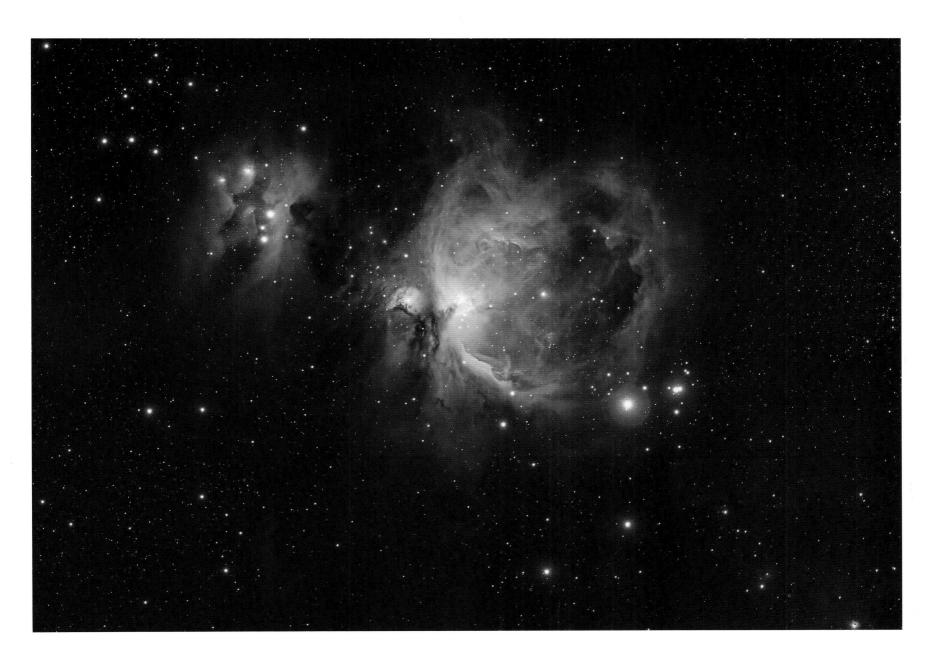

## TANJA SUND *(South Africa)*

### Star Factory, the Orion Nebula
[*13 February 2014*]

**TANJA SUND:** M42 is a gloriously diffuse but bright nebula. It's a wonderful target for novices to experience as there's always more data and detail to find. It's easy to capture, but difficult to master.

*Johannesburg, Gauteng, South Africa*

**BACKGROUND:** A vast region of gas and dust in which new stars are constantly forming, the Orion Nebula is easily visible to the naked eye, appearing as a small, fuzzy patch of light in the middle of the Sword of Orion. Its proximity and brightness make it an extremely popular target for astrophotography but in choosing exposure times, colour filters, framing and image processing each photographer brings his or her own vision to the subject. Here, the nebula is shown floating peacefully among the surrounding stars.

**Officina Stellare telescope; Celestron Advance VX mount; OS Hiper APO 105mm lens; Canon 60Da camera; 650mm f/6.2 lens; ISO 400; 196-minute total exposure**

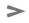

## MARCO LORENZI *(Italy)*          *HIGHLY COMMENDED*

### At the Feet of Orion (NGC 1999) – Full Field
*[16 December 2013]*

**MARCO LORENZI:** This shot is centred on NGC 1999, a fantastic area situated below Orion's Belt. The proximity of several popular targets in one of the richest constellations of the sky often means this tiny nebula and its surroundings are overlooked, and this is a real pity. In this 18-hour exposure, I particularly like the contrast between the yellow/brown dusts and red and blue gases – an explosion of colours in a rather small area. At the centre of the image, the small NGC 1999 looks like a tiny keyhole.

*Warrumbungle Observatory, Coonabarabran,*
*New South Wales, Australia*

**BACKGROUND:** Images like this one remind us that there is often more going on in our galaxy than meets the eye and that the space between the stars is rarely completely empty. An extremely long exposure brings out billowing dust and gas clouds that are normally overshadowed by their more glamorous neighbour at the top of the image, the dazzling heart of the Orion Nebula. The scatter of bright blue stars illuminates the dust, enabling us to see it.

**TEC140 refractor; Paramount ME mount; FLI Proline 16803 camera; f/7.2 lens; 12–360-minute exposures**

*"I'm impressed by the way the photographer has managed to convey the 3D texture of this nebula. The central regions almost pop out of the frame."*
MAREK KUKULA

*"What a lovely composition this is. Deep reds of swirling gas fill much of the frame, with the pink mist of the outer Orion Nebula visible in the upper right."*
PETE LAWRENCE

*"The level of detail here is incredible; there's a real sculptural quality stretching across the many light years of space captured in the image."*
CHRIS BRAMLEY

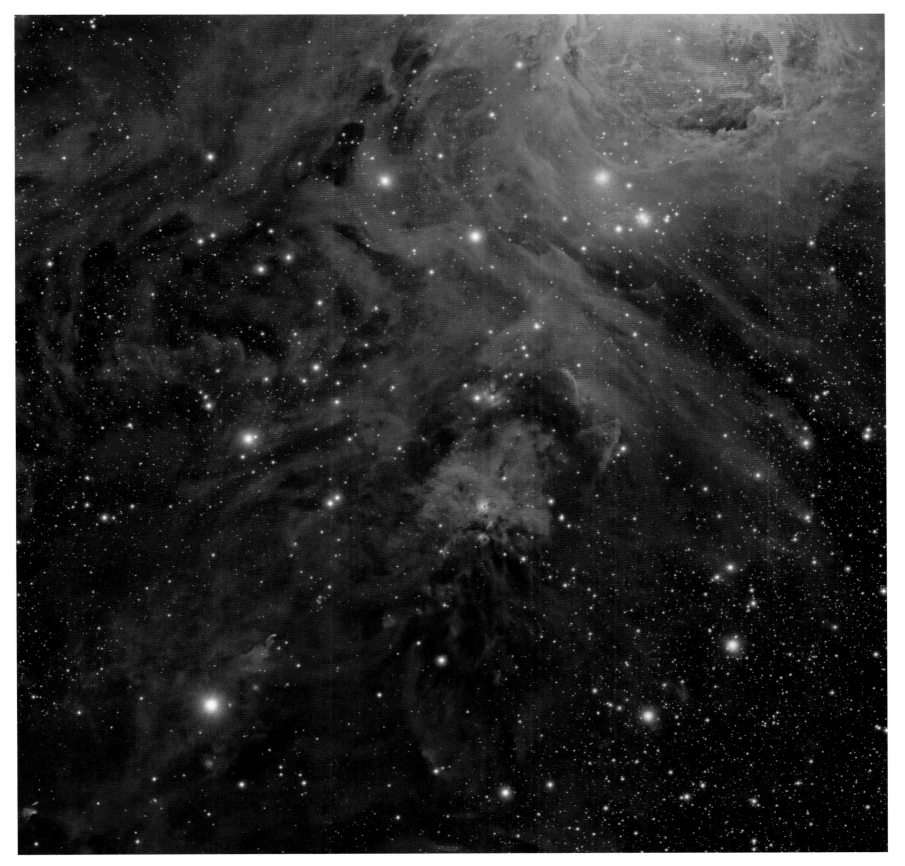

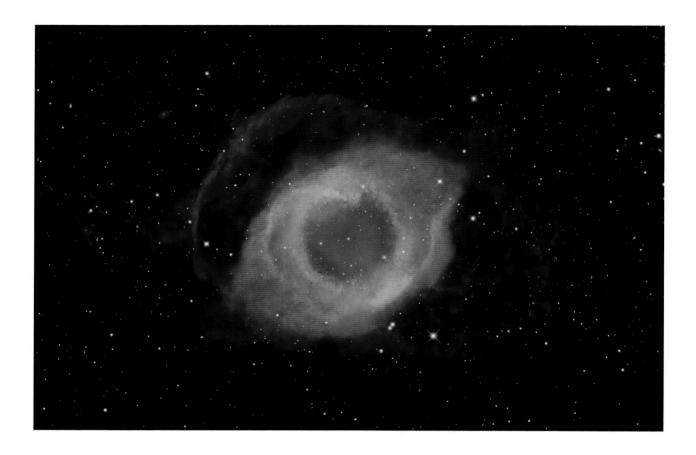

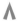

**DAVID FITZ-HENRY** (*Australia*)  RUNNER-UP

## The Helix Nebula (NGC 7293)
[*29 September 2013*]

**DAVID FITZ-HENRY:** The Helix Nebula is an example of a planetary nebula formed at the end of a star's evolution. Gases from the star in the surrounding space appear, from our vantage point, as if we are looking down a helix structure. The remnant central stellar core, known as a planetary nebula nucleus, is destined to become a white dwarf star. The observed glow of the central star is so energetic that it causes the previously expelled gases to brightly fluoresce.

*Bowen Mountain, New South Wales, Australia*

**BACKGROUND:** Looking like a giant eye peering across 700 light years of space, the Helix Nebula is one of the closest planetary nebulae to the Earth – and one of the best studied. This highly-accomplished image reveals delicate detail in the glowing gas that makes up the nebula, including the tadpole-like 'cometary knots' which seem to trail from the inner edge of the gaseous ring. These are actually nothing to do with comets but are clumps of gas being bombarded by fierce radiation from the dying star at the centre of the nebula. The 'head' of each knot is around the size of our solar system.

**Home-built Newtonian telescope; Paramount ME mount; 317.5mm mirror lens; STL-11000M camera; 1525mm f/4.8 lens**

*"The Helix Nebula always reminds me of the Lord of the Rings movies, for obvious reasons. The photographer has really brought out its resemblance to a staring eye."*
MAREK KUKULA

*"The level of detail in the inner part of the Helix is superb. It looks like a giant eye looking back at you!"*
PETE LAWRENCE

*"To me, the greatest example of the sublime aesthetic in this year's competition. The nebula is like an ominous eye looking over us; beauty can also be terrifying."*
MELANIE VANDENBROUCK

*"I gasped the first time I saw this picture. What an explosion of colour, almost like the eye of the Universe is staring right at you."*
MELANIE GRANT

*"Planetary nebulae like this one last for only a few tens of thousands of years; the beautiful rings of the Helix are the outer layers of the dying star visible right at the centre of the image."*
CHRIS LINTOTT

*"You get a real sense of peering into a 3D structure, looking at this image of this planetary nebula."*
CHRIS BRAMLEY

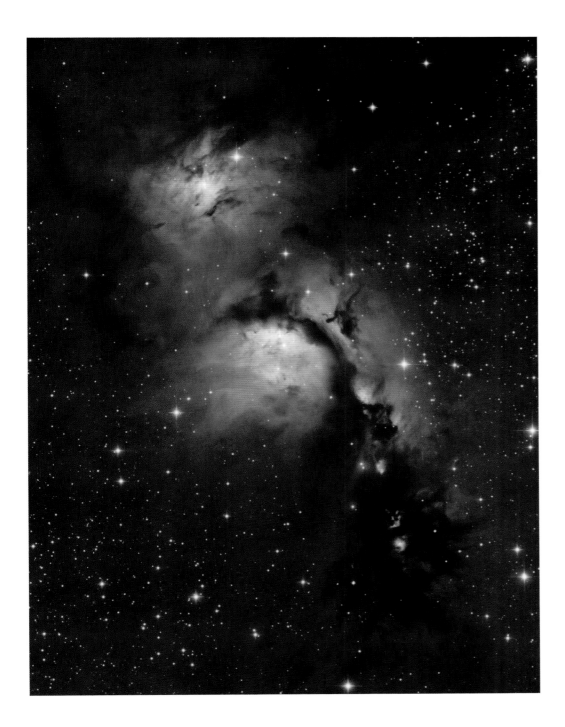

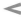

**OLEG BRYZGALOV** (*Ukraine*)

## M78: Stardust and Starlight
[*6 November 2013*]

**OLEG BRYZGALOV:** Interstellar dust clouds and bright nebulae abound in Orion. Its blue tint is due to dust preferentially reflecting the blue light of hot, young stars in the region. Dark dust lanes and other nebulae can easily be traced through this skyscape. The scene also includes the remarkable McNeil's Nebula – a newly recognized nebula associated with the formation of a sun-like star – and the tell-tale reddish glow of many Herbig-Haro objects, energetic jets from stars in the process of formation.

*Crimea, Ukraine*

**BACKGROUND:** This complex of dust, gas and newborn stars allows us a glimpse of how our own solar system must have formed 4.5 billion years ago. Deep inside the densest parts of the dust cloud, gravity is pulling together the material to create new stars and their attendant planets. As the stars' nuclear fires ignite and they begin to shine, their radiation will carve out huge cavities in the surrounding cloud, as can be seen in the blue areas of this image.

**Home-made reflector telescope; White Swan 180-GT equatorial mount; 246mm main mirror lens; QSI 583 WSG camera; 1100 mm f/4.4 lens; 600-second exposure**

## OLEG BRYZGALOV *(Ukraine)*

### Dwarf Elliptical Galaxy NGC 205 (M110) in the Local Group
*[5 November 2013]*

**OLEG BRYZGALOV:** Our Milky Way Galaxy is not alone. It is part of a gathering of about 25 galaxies known as the Local Group. Pictured on the lower left is one of the many dwarf ellipticals, NGC 205. Like M32, NGC 205 is a companion to the large M31, and can sometimes be seen to the south of M31's centre in photographs. This image shows NGC 205 to be unusual for an elliptical galaxy in that it contains at least two dust clouds and signs of recent star formation.

*Crimea, Ukraine*

**BACKGROUND:** Satellite galaxies, thoroughly overshadowed by their much larger host galaxies, are seldom the focus for astrophotographers, and this refreshingly unusual image puts the Andromeda Galaxy's largest satellite in the spotlight. Discovered in 1773 by Charles Messier, who would eventually make it the final object in his eponymous catalogue, M110 received little attention until it was independently discovered a decade later by Caroline Herschel. The photographer has brought out extremely subtle details in the structure of this dwarf galaxy, while carefully framing the image to include part of its host, emphasizing the incredible difference in scale between the two.

**Home-made reflector; White Swan 180-GT equatorial mount; 246mm main mirror lens; QSI 583WSG camera; 1100 mm f/4.4 lens; 600-second exposure**

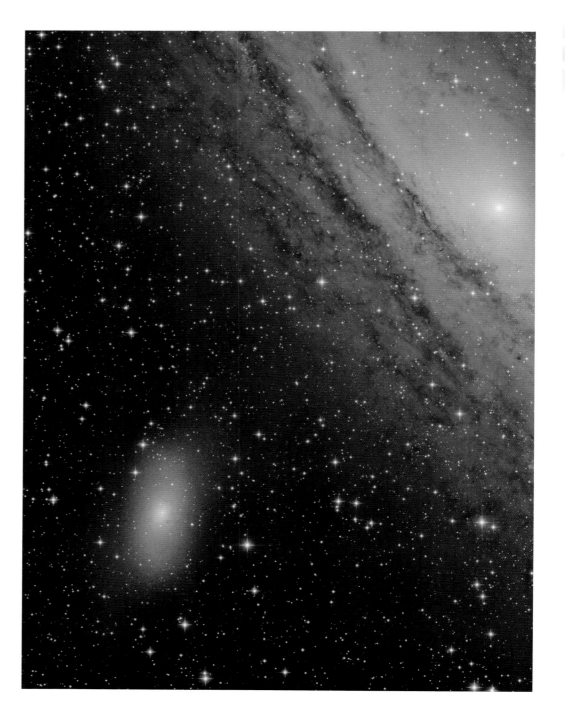

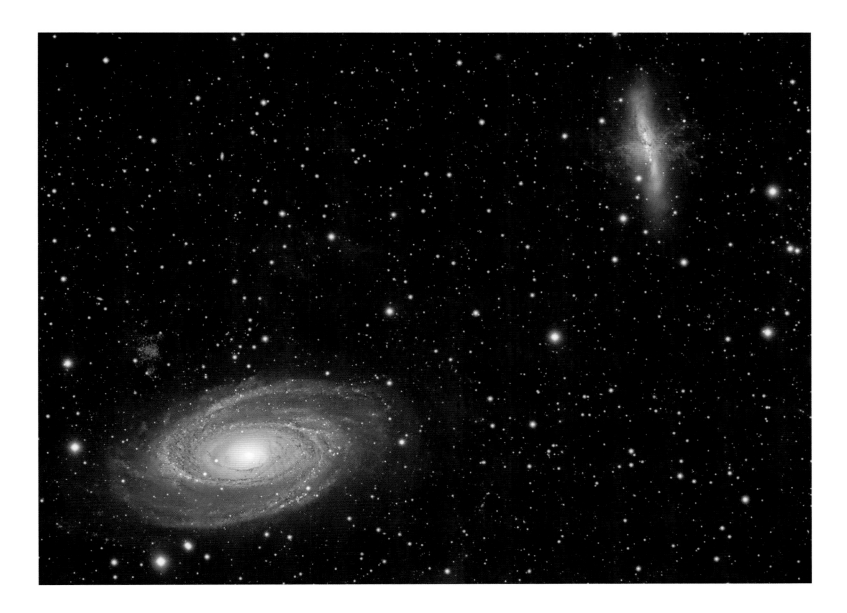

## ANDRÉ VAN DER HOEVEN, MICHAEL VAN DOORN, NEIL FLEMING *(Netherlands)*

### M81/M82 with SN2014J – Extreme Deep Field
[*25 January 2014*]

**ANDRÉ VAN DER HOEVEN, MICHAEL VAN DOORN, NEIL FLEMING:**
This image shows the galaxy pair M81 and M82. This is a familiar object for many astronomers worldwide. In January 2014 a supernova was discovered in M82 and therefore the decision was made by André van der Hoeven to image this beautiful galaxy pair. The result was later combined with data from Neil Fleming and Michael van Doorn to bring out details in the much fainter Integrated Flux Nebula, showing dust reflecting light from our own galaxy, which is highly present in this region. For this image data from four different set-ups was combined with a total exposure time of 34.5 hours.

*Hendrik-Ido-Ambacht, Netherlands*

**BACKGROUND:** Found in the constellation Ursa Major, two distinctly different objects stand out: the larger, face-on spiral galaxy M81, and the smaller, edge-on starburst galaxy M82. The pair tidally interact, triggering the ferocious star formation in the smaller of the two by channelling gas into its core. Both are part of the M81 group, and are approximately twelve million light years from our solar system.

**TEC140 telescope; NEQ6 mount; QSI 583 WSG camera**
**Celestron C11 (Hyperstar) telescope; SXVR-H16 camera**
**TMB203 telescope; SBIG STL-6303E camera**

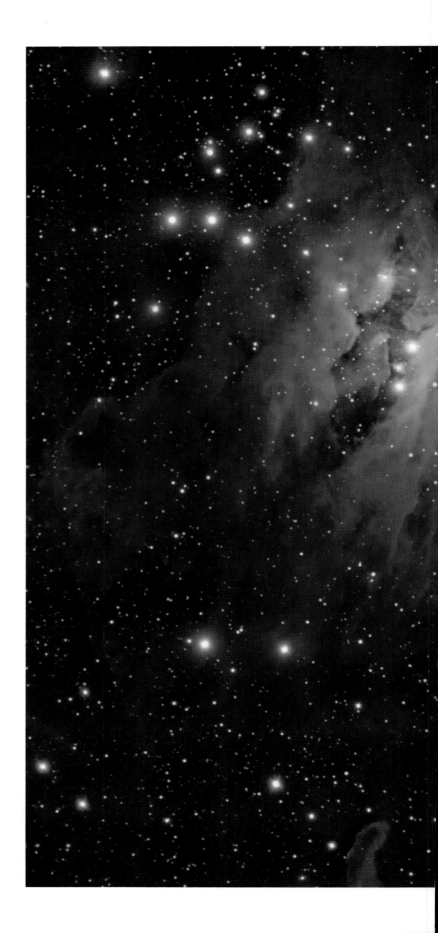

## ANNA MORRIS *(USA)*

### Orion Nebula
[*10 December 2013*]

**ANNA MORRIS:** I imaged Messier 42, the Orion Nebula, from my garden in Suffolk, England, before we moved back to the United States. It is a little bit more than eight hours of data, which was acquired over a few nights worth of imaging. Each night of imaging includes re-setting up my kit as I do not have a permanent observatory. The actual imaging was done with a stock Nikon D7000 and an Orion EON80ED scope. The processing to bring out the fainter dust lines from the data provided by my stock DSLR was a process that involved removing the stars for some super stretches and layering them back in with the original stack.

*Norton, Suffolk, UK*

**BACKGROUND:** In this view of M42 the photographer has chosen to emphasize the faint and delicate veils of dust that surround the more familiar glowing heart of the nebula. Her approach highlights the three-dimensional structure of the object, giving a sense of vast cavities filled with glowing pink hydrogen gas and the blue haze of reflected starlight.

**Orion EON80ED telescope; Celestron CPC800XLT (on a wedge),
EON is piggybacked mount; Nikon D7000 camera; 500mm f/6.25 lens;
ISO 200; 8-hours total exposure**

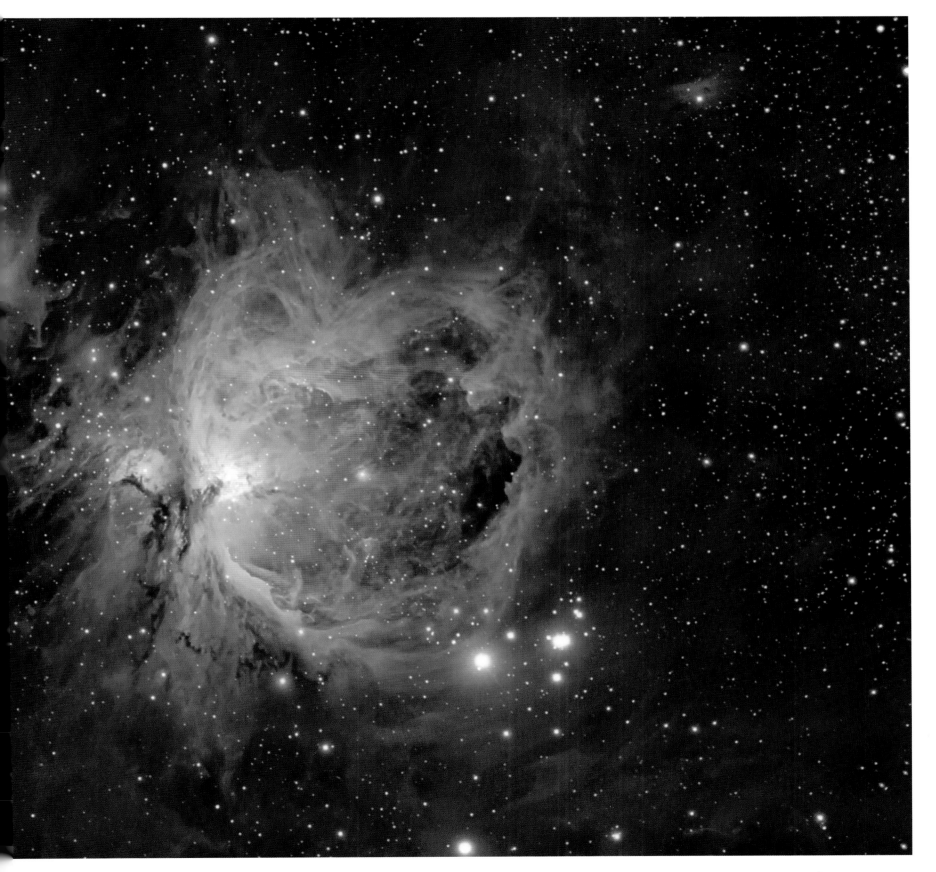

## OLEG BRYZGALOV (*Ukraine*)

### NGC 1333 Stardust
[*11 October 2013*]

**OLEG BRYZGALOV:** NGC 1333 is seen in visible light as a reflection nebula, dominated by bluish hues characteristic of starlight reflected by dust. It shows details of the dusty region along with hints of contrasting emissions in red jets, and glowing gas from recently formed stars. In fact, NGC 1333 contains hundreds of stars less than a million years old, most still hidden from optical telescopes by the pervasive stardust.

*Crimea, Ukraine*

**BACKGROUND:** This cloud of interstellar dust seems to twist and coil like a plume of smoke – an apt comparison since the grains of dust are roughly the same size as smoke particles here on Earth. The photographer has captured the different ways in which light interacts with space dust. The bright blue region indicates reflected light from a nearby star, while other stars, embedded within the cloud itself, have their light dimmed to smoky yellows and oranges. Meanwhile the thickest parts of the dust cloud completely block the light from the stars behind.

Home-made reflector; White Swan 180-GT equatorial mount; 246mm main mirror lens; QSI 583 WSG camera; 1100mm f/4.4 lens; 600-second exposure

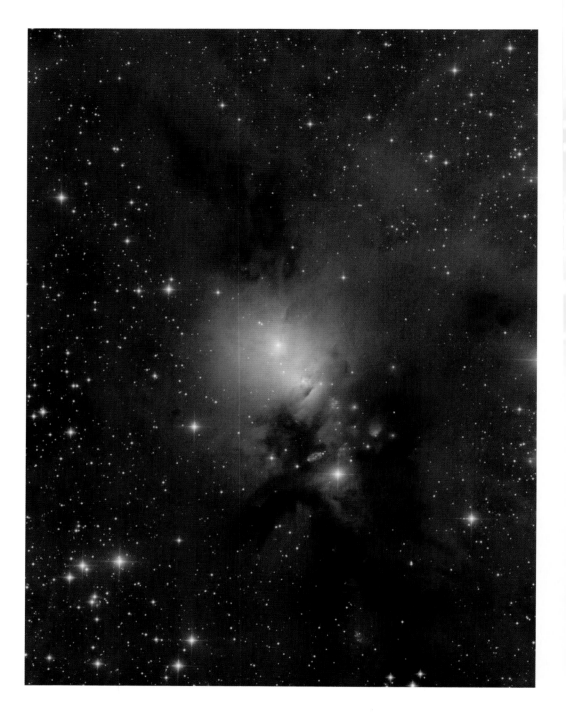

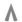

## ADAM BLOCK (USA)

### The Red Rectangle
[17 January 2014]

**ADAM BLOCK:** Is the Red Rectangle really red? Perhaps you have seen the Hubble pictures of it, but none of those are full colour images. Astrophotographers need a great deal of patience to spend hours on something that is only a few paltry pixels in extent, but I wanted to know what a full colour image of this nebula looked like. Conclusion: it is red, beautiful, and unique in all the sky!

*Mount Lemmon SkyCenter, Tucson, Arizona, USA*

**BACKGROUND:** The image is dominated by a binary star system approaching the penultimate high-luminosity period of its evolution: the creation of a protoplanetary nebula. Towards the end of its life cycle a star may expel its outer layers, increasing in temperature and ionizing the envelope of material that now surrounds it. In the core of the nebula, a disc of gas and dust channels the material into two almost-symmetrical outflows. From our point of view, fainter structures within each outflow give the appearance of ladder rungs within the more obvious x-shape.

**0.8m reflector; equatorial mount; SBIG STX-16803 camera; f/7 lens; 3 x 45-minute exposures**

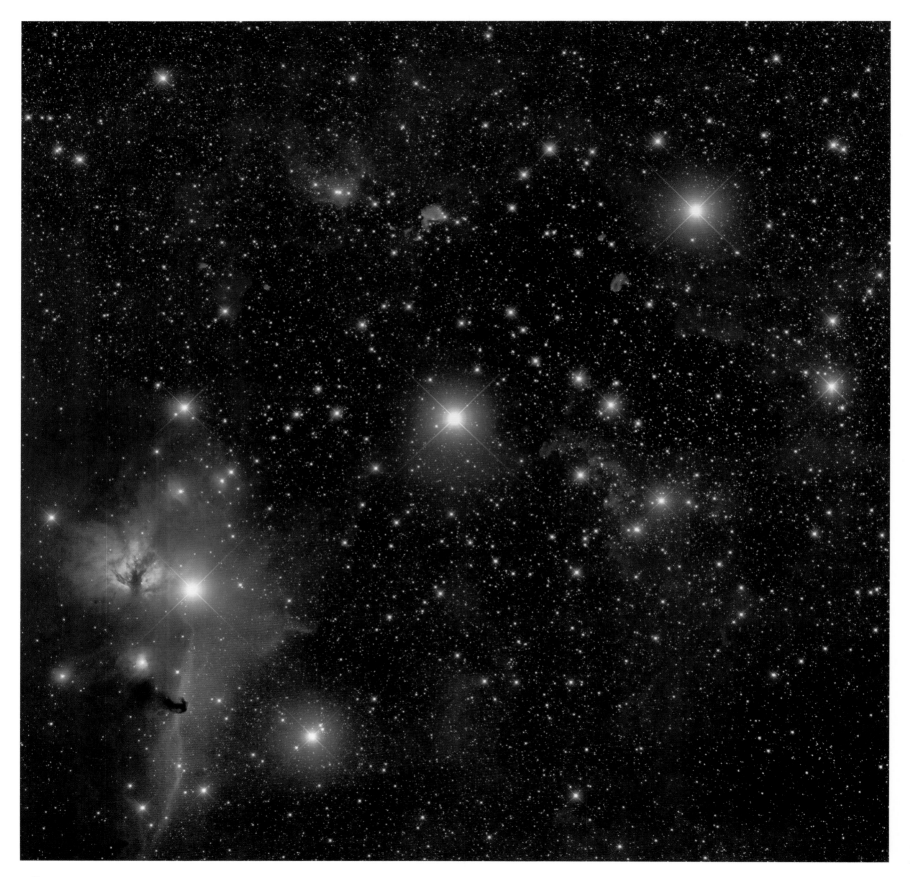

## MAURICE TOET *(Netherlands)*

### Orion's Belt
*[25 March 2014]*

**MAURICE TOET:** The three brightest stars seen from the lower left to the upper right in this mosaic image are named Alnitak, Alnilam and Mintaka. They form one of the most distinguishable asterisms of the night sky, known as Orion's Belt. The constellation of Orion holds many marvellous nebulae, hence it is one my favourite areas in the sky to point my camera at. Seen below Alnitak is the famous dark Horsehead Nebula (B33) silhouetted against a bright red emission nebula catalogued IC 434. The yellowish structure that emerges left of Alnitak is known as the Flame Nebula (NGC 2024) and is also quite familiar. Lesser known nebulae can also be seen in this image, such as the brownish blue structures and isolated 'blobs' (IC 423 and IC 426) between Alnilam and Mintaka. To acquire this square mosaic image, two sets of photographs or 'sub-images' have been calibrated, stacked and stitched together using dedicated astrophoto processing software. Each sub-image has been exposed for five minutes under a pristine dark sky in Southern France. As the total integration time of 95 minutes is relatively short by today's astrophotography standards, I was rather surprised by the depth of the final image. I intended to capture more sub-images, but ran out of time due to bad weather conditions and a late start in the year (end of March) for imaging Orion's Belt.

*Étoile-Saint-Cyrice, France*

**BACKGROUND:** These three stars are seldom known by their individual names, but taken together form one of the most famous stellar trios in the sky. The numerous nebulae captured in this image appear as separate structures, and have been catalogued as such, but are all in fact part of a single gargantuan star factory known as the Orion Molecular Cloud Complex. The stars of the belt are apparently close to the centre of the cloud, which is hundreds of light years wide. The extremely faint details visible in this image illustrate the benefits of using a modified camera with improved infrared sensitivity and fast, sharp telescope optics.

**Takahashi Epsilon-180ED telescope; Astro-Physics Mach1 GTO mount; Canon 5D Mk II camera; 500mm f/2.8 lens; ISO 1600; 95-minute exposure**

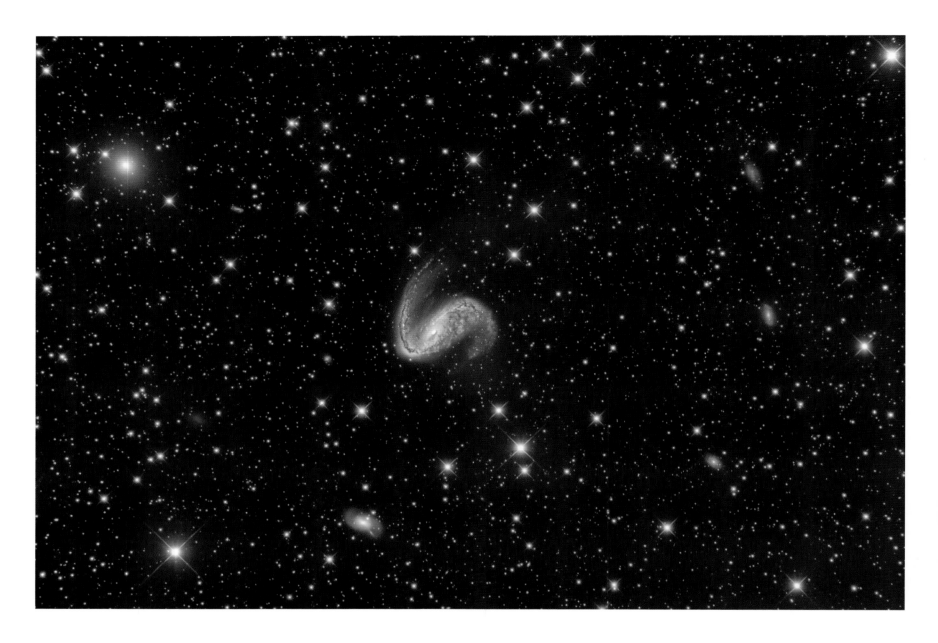

Λ

**PAUL HAESE** *(Australia)*

### The Meat Hook (NGC 2442)
[*4 March 2014*]

**PAUL HAESE:** The shape of this galaxy is what attracted me the most. It is hard to make out which arm is closest to us in space, so it is a unique-looking galaxy. It is a relatively dim object with a low surface brightness and that was all the more reason to image this interesting galaxy.

*Clayton Bay, South Australia*

**BACKGROUND:** A thick vein of dust and gas runs through the prominent hook-like arm of this unusual object. Its asymmetric shape is a hint that the galaxy has had an interesting life, perhaps surviving a close encounter with another galaxy. Detailed studies have revealed the presence of a nearby gas cloud which may have been torn away from the Meat Hook during the near miss.

**GSO RC12 telescope; Paramount MX mount; SBIG STXL-11002 camera; 2440mm f/8 lens**

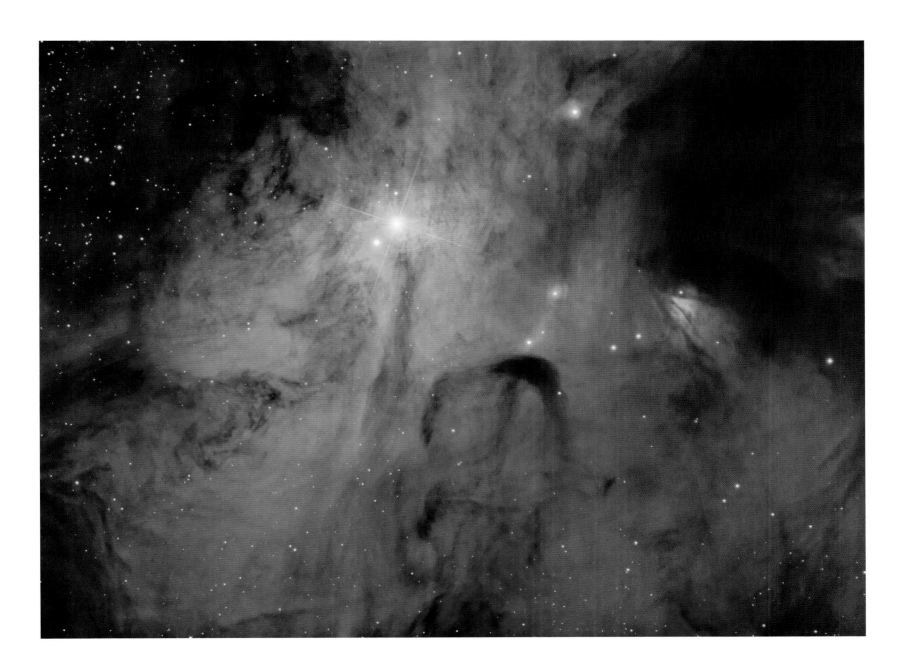

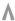

## ROLF WAHL OLSEN (New Zealand)

### The Turbulent Heart of the Scorpion
[6 April 2014]

**ROLF WAHL OLSEN:** With this study I wanted to focus on the rarely imaged, colourful, action-packed core of the larger Rho Ophiuchi area. A spectacular display of light and shade with contrasting hues makes this one of the most dramatic and colourful patches of the entire night sky. Even the brightest parts are barely noticeable when viewed through large amateur telescopes. However, a deep exposure shows the full splendour of the delicate swirling clouds, like an expressionist painting on a giant interstellar canvas.

*Auckland, North Island, New Zealand*

**BACKGROUND:** As the photographer notes, the human eye would struggle to see much detail in this patch of sky, even with the aid of a telescope. But by taking a long exposure the digital camera is able to bring out the sheets and filaments of gas and dust that fill the region, opening a window onto a vista that would otherwise be invisible to us.

**Home-built 12.5-inch Serrurier Truss Newtonian telescope; Losmandy G-11 mount; 12.5-inch mirror lens; QSI 683 WSG camera; 1270mm f/4 lens; 16-hour 25-minute exposure**

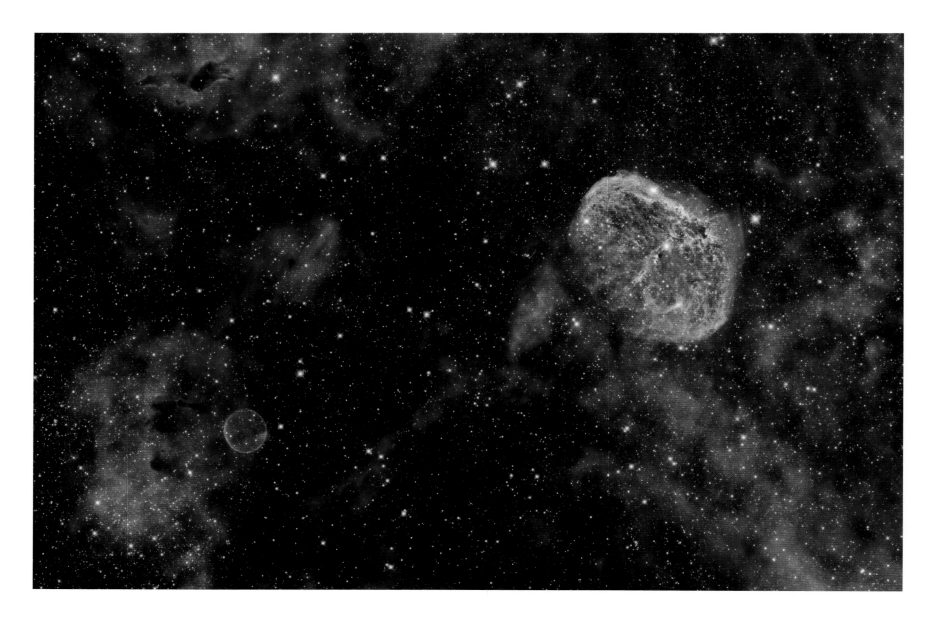

## IVAN EDER *(Hungary)*

### Soap Bubble and Crescent Nebula
[10 July 2013]

**IVAN EDER:** It was very exciting to image this pair, the Soap Bubble and Crescent Nebula. They look beautiful in this field of view; I love this composition. CCD data of H-alpha and OIII filters build up the nebulae, which were taken with my 200mm home-made Newtonian. I used H-alpha data for R, and OIII for G and B channels. Data of stars were imaged separately in their natural colours with a larger 300mm scope and modified 5D Mk II DSLR camera.

*Agasvar, Nógrád, Hungary*

**BACKGROUND:** Because the camera can detect more light than the human eye, it can sometimes be hard to tell from a photograph how astronomical objects acquired their nicknames. While the Bubble Nebula, in the lower left of this image, does indeed appear like a glowing bubble of gas, the Crescent Nebula, at upper right, seems less successful in living up to its name. But this is because the eye would only see the bright arc curving around the upper part of the nebula – the remaining gas only becomes visible in the long exposure of a photograph.

**Self-made 200/710 and 300/1130 Newtonian telescopes; modified SkyWatcher EQ6 and Fornax 51 mounts; QSI 683 WSG and Canon 5D Mk II cameras; 10-hour exposure**

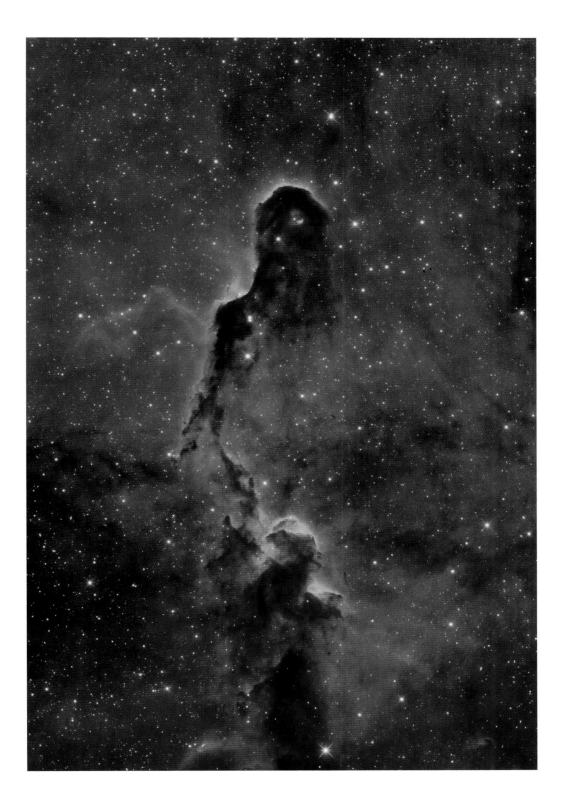

<

## IVAN EDER (Hungary)

### Elephant Trunk Nebula (IC 1396)
[5 October 2013]

**IVAN EDER:** This is not my first attempt at photographing this beautiful object. I have tried to image it several times during the last ten years with different telescopes and cameras; from old film techniques to modern digital SLR cameras. But I was never completely satisfied with my results. In October last year, the sky was remarkable over the mountains in Hungary – where I used to go out for imaging – so I chose this object again to make a tight and narrow composition. I used a CCD camera with narrowband filters and the false colour 'Hubble palette' technique. I believe both the tight composition and the new technique helped to bring life to this image, making the nebula shine brilliantly.

*Agasvar, Nógrád, Hungary*

**BACKGROUND:** The colour palette in this image is highly effective at revealing the complexity and subtle features present in the nebula. In particular, there is a beautiful contrast at the top of the central spire between the dark, dense gas and dust globule, and its edge where a massive, luminous star is ionizing the boundary of that structure.

**300/1130 self-built Newtonian telescope; Fornax 51 mount; QSI 683 WSG camera; 7.5-hour exposure**

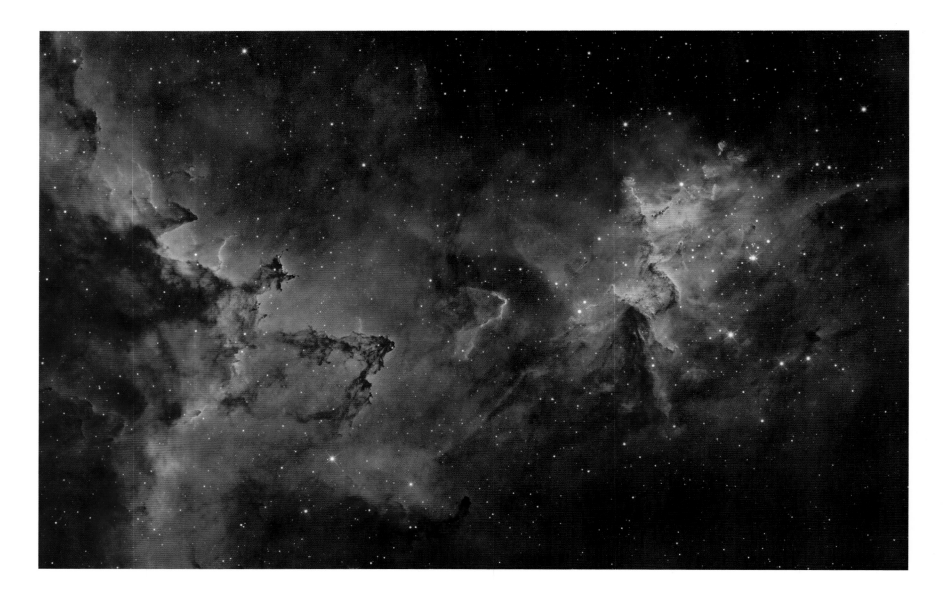

Λ

**IVAN EDER** *(Hungary)*

### Centre of the Heart Nebula
[*5 October 2013*]

**IVAN EDER:** One of my favourite targets, this active star-forming region has a lot of interesting formations, arcs, triangles and geometric forms. This narrowband image was taken with H-alpha, OIII, SII filters, while the star colour data came from the DSLR camera taken with the same scope.

*Agasvar, Nógrád, Hungary*

**BACKGROUND:** Lying at a distance of 7500 light years in the 'W'-shaped constellation of Cassiopeia, the Heart Nebula is a vast region of glowing gas, energized by a cluster of young stars at its centre. Here we see a part of this central region, where dust clouds are being eroded and sculpted into mountainous shapes by the searing stellar radiation.

300/1130 self-built Newtonian telescope; Fornax 51 mount;
QSI 683 WSG and Canon 5D MkII cameras; 7-hour exposure

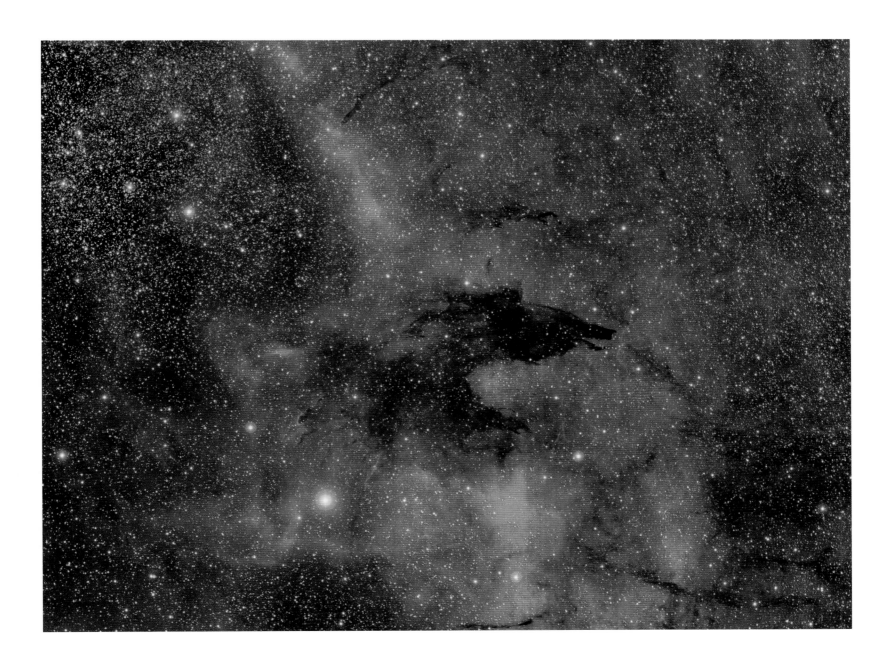

**PAUL HAESE** (*Australia*)

### The Wolf
[*4 July 2013*]

**PAUL HAESE:** I came across this object by sheer chance while looking for the dark tower in Scorpius. I hunted around on the internet for an image of the object and could not find one. Thinking this presented a unique opportunity to image it, I set about capturing the data. After several months I had all I needed – this image was the first time the object had been captured to such a depth. To me it looks like a werewolf rushing through the undergrowth and hence the reason why I named it 'the Wolf'.

*Clayton Bay, South Australia*

**BACKGROUND:** Our brains are primed to seek out familiar shapes wherever we look, and the sinister dark outline in the centre of this nebula certainly evokes European folktales about the Big Bad Wolf or cave paintings of Ice Age animals. Despite being scrutinized by astronomers for centuries the Universe still holds many surprises. Through curiosity and persistence this photographer has added a new animal to the zoo of imaginary creatures with which humans have populated the sky.

**TSA102 telescope; Paramount ME mount; QSI 683WSG-8 camera; 576mm f/5.6 lens; 21-hour exposure**

## J.P. METSÄVAINIO (Finland)

### Veil Nebula Detail (IC 1340)
[*29 October 2012*]

**J.P. METSÄVAINIO:** IC 1340 is part of the Veil Nebula, a supernova remnant in the constellation Cygnus at a distance of about 1470 light years. This is one of the more luminous areas in this SNR (supernova remnant). The shock fronts formed by the material ejected from giant explosions – the supernova – can be seen in this image.

*Oulu, Northern Ostrobothnia, Finland*

**BACKGROUND:** The angular shapes and garish colour palette help to convey the violent origins of this gaseous structure, part of the debris of an exploding star which detonated over 5000 years ago. The glowing relic is still expanding, and the entire nebula now covers an area of the sky about 36 times larger than the full Moon.

**Meade LX200 GPS 12-inch telescope; Meade fork mount; QHY9 camera; 2000mm f/6 lens**

*"There is a fabulous sense of movement, luminosity and weightlessness in the rendering of the gas emissions of this nebula."*
MELANIE VANDENBROUCK

*"Simply awe-inspiring."*
MELANIE GRANT

*"Rendering this reflection nebula with the Hubble palette brings to mind flickering flames – captivating!"*
CHRIS BRAMLEY

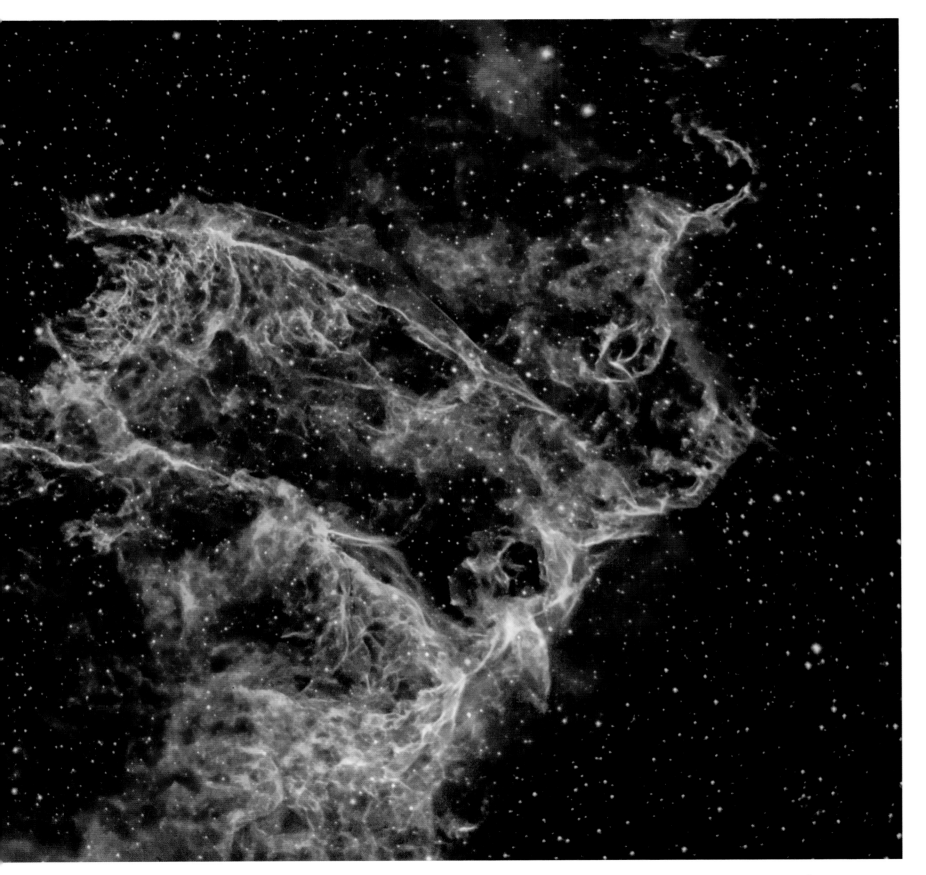

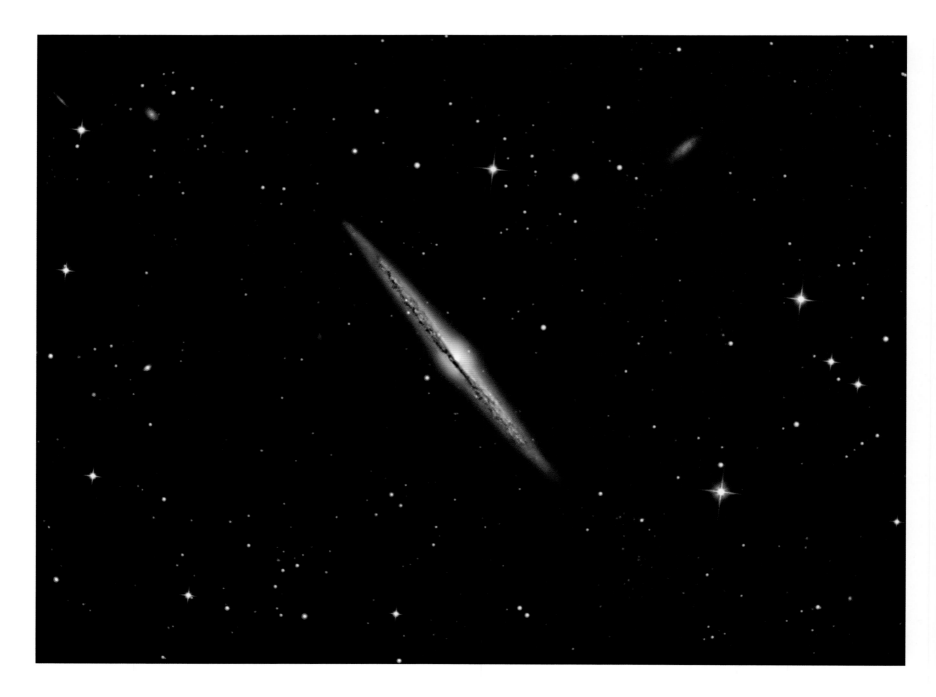

## Λ

### ANTONIS FARMAKOPOULOS *(Greece)*

**NGS 4565 Galaxy**
[*23 July 2013*]

**ANTONIS FARMAKOPOULOS:** The NGC 4565 Galaxy is also known as the Needle Galaxy because of its narrow profile, but in fact it is a spiral galaxy. The galaxy is located in the constellation Coma Berenices about 30 million light years away from us and has a diameter of 100,000 light years.

*Keratea, East Attica, Greece*

**BACKGROUND:** The edge-on view of this elegant spiral galaxy highlights how thin and delicate its disc of stars really is. The galaxy's dust lanes are thrown into sharp relief against the central 'bulge' of billions of ancient stars. Other, even more distant galaxies can be seen scattered across the background of the image.

**Toscano 10-inch Truss RC telescope; Celestron CGE Pro mount; QHY9M camera; 2250mm f/9 lens**

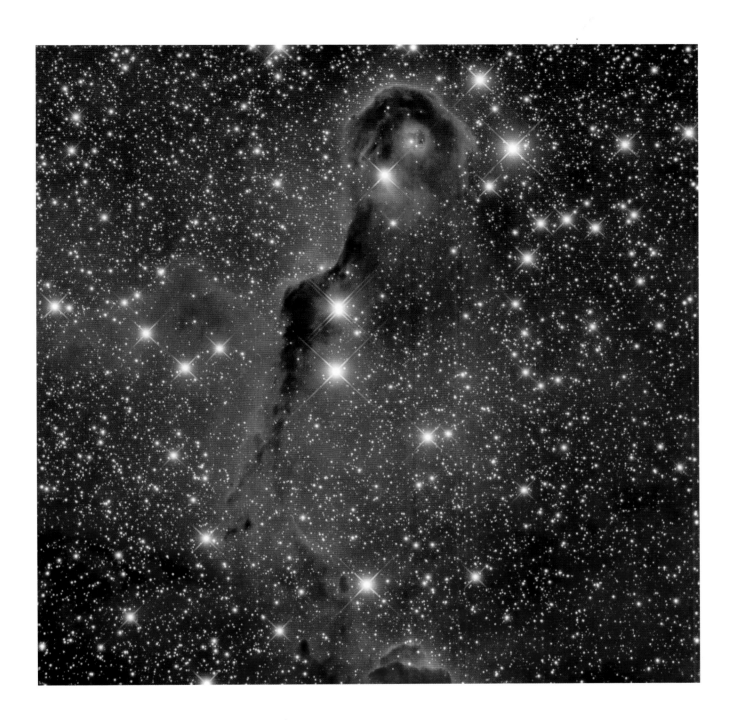

Λ

**LEONARDO ORAZI** *(Italy)*

## VDB 142
[*9 September 2013*]

**LEONARDO ORAZI:** Taking pictures at longer focal lengths is never easy, especially when you have a limited budget for equipment. This image, however, captures the wonderful depth and colours, giving proper recognition to a beautiful deep-sky object. Our Universe is always able to surprise us with textures and colours that are beyond our imagination.

*Pragelato, Turin, Italy*

**BACKGROUND:** More commonly known by its nickname the Elephant's Trunk Nebula, this is a smaller dense globule within an enormous region of ionized gas known as IC 1396. Infrared imagery has recently revealed that the nebula is a site of star formation, and winds from these stars actually help to create the compact dark clouds of gas and dust which obscure their light at visible wavelengths.

**GSP RC 10-inch telescope; Astro-Physics MACH1 GTO mount; QSI-640WSG camera; 2000mm f/8 lens**

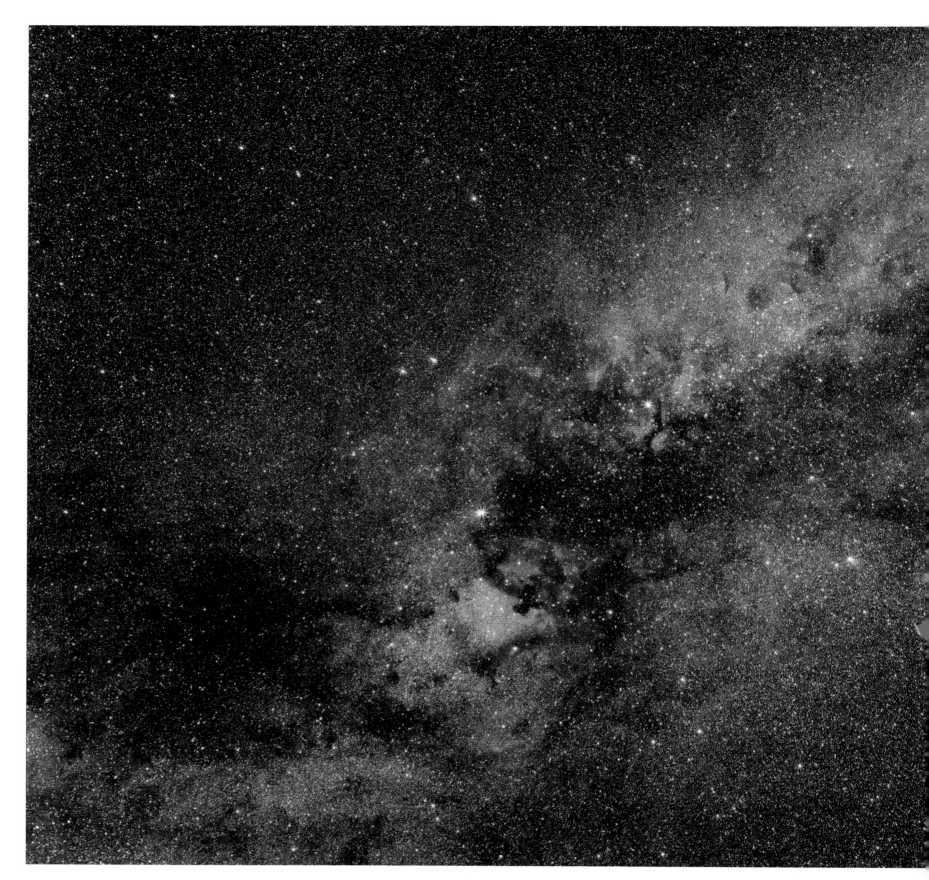

<

## LEONARDO ORAZI *(Italy)*

### Zenith of the Northern Summer Sky
[2 *September 2013*]

**LEONARDO ORAZI:** Summer nights in European skies are dominated by the Cygnus constellation. Looking at the zenith from places dark enough – such as the Italian Alps – makes it easy to enjoy breathtaking views of this area of our Milky Way. The long exposure on this photo was unplanned – I was thinking of doing a few tens of seconds, but then I got lost in watching the stars. It's a beautiful reminder of the emotions that I will always carry in my heart.

*Pragelato, Turin, Italy*

**BACKGROUND:** Despite warmer temperatures, the short nights of summer can be problematic for astronomers as it rarely gets properly dark. Nevertheless, the summer skies of the Northern Hemisphere are graced by several prominent constellations, including Cygnus, the Swan, which stretches along the band of the Milky Way.

**Astro-Physics MACH1 GTO mount; Canon 50mm f/1.8 lens; Canon 5D MKII Baader camera; f/6 lens; ISO 1600; 1200-second exposure**

# ASTRONOMY PHOTOGRAPHER

## OF THE YEAR 2014

# PEOPLE AND SPACE

Photos that include people in a
creative and original way

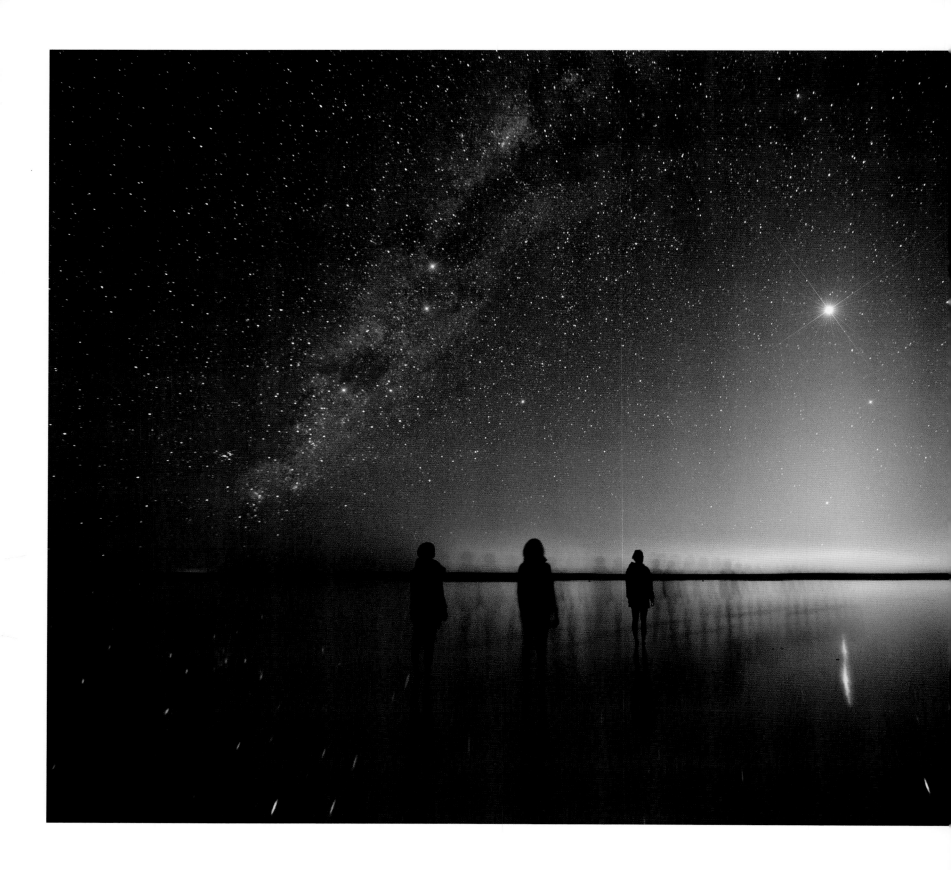

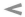

## JULIE FLETCHER (*Australia*)

### Lost Souls
[*28 September 2013*]

**JULIE FLETCHER:** This image was taken at Lake Eyre in remote South Australia. Here the rare zodiacal light around the planets Venus, Saturn and Mercury – with the Milky Way left of shot – is partially reflected in the very shallow water. This shot was carefully set up as the timing was crucial to achieve the colours and placement of elements in this image.

*Kati Thanda-Lake Eyre National Park, South Australia*

**BACKGROUND:** The zodiacal light seems to rise from the horizon like a pyramid, with the brilliant point of Venus at its apex. Made up of sunlight scattered and diffused by the tiny grains of dust that drift between the planets, this pale feature marks out the plane of the Solar System, the flat disc in which all of the planets orbit the Sun. The stillness of the heavens contrasts with the transience of the scene below, with its shifting human figures reflected in the temporary waters of Kati Thanda-Lake Eyre.

**Nikon D800 camera; 14mm f/2.8 lens; ISO 2500; 20-second exposure**

*"The remote location and ghostly figures give a strange, eerie feel to this evocative scene."*
MAREK KUKULA

*"Looks like the poster for a new sci-fi film, very atmospheric."*
MAGGIE ADERIN-POCOCK

*"The kind of picture that prompts a very subjective response. I found myself intrigued by the meditative figures as well as unsettled by their ghostly features."*
MELANIE VANDENBROUCK

*"A really odd, special and unusual image that reminds me of some sort of zombie apocalypse."*
MELANIE GRANT

*"This image shows very clearly the zodiacal light – the cone of reflected light from dust scattered throughout the Solar System."*
CHRIS LINTOTT

*"This picture captures for me what it feels like to stand under a majestic night sky; that we humans are a fleeting impression within the vastness of space and time."*
CHRIS BRAMLEY

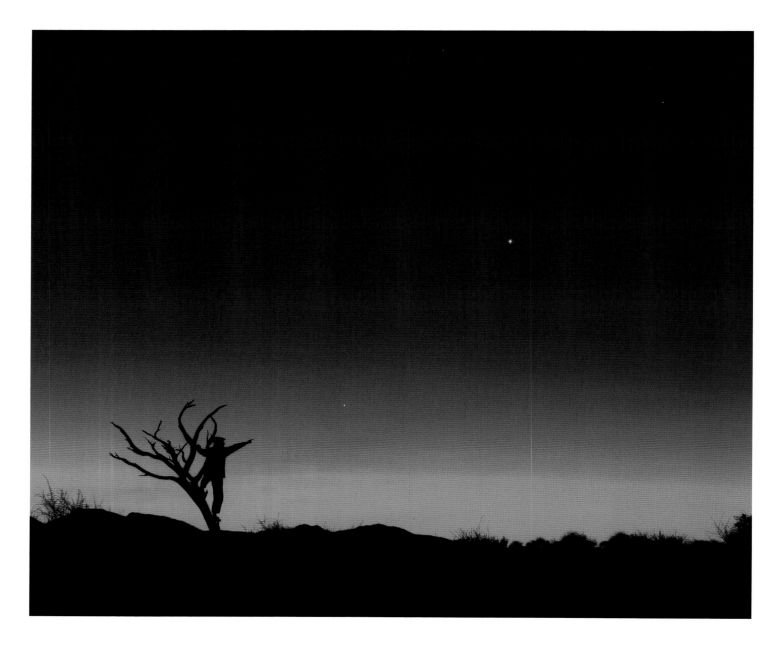

## Λ

**LÓRÁND FÉNYES** *(Hungary)*

### Three Planets in Conjunction
[*2 June 2013*]

**LÓRÁND FÉNYES:** The incredible colours of the sunset and flora of the African savannah provided a unique background for the planetary alignment in June 2013. In the golden hues of the sunrise, the three planets – Jupiter, Venus and Mercury – looked as if they were strung on an invisible thread. The bare tree and the human figure interwoven both point to one direction: Jupiter.

*Isabis, Khomas Highland, Namibia*

**BACKGROUND:** The intriguing composition of this image draws the eye from one amazing sight in the night-time sky to the next; starting with Jupiter before following through to Venus and finally Mercury. The juxtaposition of the striking landscape against a beautifully clear sky shows why Namibia is such a fantastic and well-loved destination for astronomy photographers the world over.

**Canon 70–200mm f/2.8 telescope; Canon 350D camera; 70mm f/10 lens; ISO 400; 15-second exposure**

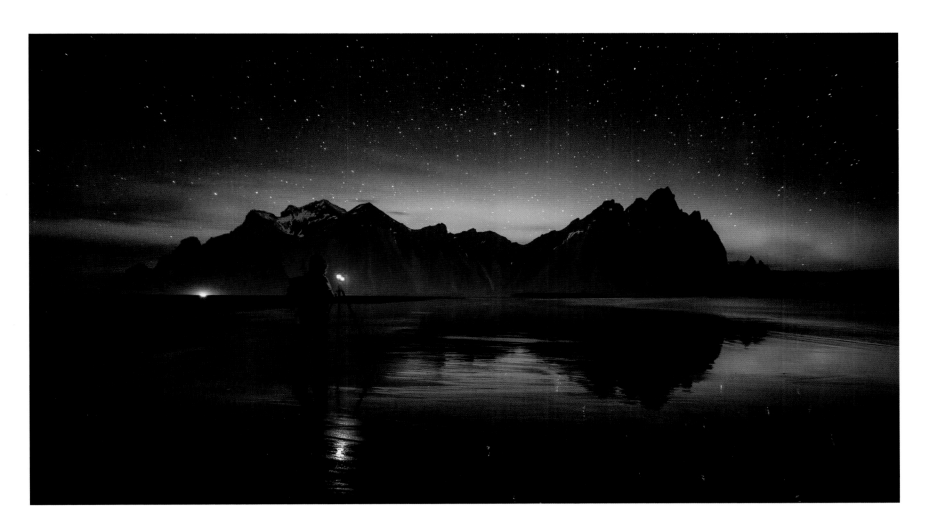

Λ

**PHILIP EAGLESFIELD** *(UK)*

### Chasing the Dragon
[*3 December 2013*]

**PHILIP EAGLESFIELD:** A truly magical location: Vesturhorn, Iceland.
A combination of being stopped in his tracks by the amazing sight, and
the cold wind whipping in, ensured my fellow photographer froze right
there as the soft auroral glow reflected in the wet sand.

*Vesturhorn, Austurland, Iceland*

**BACKGROUND:** The many different light sources – astronomical,
atmospheric and artificial – are all reflected by the wet sand of the
beach, lending symmetry to this rugged landscape. The distant stars
and icy green glow of the aurora enhance the sense of cold and even the
photographer's red lamp, used to preserve night vision, only serves to
emphasize the loneliness of the scene.

**Canon 5D Mk III camera; 15mm f/2.8 lens; ISO 3200; 30-second exposure**

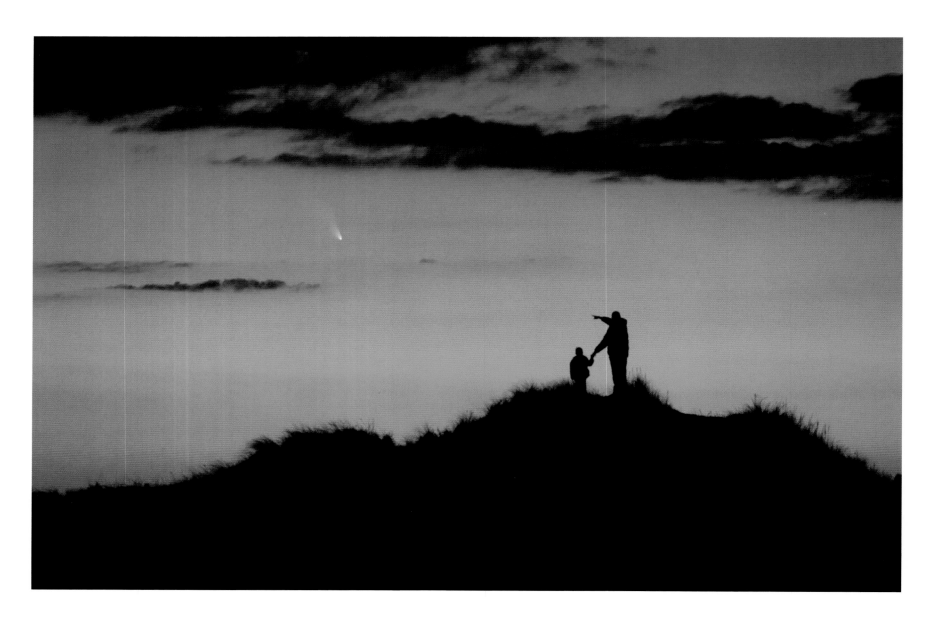

Λ

## CHRIS COOK (USA)

### Father and Son Observe Comet Panstarrs
[13 March 2013]

CHRIS COOK: I had been planning this photo for weeks leading up to Comet Panstarrs's evening display. Having a young son, I wanted to show him the comet to help foster his interest in astronomy. I also wanted to capture a foreground with a human element but needed a clear western horizon, so in March 2013, during a break in the weather, we drove out to First Encounter Beach. I set up my camera and remote trigger release 100 yards away from a sand dune, and started the camera exposure sequence as we walked to the top. From there we had an unobstructed view out over the ocean as we stood still in the fading twilight. My son was in such awe of Panstarrs; we talked about what

comets are made of, how they form their tails and where they come from. Being a father, it was a moment I will treasure forever.

*First Encounter Beach, Eastham, Massachusetts, USA*

BACKGROUND: In the seventeenth century Edmond Halley calculated that many comets orbit the Sun over extremely long periods, taking decades, centuries or even millennia to return to our cosmic neighbourhood. Comets have since come to symbolize the brief span of human lives set against the vast backdrop of astronomical time. Comet Panstarrs will not visit the Earth's skies again for more than 100,000 years.

Canon 5D camera; Canon EF 70–200mm f/2.8 lens; 200mm f/4 lens;
ISO 1250; 2-second exposure

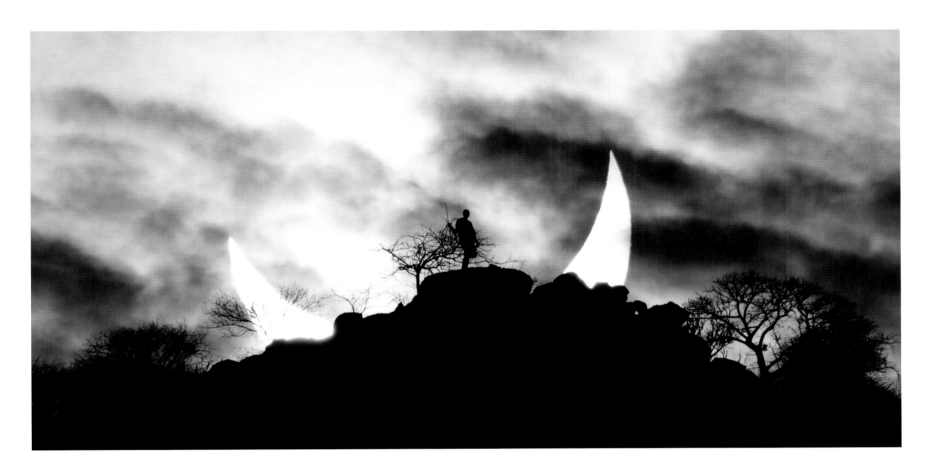

## Λ

**EUGEN KAMENEW** (*Germany*)

### Hybrid Solar Eclipse 1
[*3 November 2013*]

**See overleaf**
*Turkana County, Rift Valley, North Kenya*

**Canon 5D Mk II camera; 700mm f/29 lens; ISO 50; 1/1200-second exposure**

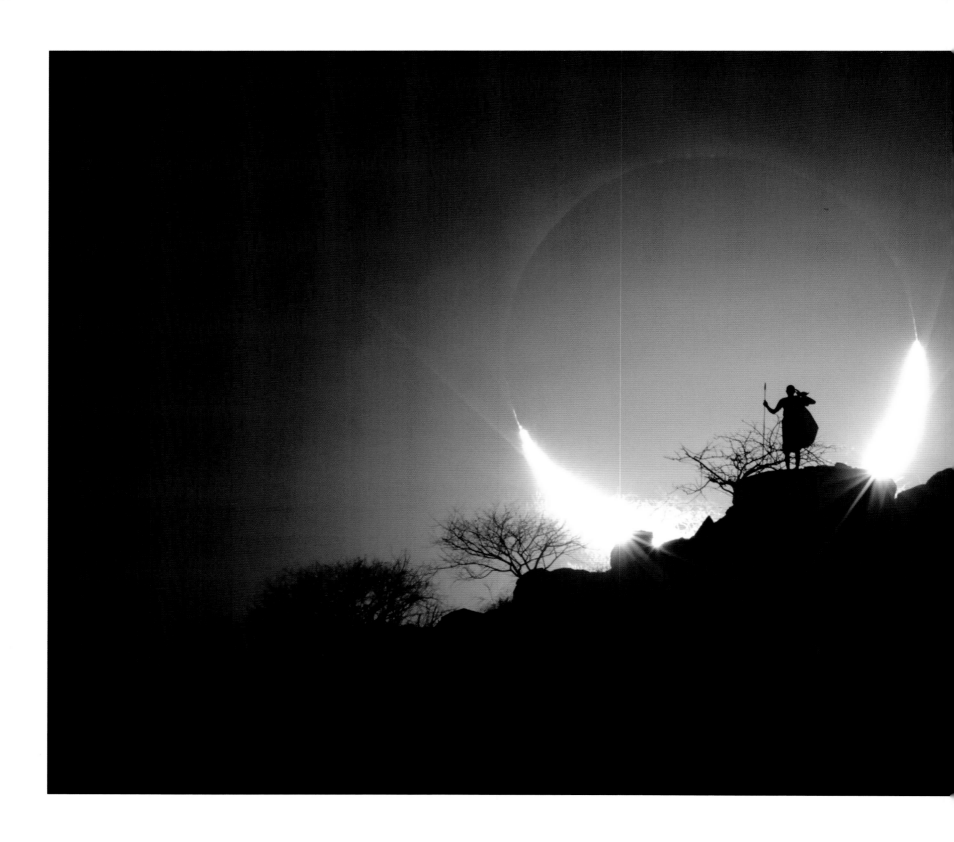

## EUGEN KAMENEW *(Germany)*

### Hybrid Solar Eclipse 2
[*3 November 2013*]

**EUGEN KAMENEW:** Geoffrey Lowa was a friend I never met in person. He was planning to be my host, driver, tour guide and, last but not least, my photographic model for a hybrid solar eclipse in North Kenya on 3 November 2013. On 8 October he sent me his last message via Facebook, excited at the prospect of our trip: 'Turkana should be blessed…it's the cradle of mankind. Oil and enormous underground lakes [were] recently discovered and now [we have a] hybrid solar eclipse…'. Sadly he was killed just one week before I arrived. These photographs are my tribute to Geoffrey.

*Turkana County, Rift Valley, North Kenya*

**BACKGROUND:** Sun and Moon sink together behind a Kenyan savannah skyline, locked in an eclipse in which the Moon is silhouetted against the Sun's bright disc. This particular event, in November 2013, was a rare example of a hybrid solar eclipse. It began at sunrise over the western Atlantic as an annular eclipse, in which the Moon does not entirely block the Sun, leaving a bright ring or annulus uncovered. As the Moon's shadow swept eastwards across the ocean the eclipse became total, with the whole of the Sun concealed from view. By the time the eclipse reached Kenya the Sun was once again emerging from behind the Moon, producing this spectacular crescent shape at sunset.

**Canon 5D Mk II camera; 700mm f/22 lens; ISO 400; 1/1600-second exposure**

*"For me, this photo really captures the emotional impact of a solar eclipse. Seeing one is always an unforgettable experience."*

MAREK KUKULA

*"This is an incredibly powerful image. Amazing timing and a crystal sharp image of the eclipse. The 'starburst' effect caused by the divided solar crescent is stunning. A magnificent image."*

PETE LAWRENCE

*"An eclipse is magical enough but with the silhouetted figure an extraordinary image is created."*

MAGGIE ADERIN-POCOCK

*"This image is rich on many levels: solar as well as terrestrial, human above all. The composition is very powerful too: soft edges, bright focus, delicate silhouetting; the refracting spikes of the sun shining through the rugged landscape."*

MELANIE VANDENBROUCK

*"To see an eclipse you have to be in precisely the right place – and the sense of location in this shot is very present."*

CHRIS LINTOTT

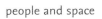

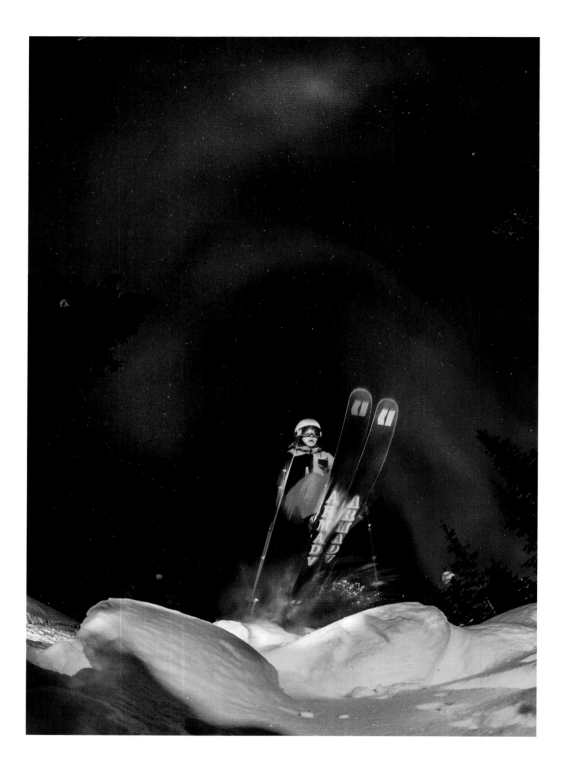

<

## MIKKO LAITINEN *(Finland)*

### Aurora Skiing
[*29 March 2013*]

**MIKKO LAITINEN:** I took the photo during a skiing trip in Lapland. We were staying in a small cabin and were ready to call it a day, when we noticed the auroras lighting up the sky. We quickly decided to go out to do some aurora-lit skiing, and the experience was well worth the freezing temperatures!

*Lapland, Finland*

**BACKGROUND:** Photographs of the aurora typically focus on the grandeur and serenity of this natural lightshow, so it's unusual to see it used as the backdrop to an action-packed scene such as this. However the juxtaposition is perhaps not quite so incongruous when you consider that the aurora is the end result of some extremely dynamic physics. This includes vast explosions on the surface of the Sun and the collision of trillions of speeding subatomic particles with the Earth's atmosphere and magnetic field.

**Canon 5D Mk III camera; 15mm f/5.6 lens; ISO 4000; 6-second exposure**

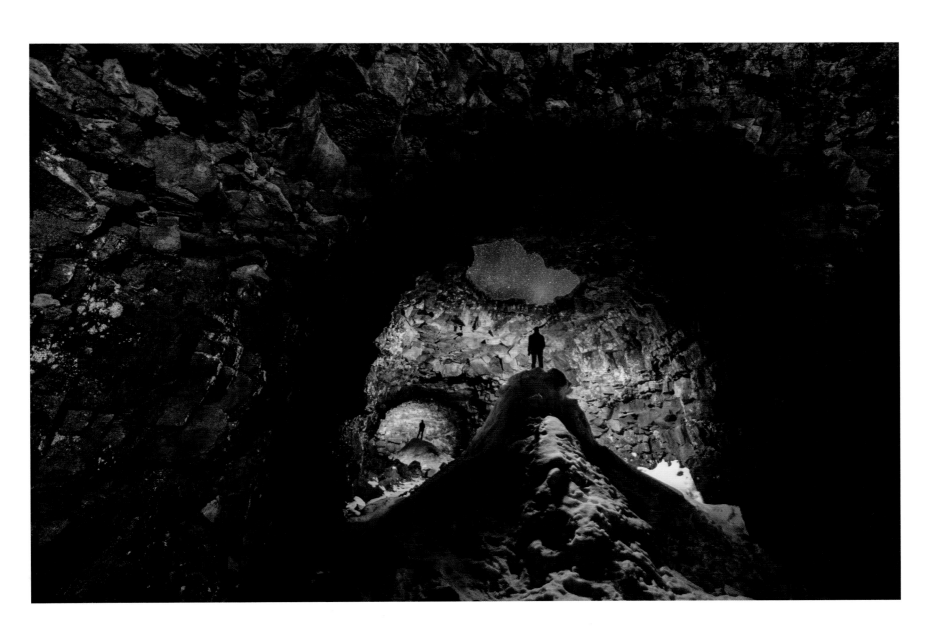

## INGÓLFUR BJARGMUNDSSON (Iceland)

### Cave with Aurora Skylight
[30 March 2014]

**INGÓLFUR BJARGMUNDSSON:** This image was taken while exploring a 1300m lava cave in Iceland. In some areas the roof has caved in, so snow piles up in the winter time and creates these snow peaks. The cave is quite high in some areas but can be treacherous. I did spend quite some time in there to capture the aurora at its peak.

*Raufarhólshellir cave, Leitahraun lava field, Iceland*

**BACKGROUND:** Even though the sky takes only a small portion of the picture, it is still the focal point, drawing you in. With the surreal effect of the opalescent, jewel-like colours of the cave echoing those of the aurora, the scene looks like a treasure trove. Its eerie quality, which recalls the pictorial tradition of the nineteenth-century German Romantic sublime, is emphasized by the repeated human figures, like doppelgängers gazing into the heavens.

**Canon 5D Mk III camera; 14mm f/2.8 lens; ISO 6400; 25-second exposure**

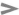

## CARLOS ORUE (Australia)

### Observing the Milky Way
[15 April 2013]

**CARLOS ORUE:** They say that the best things in life are free. Life is filled with simple pleasures, the little satisfying effects you never really anticipate, but always take great enjoyment from. They are the gifts of life that we each subconsciously celebrate in our own unique way. For me it is being outdoors on a clear night, sitting back with a couple of friends and watching the stars and the Milky Way sparkle across the sky.

*Clovelly, Sydney, Australia*

**BACKGROUND:** The 13 billion-year life story of the Milky Way Galaxy forms the immense backdrop to this very human moment. Dark filaments of interstellar dust make a spectacular silhouette against the diffuse light of the Milky Way. The clumps of white light embedded within the dust are clusters of newborn stars which have formed from the surrounding gas clouds in the last few million years. Meanwhile, the yellowish light shining out from behind the dust comes from the ancient stars of the Galactic Centre, some of which date back to the formation of the Galaxy itself.

**Canon 5D Mk III camera; 16mm f/2.8 lens; ISO 3200; 30-second exposure**

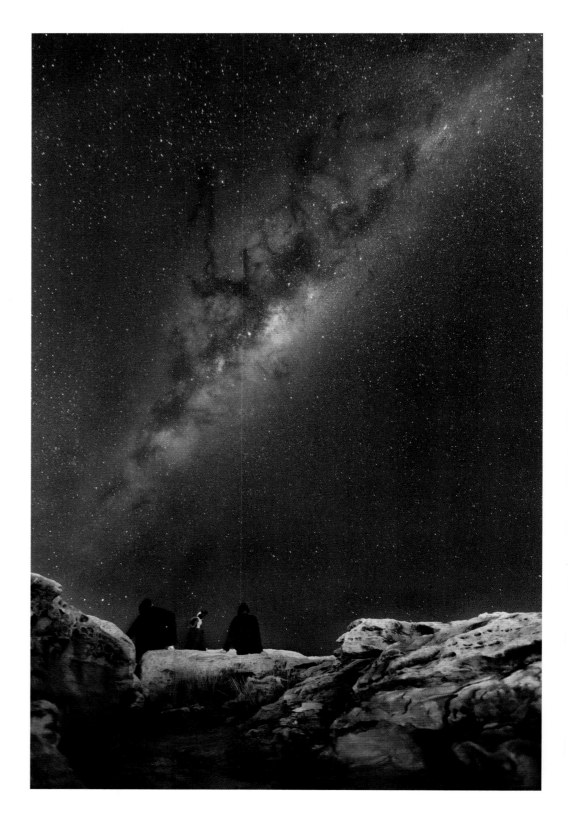

## ROBERT HOWELL (USA)

### Eclipse and Old Faithful
[20 May 2012]

**ROBERT HOWELL:** Visitors watch the Old Faithful geyser erupt as the Moon partially eclipses the Sun. This annular eclipse was taken over Yellowstone National Park in May 2012. The goal was to make a single image of the eclipse *and* the geyser eruption occurring at the same time. A scene with a sense of awe – bright day, blue sky, white geyser steam, and the gestures of the onlookers straining to see the connection of these two phenomena. The challenge was shooting 'into' the direction of the bright Sun. This photograph is a composite: two images were taken immediately after each other. One filterless shot of the scene, and another capturing the Sun being eclipsed, using the steam as an additional filter.

*Yellowstone National Park, Wyoming, USA*

**BACKGROUND:** Two transient phenomena – one geological and the other astronomical – combine in this scene of a solar eclipse shining through the steam and vapour of the Old Faithfull geyser. In an eclipse of this kind it takes the Moon around six hours to pass all the way across the face of the Sun, but Old Faithful only erupts once every 91 minutes. That only gives a photographer four chances during the eclipse in which to get viewing angles and exposure times absolutely right and capture both the geyser and the eclipse together in the same shot.

**Nikon D700 camera; 0.9ND filter**

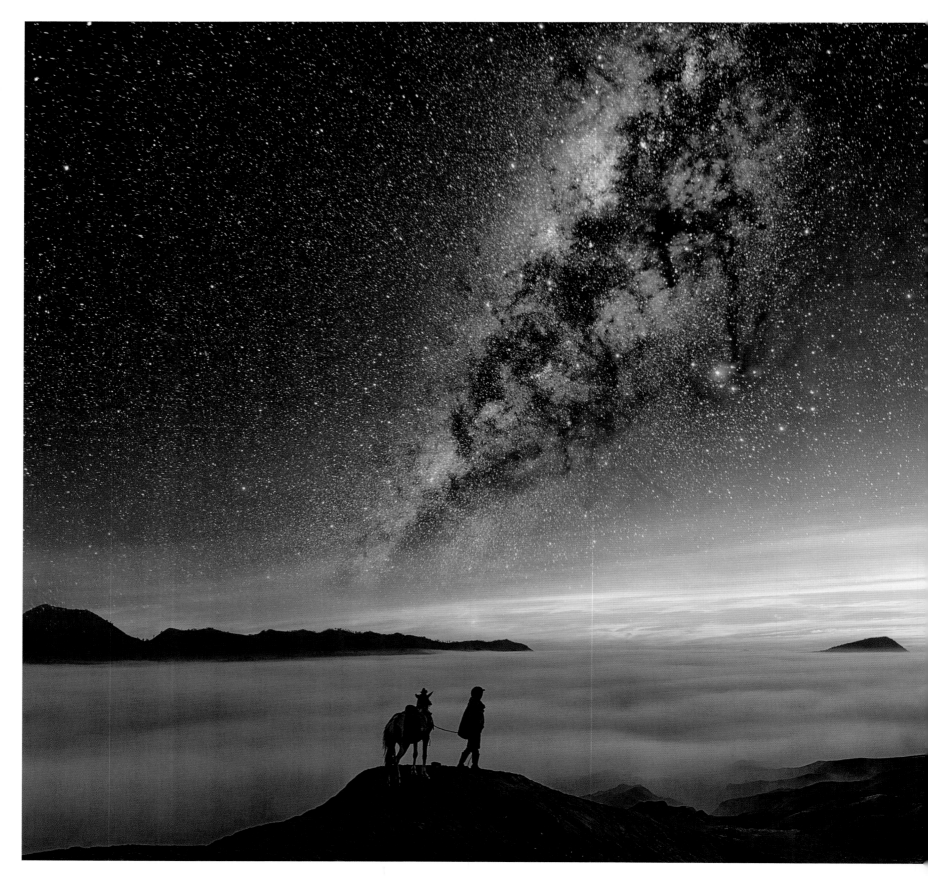

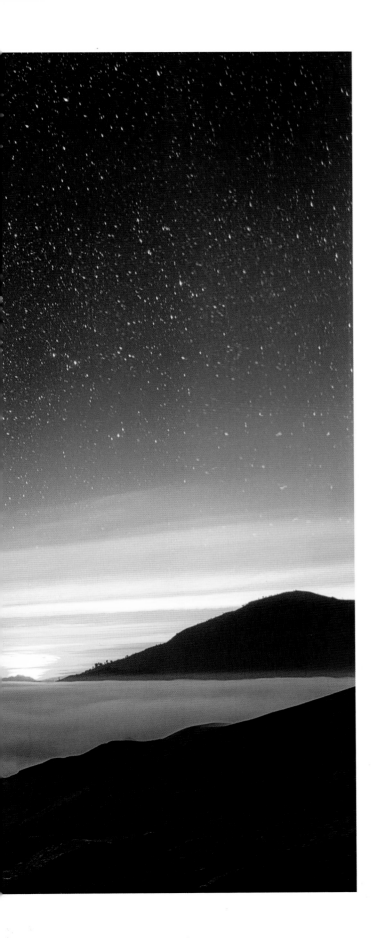

## JUSTIN NG *(Singapore)*

### Good Morning Horses!
[*30 September 2013*]

**JUSTIN NG:** A tale of two horses, catching a glimpse of the breathtaking sunrise from two awe-inspiring locations. One from above the fog on the crater of Mount Bromo, an active volcano, and the other located in our very own galaxy, the Milky Way! Needless to say I have created this composite image in order to tell the story.

*Mount Bromo, Bromo Tengger Semeru National Park, Indonesia*

**BACKGROUND:** Horses are the stars of this panoramic scene; a composite of an Earthly sunrise with an expertly-snapped view of our galaxy above. The Earth-bound steed is easy to spot, but you might need to look a little harder to see its celestial companion. Squint at the dark clouds of dust that thread the Milky Way and you should find the silhouette of a horse rearing to greet the dawn.

**Canon 5D Mk II camera; 16mm f/2.8 lens; ISO 1600; 10-second exposure**

# ASTRONOMY
# PHOTOGRAPHER
## OF THE YEAR 2014

# ROBOTIC SCOPE

Photos taken remotely using
a robotic telescope and processed
by the entrant

># 
**MARK HANSON** *(USA)*

## NGC 3718
### [*3 March 2014*]

**MARK HANSON:** Taken from Rancho Hidalgo in Animas, New Mexico, this is a very deep image of NGC 3718. Rancho Hidalgo has quite a few remote observatories on its property. Our observatory is the Doc Greiner Research Observatory (DGRO). The luminance data was collected over two full nights of excellent seeing. Aladin Sky Atlas calculates over 5000 galaxies in this photo, down to 24th magnitude.

*Rancho Hidalgo, New Mexico, USA*

**BACKGROUND:** Found in the constellation Ursa Major, NGC 3718 is known as a *peculiar* barred spiral galaxy. Gravitational interactions with its near neighbour NGC 3729 (the spiral galaxy below and to the left) are the likely reason for the galaxy's significantly-warped spiral arms, while a dark dust lane wraps around the centre.

**RCOS 14.5-inch f/8 Ritchey-Chretién telescope; Paramount ME2 mount, off-axis guided; Apogee U16M CCD camera**

*"I love the variety of shapes and forms displayed by the galaxies in this image. A great choice of subject!"*

MAREK KUKULA

*"This beautiful image shows not one but hundreds, perhaps even thousands, of galaxies scattered across space. I particularly like the fine details in the streams of stars strewn around NGC 3718."*

WILL GATER

*"Incredible image of a complex but very beautiful set of galaxies. The unusual structures in the blue arms of NGC 3718 convey complex gravitational forces shaping this galaxy. The contrast between the warm colours of the core and the outer arms is very beautiful. Magnitude +24 is very deep indeed – a great image."*

PETE LAWRENCE

*"This galaxy's unusual shape portrays a complicated past; it's undergone a collision in the recent past, probably responsible for the bright blue young stars sprinkled throughout the halo."*

CHRIS LINTOTT

*"As well as the fantastically bizarre galaxy that is at the centre of this image, many more distant examples surround it."*

CHRIS BRAMLEY

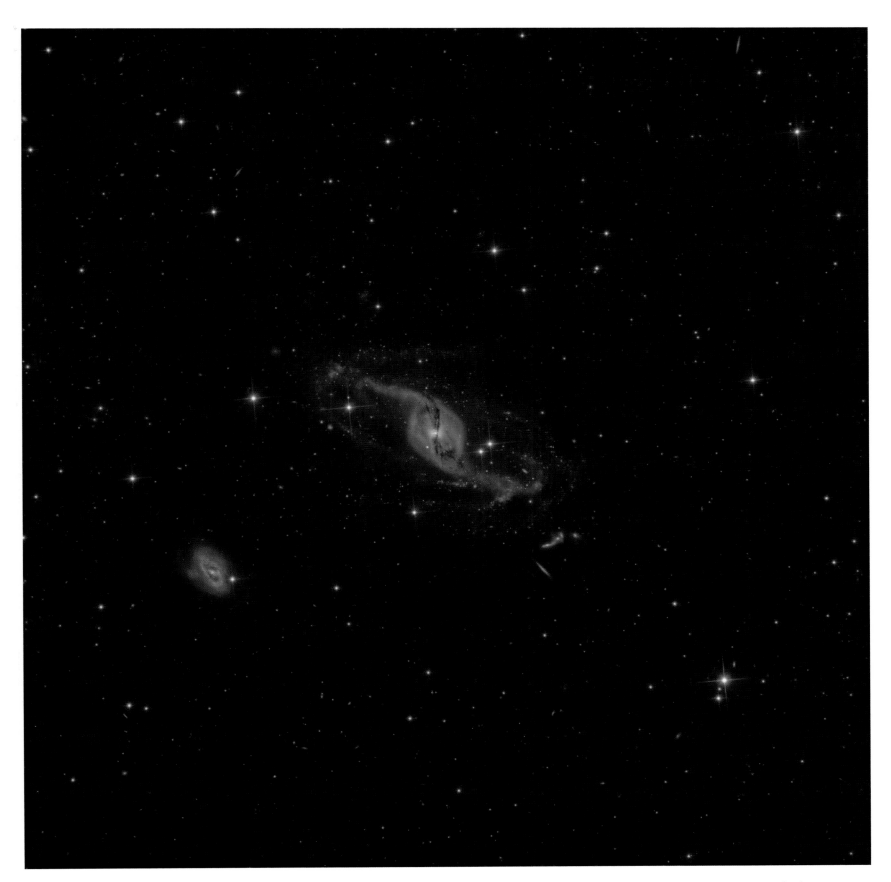

## LÁSZLÓ FRANCSICS *(Hungary)*

### Queen of the Reflection Nebulae
[*20 January 2014*]

**LÁSZLÓ FRANCSICS:** Combining images from two different telescopes it became possible to reveal the details of one of the most impressive reflection nebulae, a unique Messier object, M78. This object is not only a bluish cloud-complex reflecting the light of young stars, but also part of the Orion complex, giving birth to stars in its faint dark dust filament. Where the young stars appear, a rare and unique cloud formation emerges.

*Siding Spring Observatory, Coonabarabran, New South Wales, Australia*

**BACKGROUND:** Around 1600 light years away, M78 shines with the light of young stars – their blue brilliance partially obscured from view by intervening gas and dust. A popular object for deep sky observers, the nebula lies close to the familiar line of stars known as Orion's Belt. Binoculars and telescopes typically show a collection of pale smudges to the eye, but long exposure images such as this draw out the subtle gradations in colour, as starlight paints the dense molecular cloud. M78 was discovered by Pierre Méchain in 1780, and catalogued by his friend Charles Messier in the same year.

**PlaneWave 20-inch Corrected Dall-Kirkham reflector; FLI-PL6303E CCD camera / Custom 200mm Newtonian telescope; modified Canon 350D camera**

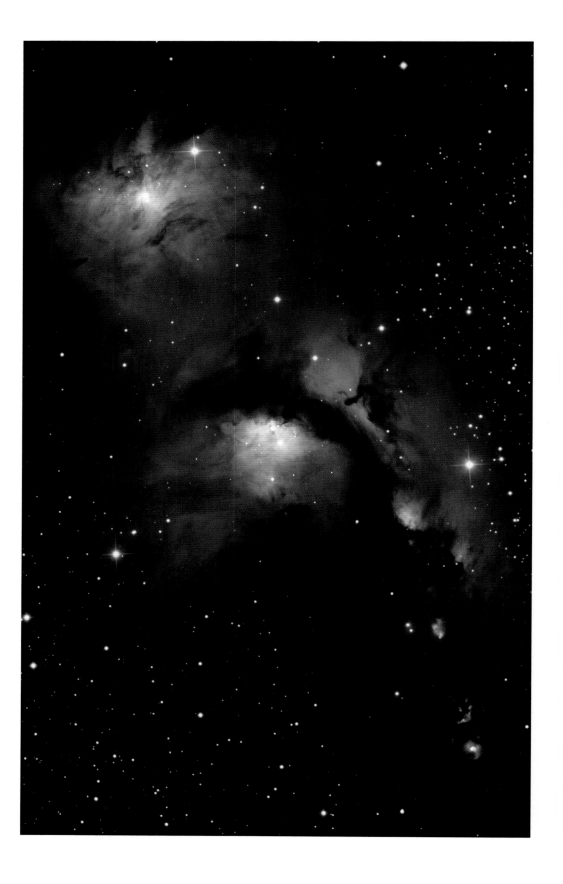

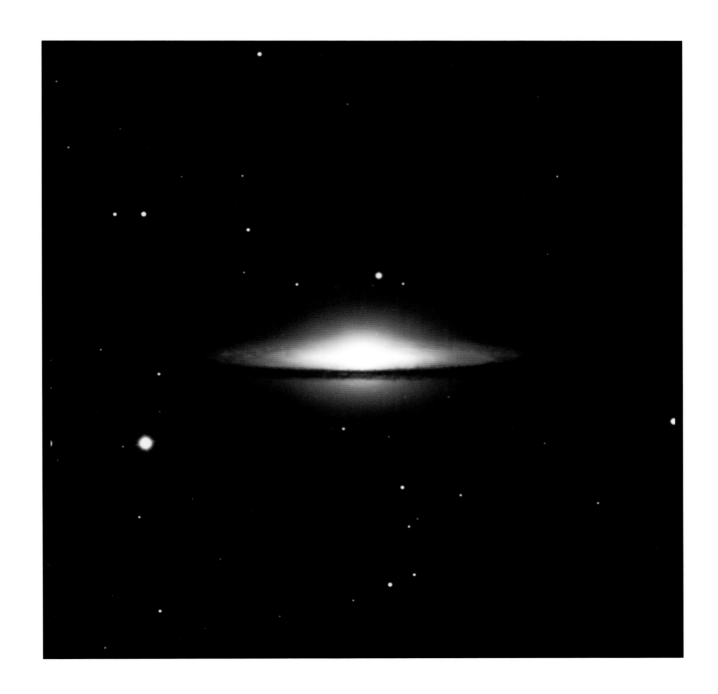

Λ

## BLAIRGOWRIE HIGH SCHOOL, S2 CLASS *(UK)*

### The Sombrero Galaxy (M104)
[*17 May 2013*]

**BLAIRGOWRIE HIGH SCHOOL, S2 CLASS:** This image was submitted by Steven Wilkinson, teacher of Physics at Blairgowrie High School, Perthshire, Scotland, on behalf of his S2 class of 13-year-old students. It shows the Sombrero Galaxy, and was taken as part of the Faulkes Telescope Project, which provides free access to a global network of robotic telescopes and related science education resources.

*Haleakala Observatory, Hawaii, USA*

**BACKGROUND:** At the heart of the Sombrero Galaxy is a supermassive black hole. It is actually one of the most massive black holes to be found within a nearby galaxy. The image shows the famous dust lane and bright nucleus, which together gave rise to the galaxy's common name.

**Faulkes Telescope North; 2m lens; CCD chip camera**

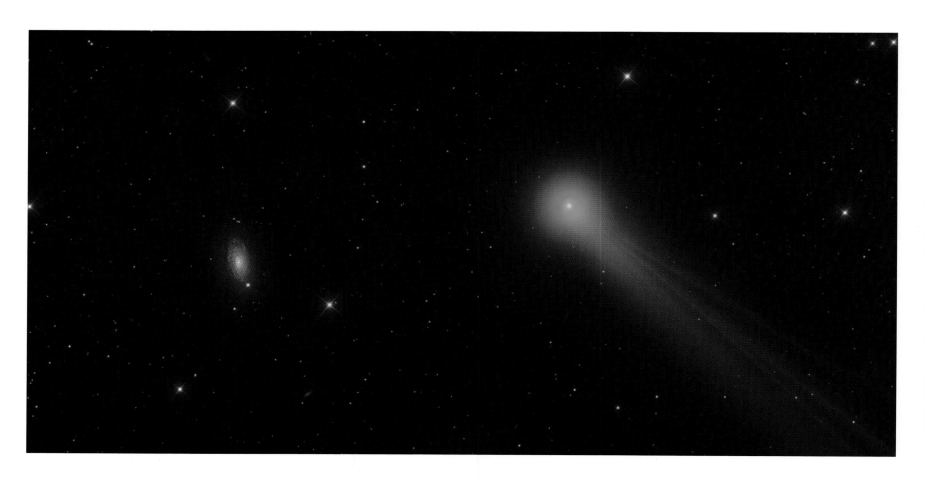

## Λ

**DAMIAN PEACH** *(UK)*

### Comet Lovejoy with M63
*[25 November 2013]*

**DAMIAN PEACH:** Comet Lovejoy captured alongside the spiral galaxy Messier 63. The image was captured using the Astrocamp Observatory at Nerpio, Spain, and operated by iTelescope. For this image, I planned the run in advance using Guide 9 to precisely position the telescope. It's actually a mosaic of two images taken at the time to encompass the comet and galaxy together. This was achieved by specifying the exact coordinates to point the telescope for both images to achieve the ideal framing. The telescope interface is via ACP – by far the most popular software for remote scope control and it allows near real-time control of all settings.

*Nerpio, Albacete, Spain*

**BACKGROUND:** Comets spend most of their time in the dark and frozen outer reaches of the Solar System. However, when their orbits bring these mountain-sized chunks of ice and rock closer to the Sun, the heat and light work an amazing transformation. Ice evaporates and huge quantities of dust are ejected as the comet warms, forming a vast halo of gas and dust which streams away forming the comet's tail. As well as ice and dust, comets are rich in organic, carbon-based compounds. The prominent green glow in this image comes from carbon molecules which have been energized by the Sun's rays.

**Takahashi TOA-150 telescope; Paramount ME mount; 150mm lens; SBIG STL-11000M camera; f/7 lens; 16-minute exposure**

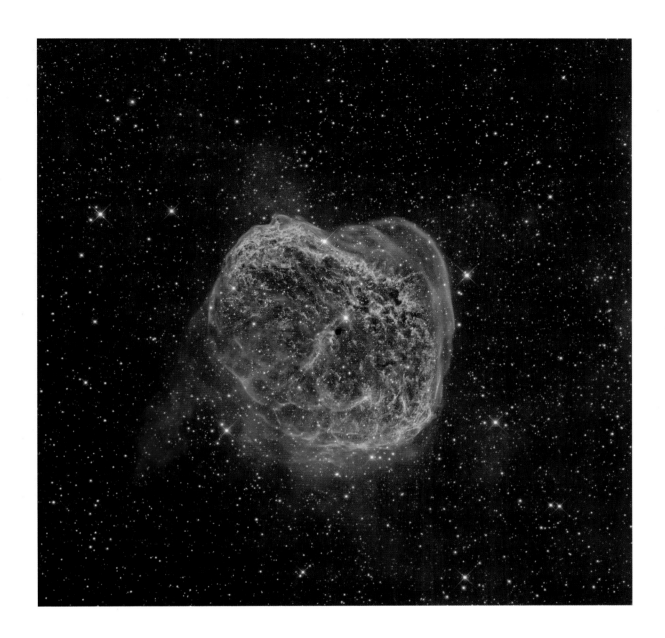

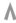

**MARK HANSON** *(USA)*

### NGC 6888
*[29 September 2013]*

**MARK HANSON:** The Crescent Nebula is an often imaged object so I wanted to do something special with it by going as deep as possible with the OIII filter. I used one hour exposures and was quite surprised at how much OIII was in this image. It almost overwhelms the H-alpha data. This is such a striking image, it seems quite 3D and just pops out at you. I had imaged the Crescent Nebula quite a few times before with different telescopes and cameras over the years. I remember looking back at the data when the 'Soap Bubble' was discovered and sure enough it was in my images, so you just never know what you will capture even when it's been imaged so frequently.

*Rancho Hidalgo, New Mexico, USA*

**BACKGROUND:** This colourful starscape reveals the intricate structure of the Crescent Nebula, a colossal shell of material ejected from a powerful but short-lived Wolf-Rayet star (WR 136), seen close to the image centre. After just 4.5 million years, this volatile star ballooned into a red giant some 250,000 years ago, losing about half its mass to space. Ultraviolet radiation and stellar wind from WR 136 now heat the billowing cloud, causing it to glow. Deep exposures with narrowband filters (H-alpha and OIII) bring out the complex shapes carved by the star, as its fierce winds slam into the surrounding gas.

**RCOS 14.5-inch f/8 Ritchey-Chretién telescope; Paramount ME2 mount, off-axis guided; Apogee U16M CCD camera; 26-hours total exposure**

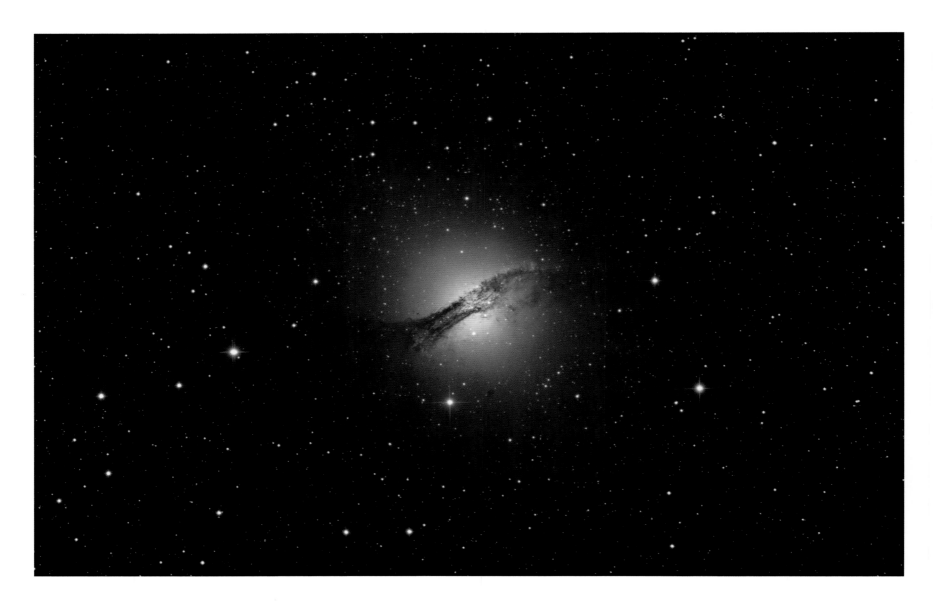

## ⋀

**LÁSZLÓ FRANCSICS** (*Hungary*)

### Centaurus A and Relativistic Jet
[*20 May 2013*]

**LÁSZLÓ FRANCSICS:** This unique galaxy went through a cosmic collision a million years ago. A look with a telescope shows signs of the former cataclysm: the active central black hole is still blowing high-temperature gas into intergalactic space. Using narrowband filters, not only are the central dust lane and the galactic halo revealed, but also the faint relativistic jet. The hot gases running out of the black hole area are cooled enough to become visible.

*Siding Spring Observatory, Coonabarabran, New South Wales, Australia*

**BACKGROUND:** Bright, and with a striking appearance (its peculiar nature specifically noted by John Herschel in 1847), Centaurus A is a popular target for amateur astronomers. At the same time, professional astronomers extensively study the radio and X-ray wavelength emissions from the relativistic jets, which extend for more than a million light years from the galactic nucleus.

**PlaneWave 20-inch Corrected Dall-Kirkham reflector; FLI-PL6303E CCD camera**

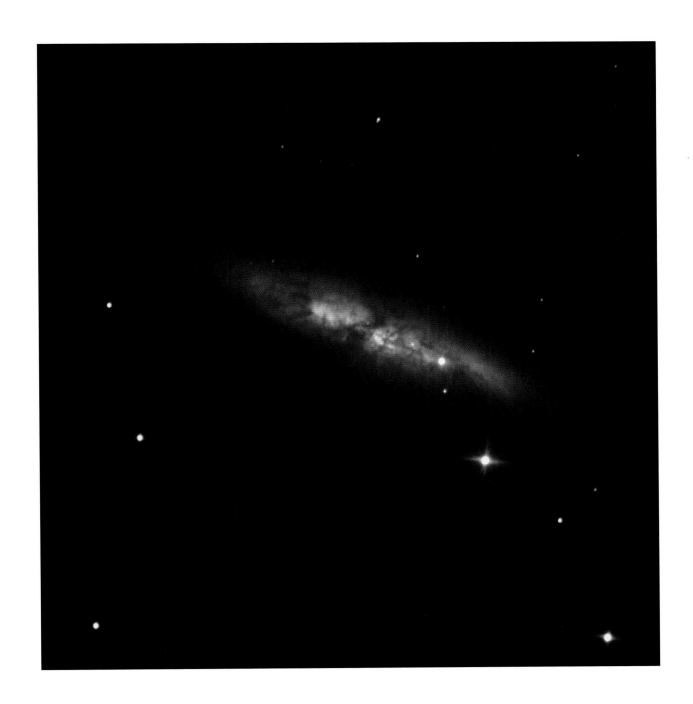

## BLAIRGOWRIE HIGH SCHOOL, S6 CLASS *(UK)*

### Supernova SN2014J in the Cigar Galaxy (M82)
*[24 January 2014]*

**BLAIRGOWRIE HIGH SCHOOL, S6 CLASS:** Another image submitted by Steven Wilkinson, teacher of Physics at Blairgowrie High School, this time on behalf of his S6 class of 17-year-old students. It was taken as part of an Advanced Higher Physics class and shows the supernova starburst to the right of the Galactic Centre. This image was also taken as part of the Faulkes Telescope Project.

*Haleakala Observatory, Hawaii, USA*

**BACKGROUND:** Many robotic telescopes like the Faulkes Telescope now give teachers the unique opportunity to use them in classes to remotely photograph whatever sparks their interest. This means that school groups can now work on collaborative projects that use real data, and they can explore the Universe without leaving the classroom. The results of working in this way, as shown in this image, can be truly exquisite.

**Faulkes Telescope North; 2m lens; CCD chip camera**

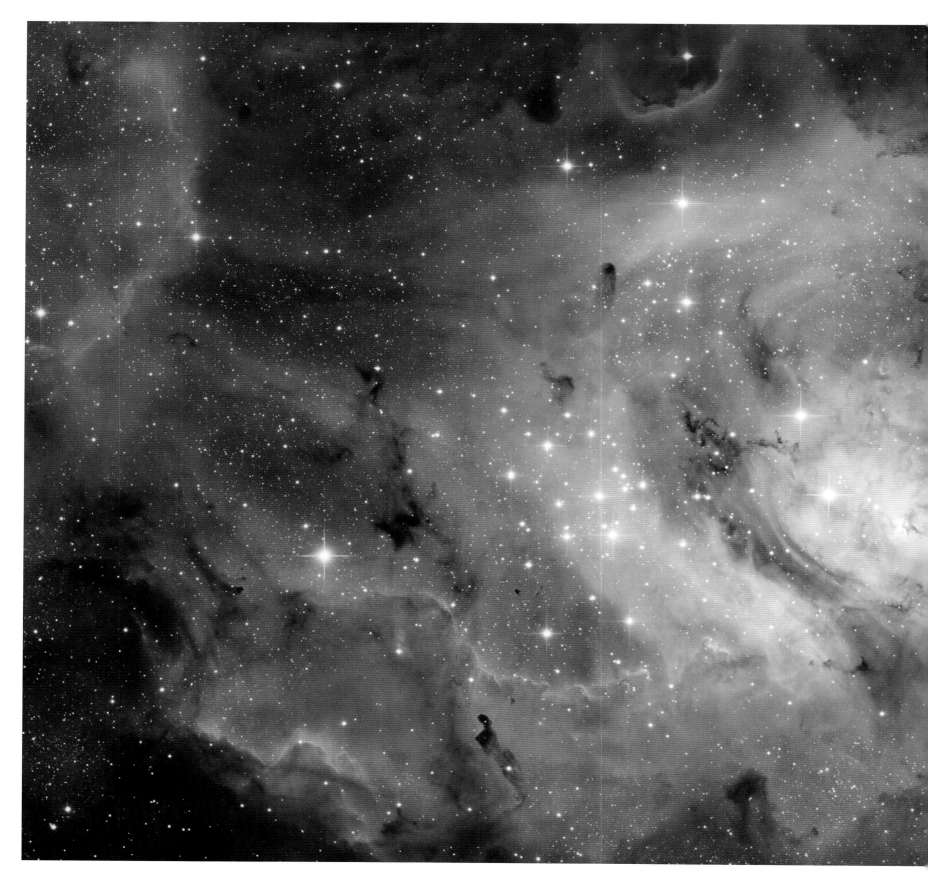

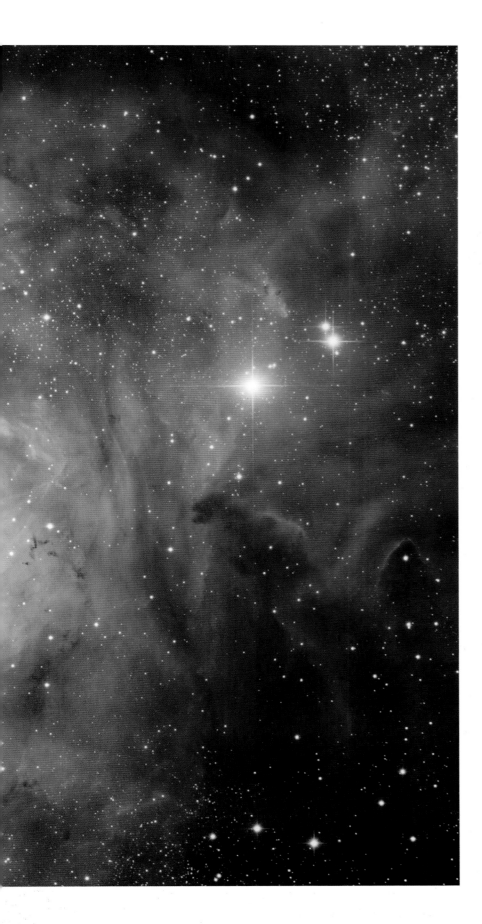

&lt;

## LÁSZLÓ FRANCSICS *(Hungary)*

### The Morphology of the Lagoon Nebula
[*22 May 2014*]

**LÁSZLÓ FRANCSICS:** The Lagoon Nebula is well known for its oval form, crossed with a dark gas and dust stream, surrounded by young star clusters. However, when capturing it with a 0.5m aperture telescope, in good seeing conditions, smaller details are revealed. Thousands of gas filaments, dark globules containing protostars, and huge mountains of hydrogen clouds are visible. It is the thousands of undiscovered details that make the Lagoon Nebula even more interesting.

*Siding Spring Observatory, Coonabarabran, New South Wales, Australia*

**BACKGROUND:** The discovery of this giant stellar nursery dates back to the earliest days of modern astronomy and is often attributed to Giovanni Hodierna in the seventeenth century. Despite being thousands of light years away, its enormous size – over 100 light years wide – makes it highly conspicuous in binoculars and telescopes, seen roughly in the same apparent part of the sky as the centre of the Milky Way. The vivid pink colour, not visible to the eye but clear in this long exposure image, is characteristic of atomic hydrogen gas being ionized by the intense radiation of young stars.

**PlaneWave 20-inch Corrected Dall-Kirkham reflector; FLI-PL6303E CCD camera**

# ASTRONOMY PHOTOGRAPHER

## OF THE YEAR 2014

# BEST
# NEWCOMER

Photos by people who have taken up
astrophotography in the last year and
have not entered the competition before

> 

## CHRIS MURPHY *(New Zealand)*

### Coastal Stairways
*[1 November 2013]*

**CHRIS MURPHY:** This was my first night of shooting dedicated to astrophotography. I drove from Wellington, New Zealand, to the Wairarapa district. There are some amazing rock formations there and I knew they would make great foregrounds. Conditions were perfect, with no light pollution and a super clear, crisp night.

*Wairarapa, New Zealand*

**BACKGROUND:** Deep time seems to be the subliminal message of this moody scene, with each layer of the foreground rocks recording thousands of years of geological history. Meanwhile, in the sky, time and distance are inextricably entwined, as the light from the stars takes decades, centuries or even millennia to reach us across the immense gulf of space.

**Nikon D600 camera; 14–24mm f/2.8 lens at 17mm; ISO 3200; 20-second exposure**

*"It's the colours that make this image stand out for me. I also love the way the Milky Way lines up with the strata in the rock formations."*
MAREK KUKULA

*"A great blend of colours here. Good detail in the Milky Way and an overall highly pleasing composition."*
PETE LAWRENCE

*"The riot of stars dancing above this rocky canopy falls within a sumptuously photographed sky. A triumph."*
MELANIE GRANT

*"The dark clouds of dust that streak through the Milky Way provide a pleasing contrast to the stark foreground in this image."*
CHRIS LINTOTT

*"A deeply dark sky site reveals stunning detail in the Milky Way, including a touch of greenish airglow – the faint illumination of Earth's atmosphere."*
CHRIS BRAMLEY

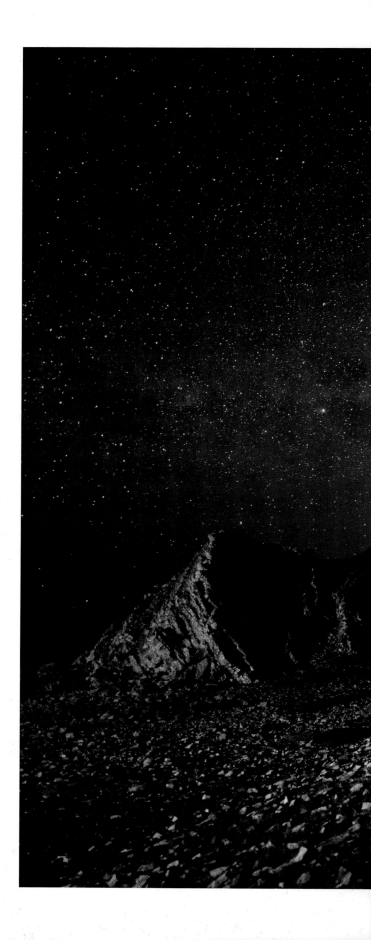

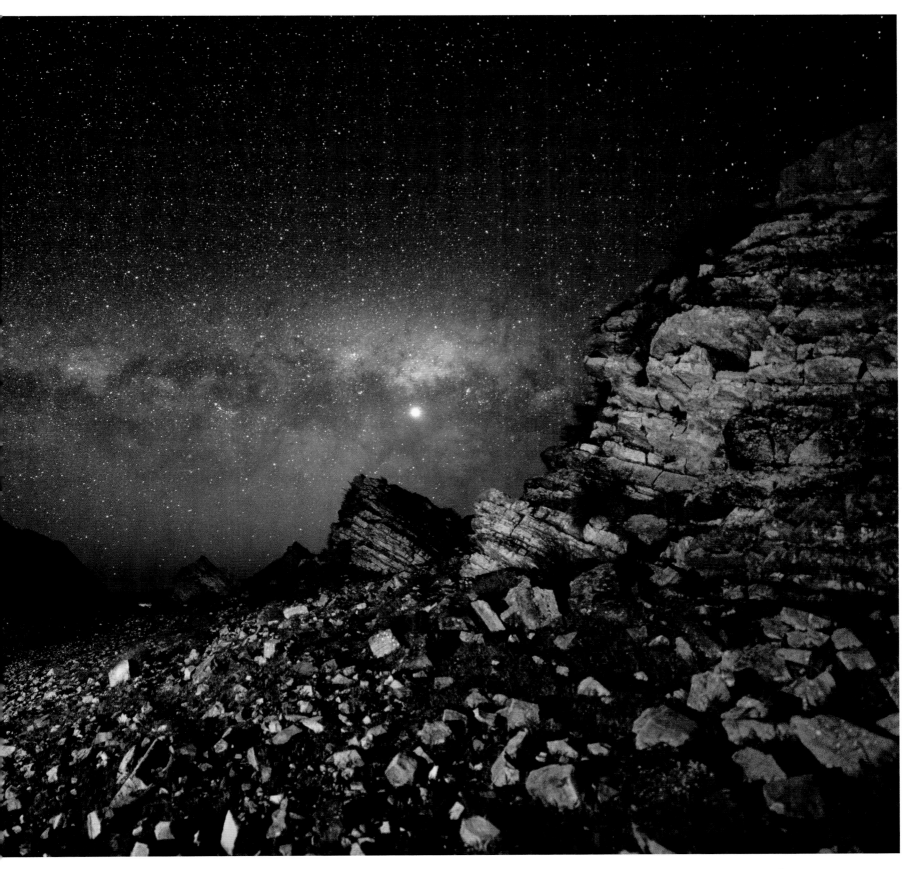

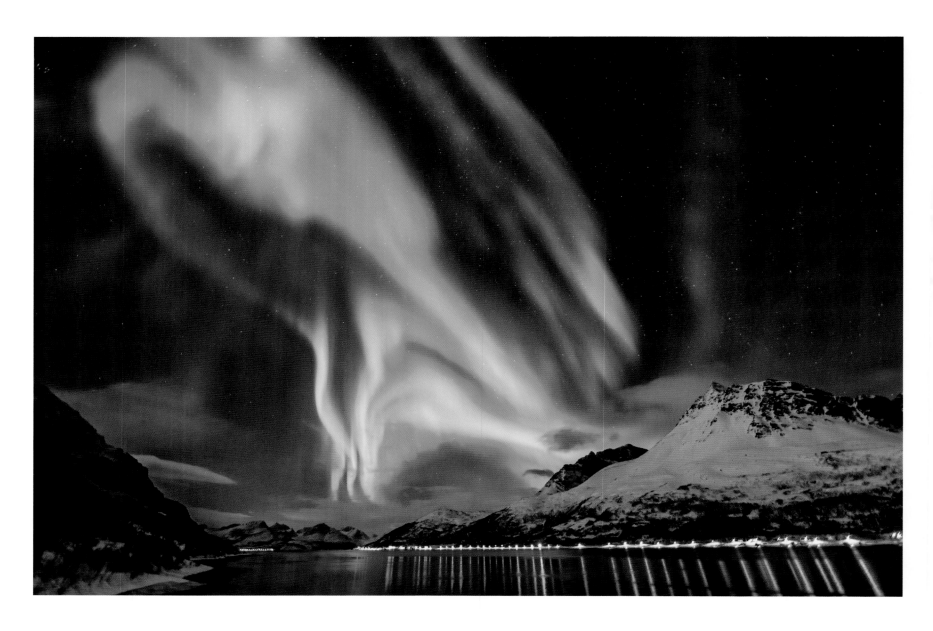

Λ

## CLAUS POSSBERG *(Germany)*

### Celestial Dance
*[16 February 2013]*

**CLAUS POSSBERG:** On that night I was dozing in my car, plagued by a severe flu and high fever. Suddenly I saw a greenish light through my closed lids. I opened my eyes and was amazed by the spectacular Northern Lights that were unfolding over the fjord. For the rest of the long night I forgot my discomfort, only the *Aurora Borealis* was present for me.

*Skjervøy, Troms, Norway*

**BACKGROUND:** The hallucinogenic intensity of this spectacular auroral display seems to reflect the photographer's feverish state. The vivid colours are produced at various altitudes by different atmospheric gases, with blue light emitted by nitrogen and green by oxygen. Red light can be produced by both gases, while yellows, pinks and purples occur where the various colours mix and overlap.

**Canon 5D Mk III camera**

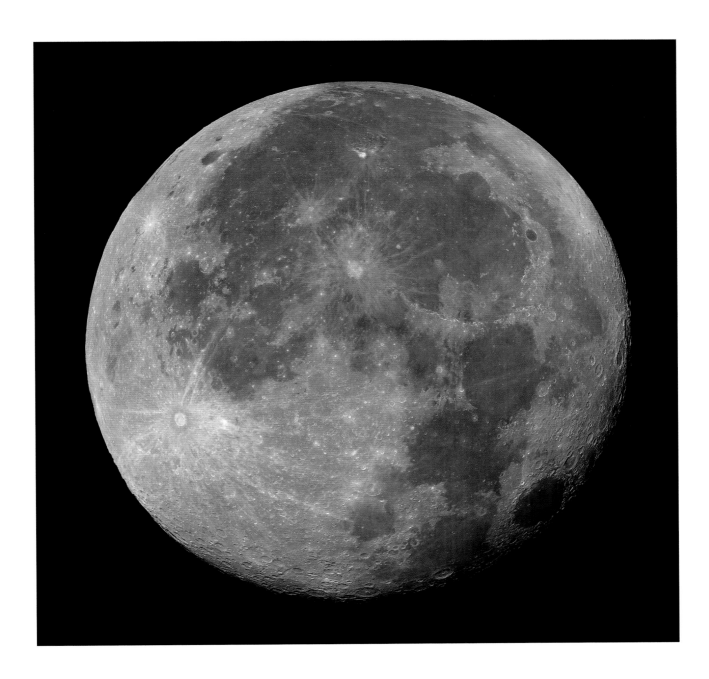

## Λ

### ALEXANDRE BOUDET *(France)*

**99%**
[*17 March 2014*]

**ALEXANDRE BOUDET:** I have dreamed for 20 years of taking pictures of the night sky. I have read hundreds of books and magazines about astronomy but as a photographer I longed to capture it. After a few months of research I finally decided to buy some astronomy gear. I had to adapt my Nikon camera, and spent every clear night since September 2013 practising and experimenting. This is my first attempt at capturing a picture of the Moon: the image was created using 28 videos – each two minutes long, shot at 30 frames per second – which were then stacked.

*Châteauneuf-sur-Cher, Centre, France*

**BACKGROUND:** Here '99%' refers to the fraction of the Moon's near side that is being illuminated by the Sun, showing our natural satellite in almost complete daylight. The Moon's phase is just a fraction past being full, but already the oncoming night can be seen creeping across the lunar globe from the lower right. As the shadows lengthen, the craters and mountains are thrown into stark relief before being plunged into two weeks of darkness.

**Orion 12-inch Newtonian telescope; Orion Atlas EQ-G mount;
2x TeleVue Powermate lens; Nikon D4 camera; 1.7x Nikon Teleconverter lens;
4080mm f/16 lens; ISO 400**

## DANIELE MALLEO *(USA)*

### The Crescent Nebula in H-alpha and OIII (NGC 6888)
*[8 November 2013]*

**DANIELE MALLEO:** The Crescent Nebula (also known as NGC 6888, Caldwell 27 and Sharpless 105) is an emission nebula in the constellation Cygnus, about 5000 light years away. It is formed by the fast stellar wind from the Wolf-Rayet Star WR 136 (HD 192163), colliding with and energizing the slower moving wind ejected by the star when it became a red giant around 250,000 to 400,000 years ago.

*El Cerrito, California, USA*

**BACKGROUND:** WR 136 is very close to the end of its life. Having 'puffed off' its outer layers into space, it now burns recklessly, poised to explode as a spectacular supernova, perhaps within the next 100,000 years. Fortunately it lies a great distance from our solar system, and presents no danger to Earth. Such an explosion will scatter 'metals' (in astronomy, elements heavier than helium) into the galaxy, perhaps seeding a new generation of solar systems.

**Celestron 8-inch Edge HD telescope; Astro-Physics Mach 1 mount, off-axis guided with Starlight Xpress SXV Lodestar and SXV-AO-LF Adaptive Optics unit; QSI 583 WSG camera; 2032mm f/10 lens; 18-hours total exposure**

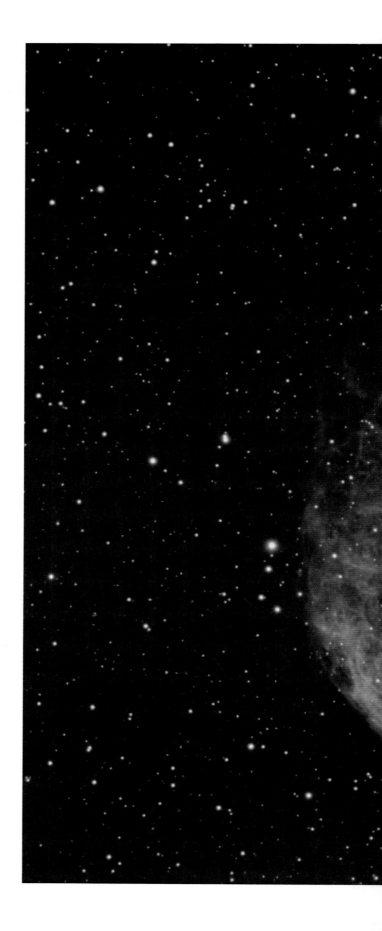

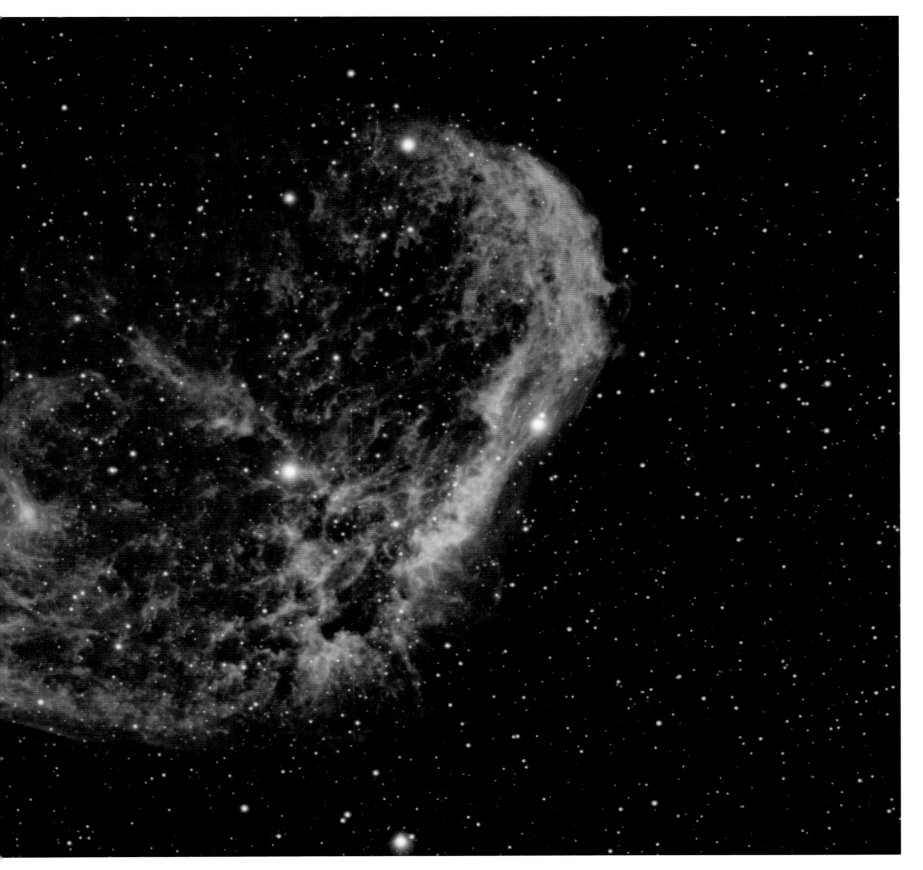

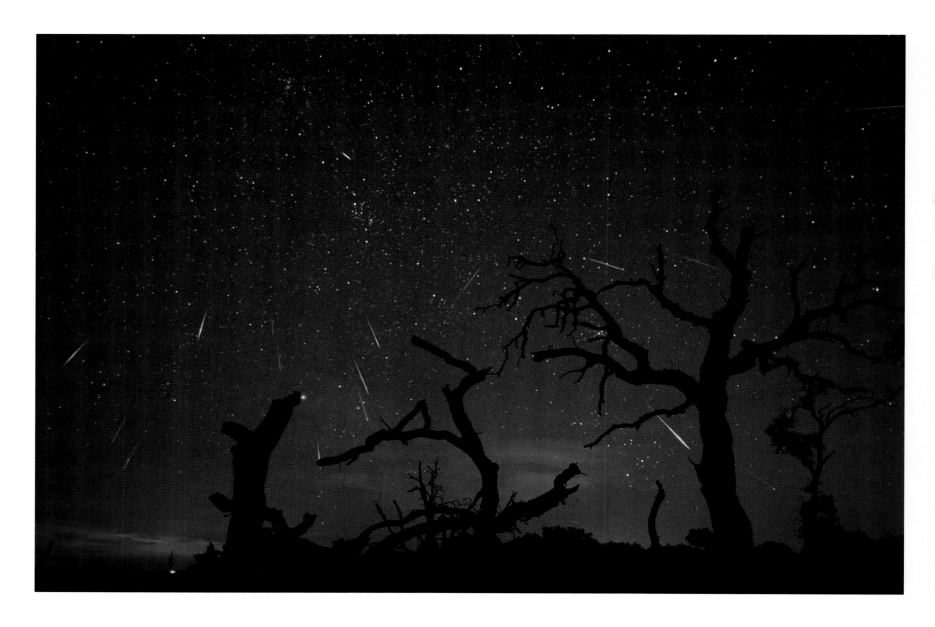

## MARK EZELL (USA)

### Raining Perseid Meteors
[*12 August 2013*]

**MARK EZELL:** I had become interested in astronomy earlier that year, after accidentally capturing meteor showers while taking long exposure night shots. At that time, I was new to astronomy so I had no idea that a meteor and shooting star are basically one and the same thing, but after making a dedicated effort to photograph Comet Panstarrs in March 2013, the research floodgates opened. This is an image of the Perseid meteor shower from August 2013; it was a composite shot from the night. The leafless dead oak trees are victims of the Texas drought and the meteors resemble the desperately needed raindrops.

*Lometa, Texas, USA*

**BACKGROUND:** Here, the drama of an entire night of shooting stars is encapsulated in a single frame. The Perseid shower is one of the most reliable and spectacular annual meteor displays. It occurs as the Earth passes through a stream of dust ejected by comet Swift-Tuttle. The dust particles that burn up high in our atmosphere produce streaks of light that appear to be radiating from the constellation of Perseus – hence the shower's name.

**Canon 5D Mk II camera; 24mm f/1.8 lens; ISO 1600; 15-second exposure**

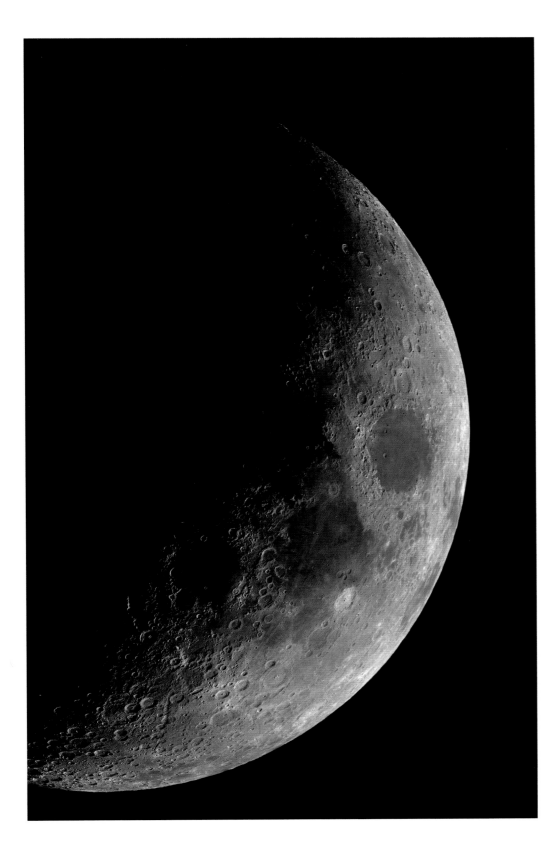

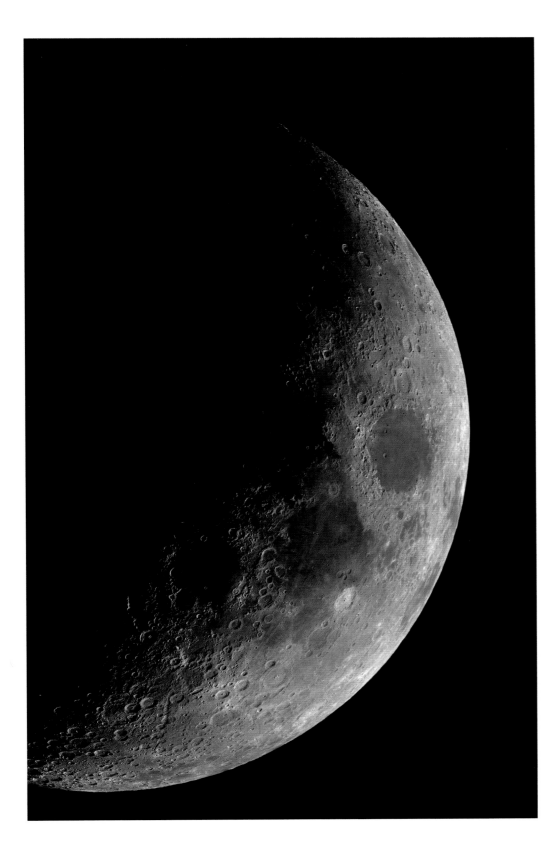

## MICHAEL SCHMIDT (*Austria*)

### Moon Mosaic
[*6 January 2014*]

**MICHAEL SCHMIDT:** I recorded 48 single videos of the Moon at the highest possible resolution my QHYCCD webcam could achieve. I used my 10-inch standard Sky-Watcher Newton telescope and a small Barlow lens. All those videos then had to be processed, which took my seven-year-old PC almost 40 hours! All 48 files were checked individually, and then stacked to create a final mosaic of the Moon.

*Jennersdorf, Burgenland, Austria*

**BACKGROUND:** Captured in incredible detail, this waxing crescent Moon clearly shows two of the dark patches on its surface that we call the *maria* or seas. The one visible at centre right is the Sea of Crises while below and to the left of this is the Sea of Fertility. At the southern edge of the latter sea you can spot the huge, bright crater Langrenus. This crater may appear narrow from our perspective but is in fact 132km in diameter.

**Sky-Watcher 254/1200 Newtonian telescope; EQ6 Pro mount; QHYCCD 5L-II colour camera; 3200mm f/13 lens; 1/83-second exposure**

<

## PAUL MOORE *(UK)*

### Orion's Constellation over Kilbeacanty
*[17 February 2014]*

**PAUL MOORE:** I have been an amateur photographer for a few years and I love low-light work. That said, astrophotography has always eluded me. I have always marvelled at the work others produce in this field and thought to myself, 'someday I'll do that', but light pollution where I live in Essex allows little opportunity. So, while staying with my in-laws in rural Ireland, I had a rare chance to photograph the stars in their full glory. This image is a single shot taken on a night where I had a brief window of clear skies. I set a high ISO, focused to infinity, and, using a shutter release I took several shots. I was lucky because 30 minutes later a fog descended, stopping play. I am pleased with the result as it shows Orion clearly. I definitely have the bug now and will return to Ireland in August 2014.

*Kilbeacanty, County Galway, Ireland*

**BACKGROUND:** This shot seems to capture perfectly the way our eyes perceive the night sky, without the intervention of telescopes, filters or image enhancement. The constellation of Orion the Hunter, with his famous belt of three bright stars, stands aloof from the lights of the town on the horizon – a familiar sight for winter stargazers across the Northern Hemisphere.

**Canon 50D camera; 17mm f/7.1 lens; ISO 3200; 13-second exposure**

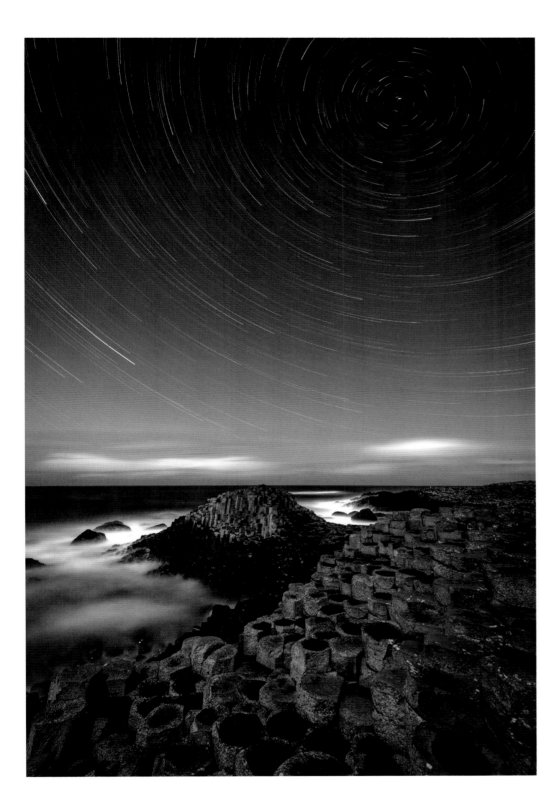

## ROB OLIVER *(UK)*

### A Giant's Star Trail
[10 *January 2014*]

**ROB OLIVER:** A composition of several images taken at the Giant's Causeway in Northern Ireland. I initially went looking for the Northern Lights, but while waiting I set about capturing a set of images that I would later merge together to get some star trails. The aurora never appeared but I was more than happy with the results of my night's work.

*Giant's Causeway, County Antrim, Northern Ireland*

**BACKGROUND:** A familiar Irish landmark is transformed into a scene of contrasting geometries, evoking classical notions of the division between Heaven and Earth and highlighting processes on both astronomical and microscopic scales. Above, our planet's rotation draws the stars out into circles – considered to be the most perfect shape by ancient philosophers. Meanwhile, separated from the sky by the sharp line of the horizon, the atomic symmetries of crystallized rock manifest themselves in the hexagonal columns of the Giant's Causeway.

**Nikon D800E camera; 14mm f/5.6 lens; ISO 400; multiple 5-minute exposures**

## YANNAN ZHOU *(China)*

### Qinghai Lake Before Dawn
[*12 August 2013*]

**YANNAN ZHOU:** After stargazing for the whole night, I stood beside the Qinghai Lake waiting for dawn. The winter stars were just rising, and the bright light on the ground is from the Jiangxigou village.

*Qinghai Province, China*

**BACKGROUND:** Anyone who has stayed up all night to enjoy the stars will recognize the emotions evoked by this tranquil scene in the moments before sunrise. Orion the Hunter seems to recline above the horizon as the stars prepare to give way to the approaching daylight.

**Canon 5D Mk III camera**

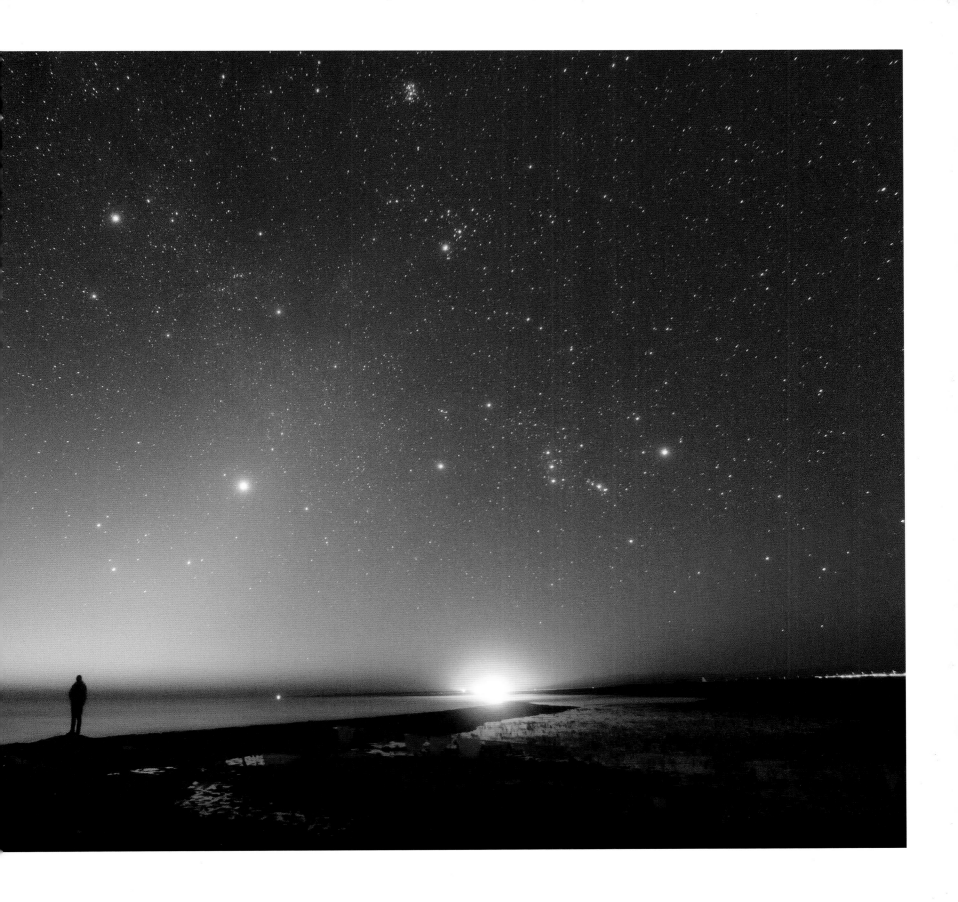

# ASTRONOMY
# PHOTOGRAPHER
## OF THE YEAR 2014

# YOUNG
# ASTRONOMY
# PHOTOGRAPHER
# OF THE YEAR

Photos by people under 16 years of age

## SHISHIR & SHASHANK DHOLAKIA
*(USA)*, AGED 15 — *WINNER*

### The Horsehead Nebula (IC 434)
*[24 November 2013]*

**SHISHIR & SHASHANK DHOLAKIA:** The famous Horsehead Nebula is arguably one of the most recognizable deep space celestial objects. This image comprises the dark nebula (Barnard 33), the surrounding red emission nebula (IC 434), and the Flame Nebula (NGC 2024). We used our father's equipment to take the image during our first trip to remote Lake San Antonio.

*Lake San Antonio, California, USA*

**BACKGROUND:** This is a superb image of the Horsehead Nebula. It shows clearly the well-known red glow that appears to come from behind the horsehead. This glow is produced by hydrogen gas that has become ionized by neighbouring stars. The image draws particular attention to the cloud of heavily concentrated dust within the horse's head, which appears in silhouette as it blocks the light from behind.

**Astro-Tech 111mm f/7 triplet refractor; Orion Atlas EQ-G mount; SBIG ST-8300M camera; varying exposure times**

*"The star colours are beautifully controlled in this image. The detail in the horse's head and the Flame Nebula are particularly good, too."*

WILL GATER

*"There's great balance in this image of the famous Horsehead Nebula, between the reds being given off by excited hydrogen atoms, the blues of the nebulae which reflect light best at that wavelength, and the bright light of the star to the left of the image, which is located in the belt of that familiar constellation, Orion."*

CHRIS BRAMLEY

*"The Horsehead Nebula is one of the most photographed deep space sights, yet this shot sets itself apart from others. It skillfully contrasts the sharpness of the stars with the subtle hues of the dust and the surrounding dark opacity. I like the idea of talent running in a family and siblings collaborating on a beautifully crafted work of art. It brings to mind the example of famous forebears, like the Carracci in Renaissance Italy, or, closer to us, Jane and Louise Wilson."*

MELANIE VANDENBROUCK

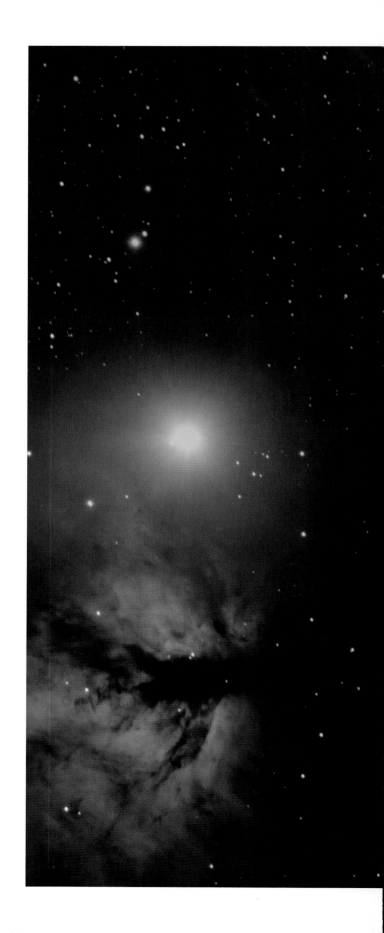

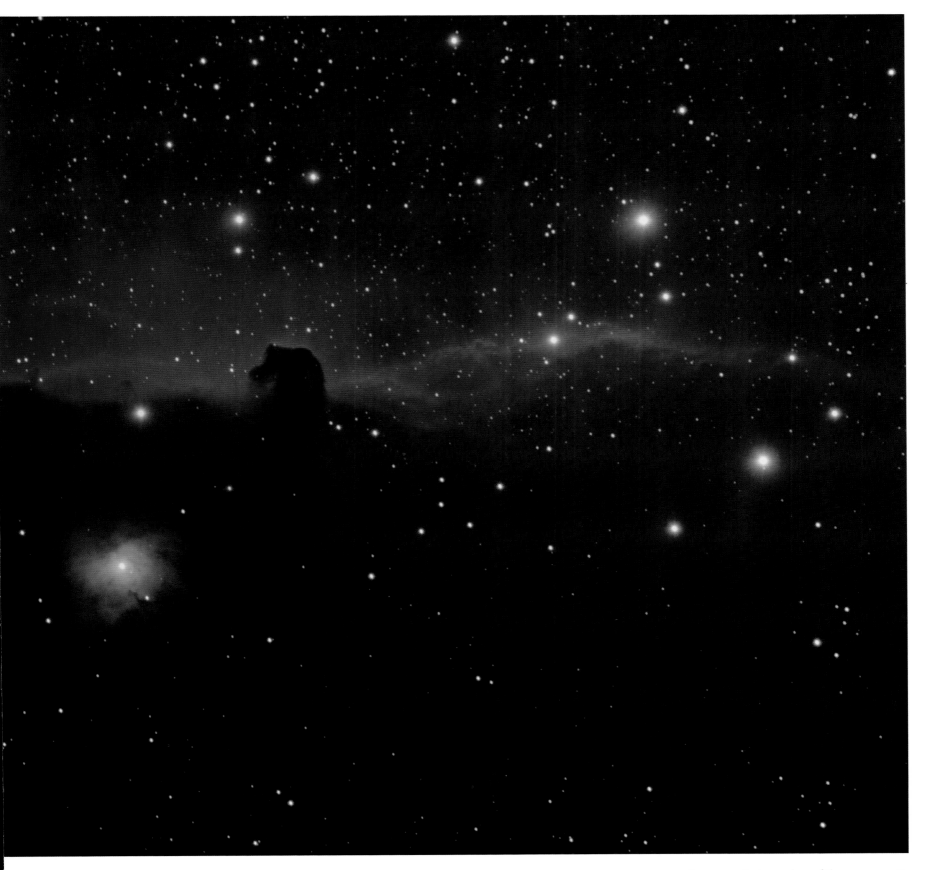

Λ

**EMILY JEREMY** *(UK)*, AGED 12          *HIGHLY COMMENDED*

*Wigan, Greater Manchester, UK*

## Moon Behind the Trees
[*15 April 2014*]

**EMILY JEREMY:** One night I was gazing out at the stars when I noticed how beautiful and radiant the Moon was looking. I live in urban north-west England so it is not often you get such a spectacular view of it. I had recently bought a new bridge camera with a very good zoom, so I thought I would see if I could capture the beautiful essence of our satellite. The Moon was behind some trees and it was almost as if some of the branches were creeping up across its surface. I have always been fascinated by the Moon's pristine beauty so I thought this would be a great time to take a picture of it.

**BACKGROUND:** Earth's nature and its satellite seem to have merged into one another in this picture. Using relatively basic equipment to striking compositional and aesthetic results, this photographer uses the Moon as a backdrop to frame her subject. This silhouetted effect recalls early glass plates of the Moon, or camera-less photography, where shadows are fixed on light-sensitive surfaces.

**Kodak Pixpro AZ521 camera; 222mm f/6.4 lens; ISO 800; 1/340-second exposure**

*"For me, this photo captures the beauty and mystery of the night sky. The more we learn about the Universe, the more awe-inspiring it seems."*
MAREK KUKULA

<

**GABRIEL TAVARES** *(Brazil)*, AGED 14

### Jupiter from my Back Yard
*[18 January 2014]*

**GABRIEL TAVARES:** I took the photo using a telescope with 150mm aperture and 1000mm focal length. It was obtained from the stacking of about 1500 frames. The mounting of my telescope isn't motorized, so when I took this photo, I had to guide it manually to follow the Planet. Even with all the difficulties of my equipment, I was very happy with the result, since it is always a challenge to get a good picture of this planet.

*Rio Negrinho, Santa Catarina, Brazil*

**BACKGROUND:** This image reminds us why Jupiter is such a popular target for photographers the world over. Jupiter has a very fast rotation period of once every ten hours, which means clouds get swept into beautiful bands by the strong jet streams. It was not known that Jupiter had rings similar to those of neighbouring Saturn until the visit of NASA's *Voyager 1* in 1979. Jupiter remains a planet with many unsolved mysteries.

**Sky-Watcher telescope; EQ3-2 mount; Barlow GSO 3 x lens; ASI120MC camera; 1000mm f/6.6 lens**

> 

**EMMETT SPARLING** *(Canada)*, AGED 15

## Milky Way over Bowen Island
[*31 December 2013*]

**EMMETT SPARLING:** I had just saved up and bought a new Sigma camera lens. I decided to try it out under the night sky, and after one or two pictures I discovered how awesome it really is. I could see things in the photos I was taking that I couldn't detect with my naked eye. By using a low f-stop and high ISO I was able to capture the Milky Way and see it in a way that wasn't possible for me before.

*Bowen Island, British Columbia, Canada*

**BACKGROUND:** As exceptional as our eyes are they struggle to see the Milky Way in places with high levels of light pollution so it often remains hidden from view. This image highlights the concealed gems that can be discovered if the correct equipment and skill are used, revealing the beauty of our home galaxy.

**Canon 7D camera; 18mm f/1.8 lens; ISO 1000; 30-second exposure**

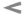

**EMMETT SPARLING** *(Canada)*, **AGED 15**      *RUNNER-UP*

### New Year over Cypress Mountain
*[31 December 2013]*

**EMMETT SPARLING:** On New Year's Eve 2013, my little brother and I climbed on to our friend's roof on Bowen Island in order to get a clear view across Howe Sound. It was a new Moon that night so there was almost no extra lunar light pollution. This long exposure was taken at midnight, as 2013 changed to 2014. One year finishing, another beginning.

*Bowen Island, British Columbia, Canada*

**BACKGROUND:** The juxtaposition of the tranquil lake and hills with the apparent circular movement of the stars in the sky around a central point (the Pole Star) adds a beautiful contrast to this image. Looking closely at the light coming from each of the stars we can see different colours, which are extremely useful to the scientists who study them. The different coloured light can tell us about what stage of life stars are at; they could be young, hot blue stars or older red stars nearing the end of their life.

**Canon 7D camera; 18mm f/1.8 lens; ISO 100; 439-second exposure**

*"A lovely scene. This would be the perfect view from a bedroom window!"*
MAREK KUKULA

*"This is a very sophisticated shot, with a melancholy mood to it. It reminds me of the work of some of the greatest contemporary photographers, someone like Todd Hido, in how the soft urban lights and delicate star trails shine against the atmospheric mist. Strikingly beautiful."*
MELANIE VANDENBROUCK

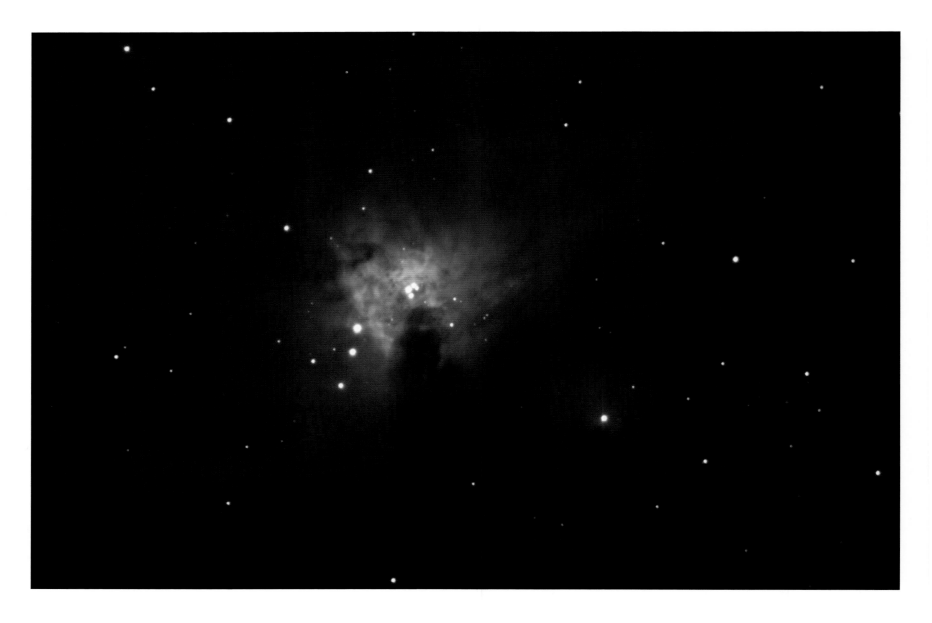

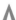

## JACOB MARCHIO *(USA)*, AGED 15

### Nebulous Beauty
*[27 February 2014]*

**JACOB MARCHIO:** The Orion Nebula, or M42, is a beautiful and bright nebula to observe. This was my first serious attempt at nebula astrophotography; I was happy with the colours that I captured in the exposure.

*Opelika, Alabama, USA*

**BACKGROUND:** The Orion Nebula is a fabulous target for astronomy photographers as it can even be seen with the naked eye, appearing just beneath the three stars of Orion's Belt as a hazy patch of sky. Nebulae can be thought of as stellar nurseries where new stars are formed. They are incredibly dynamic places, a characteristic that this image seems to capture beautifully.

**Celestron C9.25 telescope; Celestron CGEM mount; Nikon D3100 camera; 2350mm f/10 lens; ISO 800; 25-second exposure**

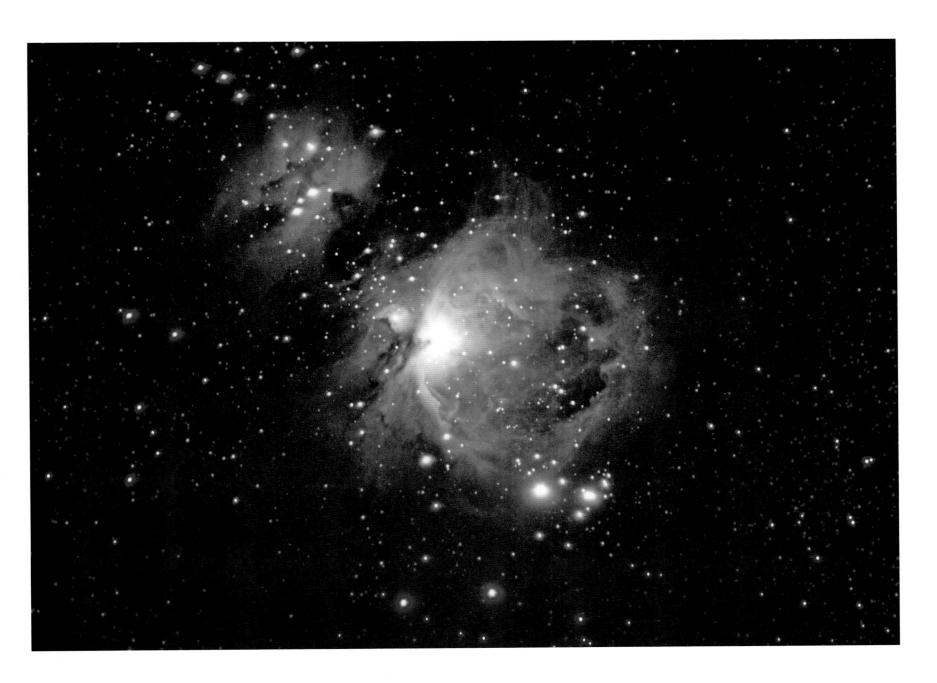

**GRAY OLSON** *(USA)*, AGED 15

### The Great Orion Nebula
[*22 January 2014*]

**GRAY OLSON:** The Orion Nebula (also known as Messier 42, M42 or NGC 1976) is a diffuse nebula situated south of Orion's Belt in the constellation of Orion. It is one of the brightest nebulae, and is visible to the naked eye in the night sky. M42 is located at a distance of about 1350 light years and is the closest region of massive star formation to Earth. It is one of the most popular targets for amateur astronomers because of how bright it is, as well as the great detail that can be seen in its 'wings'.

*Ajo, Arizona, USA*

**BACKGROUND:** For many decades the Orion Nebula has been studied in great depth to investigate how new stars are formed. Within the nebula it is possible to find stars of different ages and at various stages of their lives. This image is a beautiful reminder of how much there remains to discover about this intriguing and fascinating object.

**Canon 7D camera; modified Celestron 4SE mount; Canon 70-200mm f/2.8 IS II lens; ISO 2000; 10-second exposure**

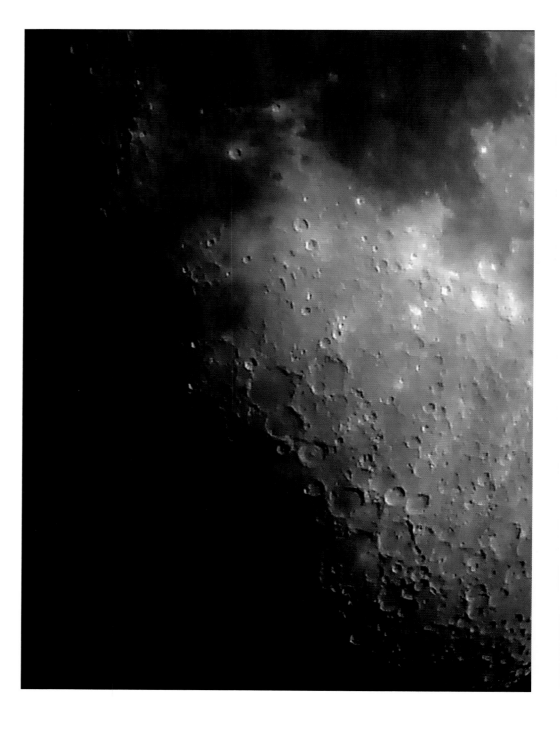

## HARRY ASPREY *(UK)*, AGED 13

### The Line Between Day and Night
*[8 April 2014]*

**HARRY ASPREY:** I took this in my garden on a moonlit night using my webcam eyepiece to take a 15-second video. I'm happy with all the craters that have come out and the visibility of the lunar Apennines at the top. It displays the craters Arzachel, Alphonsus and Ptolemaeus with others all along the terminator, a striking difference between day and night, plus dark *maria* above. I'm more than satisfied with this image and will continue to take close-ups like this in the future, maybe when the Moon is in a different phase.

*Camberley, Surrey, UK*

**BACKGROUND:** This image was taken during the Moon's first quarter phase. It would be another 29.5 days before the Moon is lit up in the same way again. A prominent crater on the terminator is the smallest of the three craters that chain together one on top of the other. This one, called Arzachel, is home to a central mountain peak that stretches 1.5km high from the crater floor.

**Celestron PowerSeeker 70AZ telescope; 70mm objective;
Orion StarShoot USB Eyepiece Camera II**

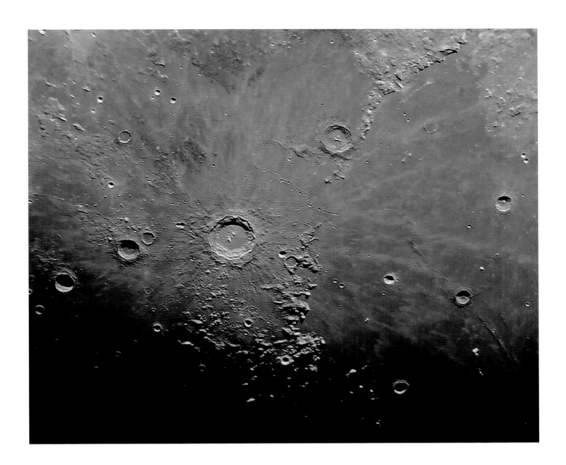

## JACOB MARCHIO (USA), AGED 15

### Crater Copernicus
[*9 April 2014*]

**JACOB MARCHIO:** This is a photo of the crater Copernicus. There are many other interesting features though; some of Montes Carpatus is visible as well other craters and craterlets.

*Opelika, Alabama, USA*

**BACKGROUND:** The rugged crater Copernicus is 93km across and is a relatively recent impact on the Moon. The white rays surrounding the crater indicate that the impact ejected the lunar soil at high speed, spreading material for more than 800km around the impact site, just like a stone dropped into a basin of flour. This image vividly displays the walls of Copernicus and its fellow craters through light and shadow seen close to the terminator.

**Celestron C9.25 telescope; Celestron CGEM mount; 235mm objective; Nikon D3100 camera; 5875mm f/25 lens**

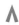

## SHISHIR & SHASHANK DHOLAKIA (USA), AGED 15

### The Leo Triplet
[*30 December 2013*]

**SHISHIR & SHASHANK DHOLAKIA:** A striking triad of galaxies in the constellation Leo, these three gravitationally bound spiral galaxies are stunningly contrasted in their proximity to each other. These galaxies, M66, M65 and NGC 3628, are a perfect example of the multitude of shapes and sizes of galaxies in the cosmos. My twin brother and I decided to take this image on our second camping trip to Lake San Antonio in the wee hours of the morning, just as we noticed the magnificent Leo rising. We used our father's equipment to take the photo, and we used PixInsight to post-process the images.

*Lake San Antonio, California, USA*

**BACKGROUND:** Although these galaxies are of the spiral variety, each one offers a different perspective. M66 is seen 'face-on', M65 is seen at an oblique angle and NGC 3628 is seen 'edge-on'. With multiple exposures using four filters, the astrophotographers obtained a crisp, clear image of the trio so that each is a visual treat when inspected up close. The light from these galaxies has had a journey of 35 million years.

**Astro-Tech 111mm f/7 triplet refractor; Orion Atlas EQ-G mount; SBIG ST-8300M camera; 8 x 900-second exposures (L) and 5 x 600-second exposures (RGB)**

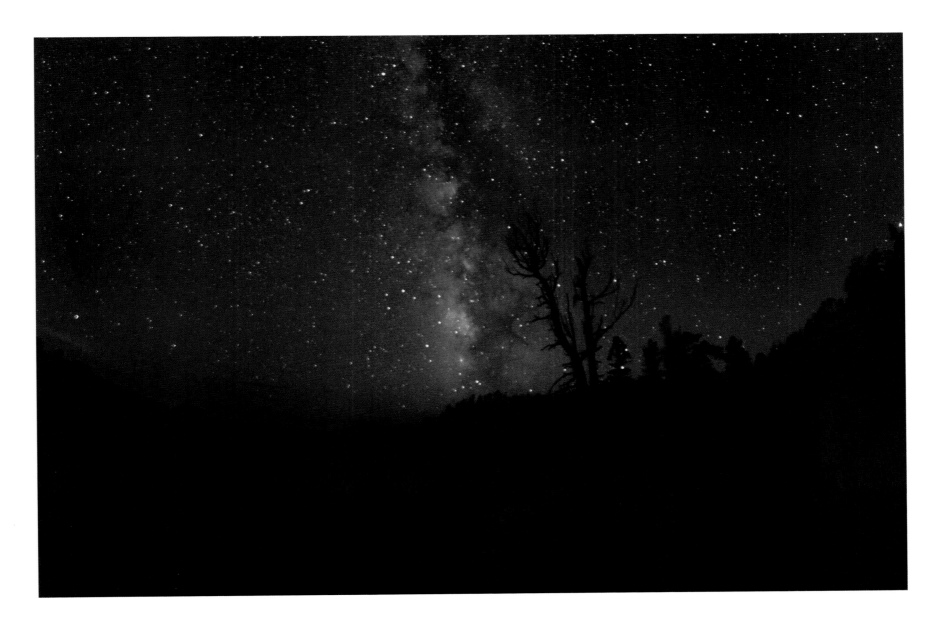

## Λ

**TOM OLIVER** *(UK)*, AGED 14

### Midnight Sky
*[5 August 2013]*

**TOM OLIVER:** This shot required an early night to fit in a quick nap before waking at around 11.00pm to drive the short journey up into Bryce Canyon with my brother. It was at least a 20-minute drive before we found somewhere to set up the tripods. Two brothers, two cameras, surrounded by miles of scrubby desert under an amazing sky. Arriving back at our motel we were careful not to wake the others. While they slept I was out capturing the Milky Way.

*Bryce Canyon National Park, Utah, USA*

**BACKGROUND:** This serene image of the Milky Way stretching overhead shows how freely the galaxy reveals its stellar population in a long exposure. If this was a shot taken in or near an urban area instead of the wonderful setting of Bryce Canyon, the image would be awash with the orange haze of light pollution.

**Canon 1100D camera; ISO 3200; 30-second exposure**

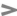

## OLIVIA WILLIAMSON (UK), AGED 10

### The Plain Face of Jupiter
[19 January 2014]

**OLIVIA WILLIAMSON:** I remember my dad making a last-minute decision to delay going back to work on the Sunday evening as he was working away during weekdays. Dad placed the equipment in the garden and then I took control and polar-aligned it before slewing to Jupiter. I got the camera all set up and when the picture was displayed on the screen I was amazed to see how clear the image was. I remember feeling excited and my dad told me that this was the clearest we had seen it. I captured the RGB videos and then we went back into the warmth of the house as it was a very cold January night. I immediately started the processing and this was the result.

*Winchester, Hampshire, UK*

**BACKGROUND:** This amazing planet has an atmosphere made mostly of hydrogen and helium, which is quite similar to the composition of the Sun. Gas giant planets like Jupiter are so massive that they generate their own heat deep beneath the clouds but, unlike the Sun, they aren't quite massive enough to sustain the nuclear reactions which would allow them to shine. For this reason Jupiter is sometimes called a 'failed star'.

**Celestron C8 telescope; Sky-Watcher AZ-EQ6 mount; DMK 21.618 camera; f/25 lens**

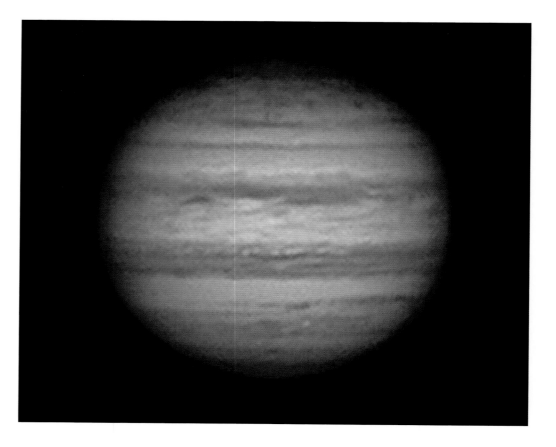

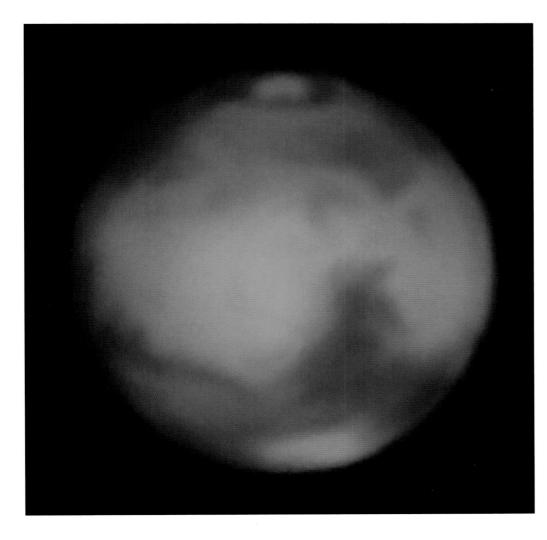

<

## OLIVIA WILLIAMSON *(UK)*, AGED 10    *HIGHLY COMMENDED*

### The Martian Territory
*[18 April 2014]*

**OLIVIA WILLIAMSON:** This was one of the last times that my dad and I got out before he had to leave the UK for his work. We were watching the weather reports all day and finally we went ahead and set up. I remember that it was a late night as Mars was so low in the sky. Around 10:30pm I started the video sequences. Once completed I left my dad to pack up whilst I went to bed (sometimes I love being unable to carry the heavy equipment). I woke the next morning, late, and started to process the image.

*Winchester, Hampshire, UK*

**BACKGROUND:** To the naked eye Mars looks like a bright red star but with a large enough telescope and the appropriate image processing, the true face of the planet is revealed. This image shows the polar ice caps of the planet, high clouds on the left and right sides, and the mainly orange-brown colour of the surface, which gets its signature look from a thin layer of iron oxide – more commonly known as rust.

**Celestron C8 telescope; Sky-Watcher AZ-EQ6 mount; 203mm lens; DMK 21.618 camera; f/30 lens**

*"I'm stunned to see such an accomplished photo of Mars from a young photographer. Polar ice caps, surface features and clouds – they're all here."*
MAREK KUKULA

*"This superb image shows the Martian clouds, which have been so prevalent lately, in wonderful detail. Imaging Mars is not easy, but Olivia has produced a picture rich in surface details and the colour balance is excellent, too."*
WILL GATER

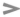

## SHISHIR & SHASHANK DHOLAKIA
### (USA), AGED 15                    HIGHLY COMMENDED

### The Heart Nebula (IC 1805)
[*30 December 2013*]

**SHISHIR & SHASHANK DHOLAKIA:** The Heart Nebula (IC 1805) is an emission nebula in the constellation Cassiopeia that takes the curious and distinctive shape of a heart. The nebula is 7500 light years away from Earth. The beautiful open cluster Melotte 15 at the Heart's centre illuminates the nebula. This was our first serious attempt at a mosaic, and we learned a lot of imaging and processing techniques during this endeavour. The image is a mosaic of two panes.

*Lake San Antonio, California, USA*

**BACKGROUND:** Choosing different techniques when photographing nebulae helps us to peek through the dust into their hidden secrets. Each technique highlights different features of the nebula. This image demonstrates a careful understanding of the balance between filters in the visible part of the spectrum allowing us to see why this nebula got its name.

**Astro-Tech 111mm f/7 triplet refractor; Orion Atlas EQ-G mount; SBIG ST-8300M camera; 8 x 600-second exposures (L) and 5 x 600-second exposures (RGB)**

*"Imaging faint deep-sky objects requires a tremendous amount of time, effort and, most importantly, skill. It's clear all of that has gone into making this beautiful picture of the Heart Nebula."*

WILL GATER

*"Subtle processing brings out the overall shape of this emission nebula beautifully and adds a real sense of depth to the knots of gas and dust being bathed in radiation from the central star cluster, Melotte 15."*

CHRIS BRAMLEY

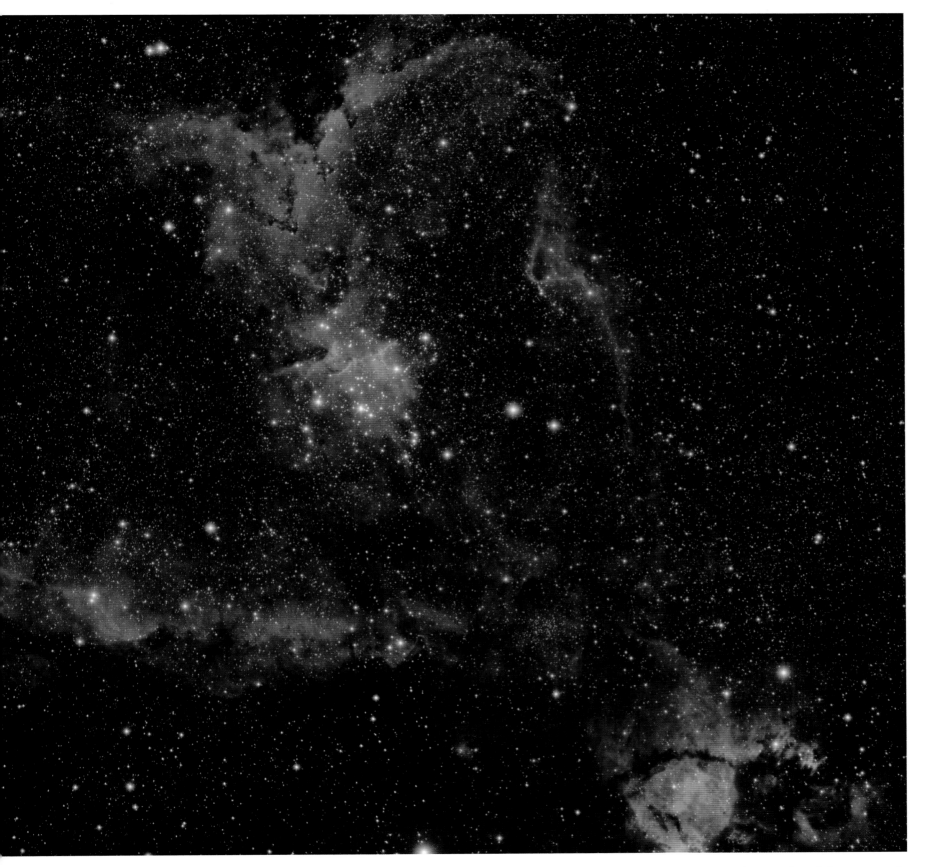

## MARTIN PUGH *(UK/Australia)*     *OVERALL WINNER 2009*

### Horsehead Nebula (IC 434)
*[16 March 2009]*

**MARTIN PUGH:** An extremely popular imaging target, it was an absolute 'must do' for me. My objective was to produce a high-quality, high-resolution image, blending in Hydrogen-alpha data to enhance the nebulosity. With this image, I really wanted to capture the delicate gas jets behind the Horsehead and kept only the very best data. If I could change anything about this photograph I would expand the frame to include the Flame Nebula and the Great Orion Nebula to create a superlative wide-field vista of this region.

My brother-in-law pulled a dusty old 3-inch refractor out of a closet in early 1999. This represented my first real look through a telescope and from then on I was completely hooked.

**BACKGROUND:** The Horsehead Nebula is a dark cloud of dust and gas, which from Earth appears to resemble the shape of a horse's head. The gas, dust and other materials condense to form dense knots, which will eventually become stars and planets. New stars have already formed inside part of the dust cloud, as can be seen on the bottom left. The nebula is silhouetted against a background of glowing hydrogen gas, with its characteristic reddish colour, and this exquisite image shows the delicate veils and ripples in the structure of the gas cloud. First identified in 1888, the nebula is located in the star constellation Orion and is about 1500 light years from Earth.

**SBIG STL11000 CCD camera guided with adaptive optics; 12.5-inch RC Optical Systems Ritchey-Chrétien telescope; Software Bisque Paramount ME mount; 19-hours of exposure**

*"The Horsehead Nebula is one of the most photographed objects in the sky, but this is one of the best images of it I've ever seen. Thirty years ago it would have taken hours of effort on a large professional telescope to make an image like this, so it really shows how far astronomy has come – a fitting way to celebrate the International Year of Astronomy in 2009."*

MAREK KUKULA

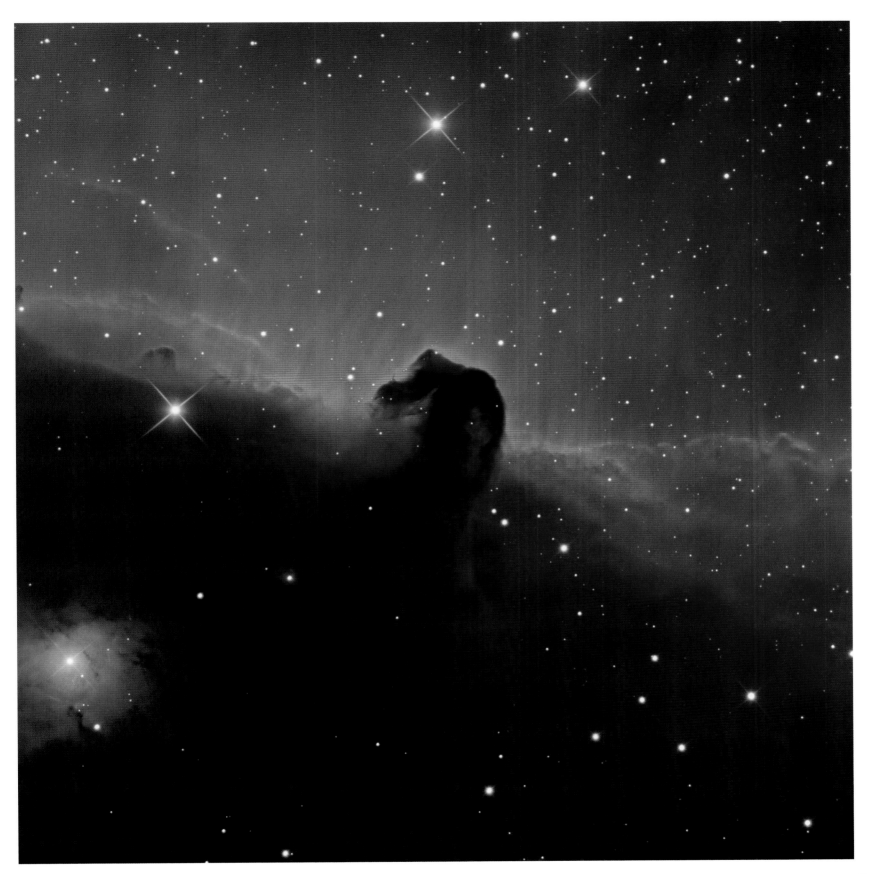

# TOM LOWE *(USA)*

## Blazing Bristlecone
### [*14 August 2009*]

**TOM LOWE:** If I could change anything about this photo, it would be the artificial lighting! The light on that tree occurred accidentally because I had my headlamp and possibly a camping lantern on while I was taking a series of test shots! The artificial light is too frontal for me and not evenly distributed, but in the end the light did in fact show the amazing patterns in the tree's wood.

The reason these trees inspire me so much, aside from their obvious and striking beauty, is their age. Many of them were standing while Genghis Khan marauded across the plains of Asia. Being a timelapse photographer, it's natural for me to attempt to picture our world from the point of view of these ancient trees. Seasons and weather would barely register as events over a lifetime of several thousand years. The lives of humans and other animals would appear simply as momentary flashes.

**BACKGROUND:** The gnarled branches of an ancient tree align with a view of our Milky Way galaxy. The Milky Way is a flat, disc-like structure of stars, gas and dust measuring more than 100,000 light years across. Our sun lies within the disc, about two-thirds of the way out from the centre, so we see the Milky Way as a bright band encircling the sky.

This view is looking towards the centre of our galaxy, 26,000 light years away, where dark clouds of dust blot out the light of more distant stars. What appears to be an artificial satellite orbiting the Earth makes a faint streak of light across the centre of the image.

**Canon 5D Mark II camera; Canon EF 16–35mm lens at 16mm**

*"I like the way the tree follows the Milky Way and the definition is very good."*

SIR PATRICK MOORE

*"I think this beautiful picture perfectly captures the spirit of Astronomy Photographer of the Year, linking the awe-inspiring vista of the night sky with life here on Earth. The bristlecone pines in the foreground can live as long as 5000 years. But they are babies compared to the starlight shining behind them, some of which began its journey towards us almost 30,000 years ago."*

MAREK KUKULA

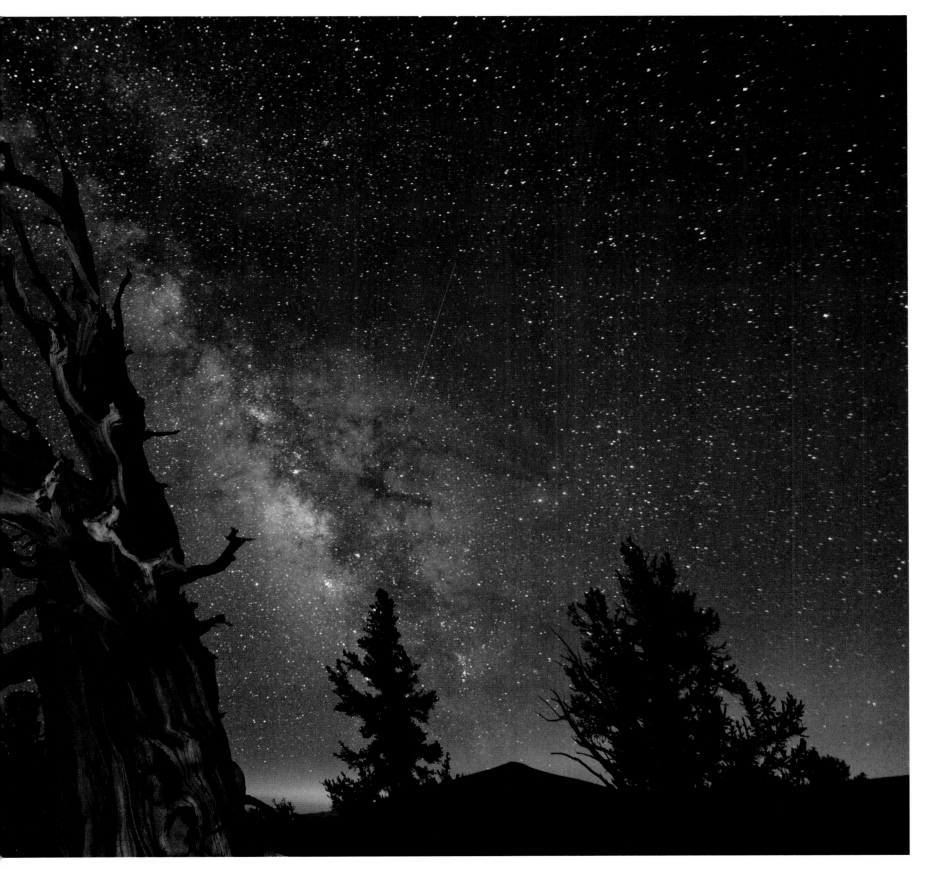

## Jupiter with Io and Ganymede, September 2010
[12 *September 2010*]

**DAMIAN PEACH:** This photograph was taken as part of a long series of images taken over a three-week period from the island of Barbados in the Caribbean – a location where the atmospheric clarity is frequently excellent, allowing very clear and detailed photographs of the planets to be obtained.

I've been interested in astronomy since the age of ten and have specialized in photographing the planets for the last 14 years. I'm very happy with the photo and wouldn't really change any aspect of it.

**BACKGROUND:** Jupiter is the largest planet in the Solar System. It is a giant ball of gas with no solid surface, streaked with colourful bands of clouds and dotted with huge oval storms.

In addition to the swirling clouds and storms in Jupiter's upper atmosphere, surface features of two of the planet's largest moons can be seen in this remarkably detailed montage. Io, to the lower left, is the closest to Jupiter. The most geologically active object in the Solar System, its red-orange hue comes from sulphurous lava flows. Ganymede, the largest moon in the Solar System, is composed of rock and water ice. The planet and its moons have been photographed separately, then brought together to form this composite image.

**Celestron 356mm Schmidt-Cassegrain telescope (C14); Point Grey Research Flea3 CCD camera**

*"This is a truly incredible image of the planet Jupiter. Damian has even managed to capture detail on two of Jupiter's moons! It's truly astonishing to think that this was taken from the ground by an amateur astronomer using his own equipment."*

PETE LAWRENCE

*"There were so many beautiful images this year but this one really stood out for me. It looks like a Hubble picture. The detail in Jupiter's clouds and storms is incredible, and the photographer has also managed to capture two of the planet's moons. An amazing image."*

MAREK KUKULA

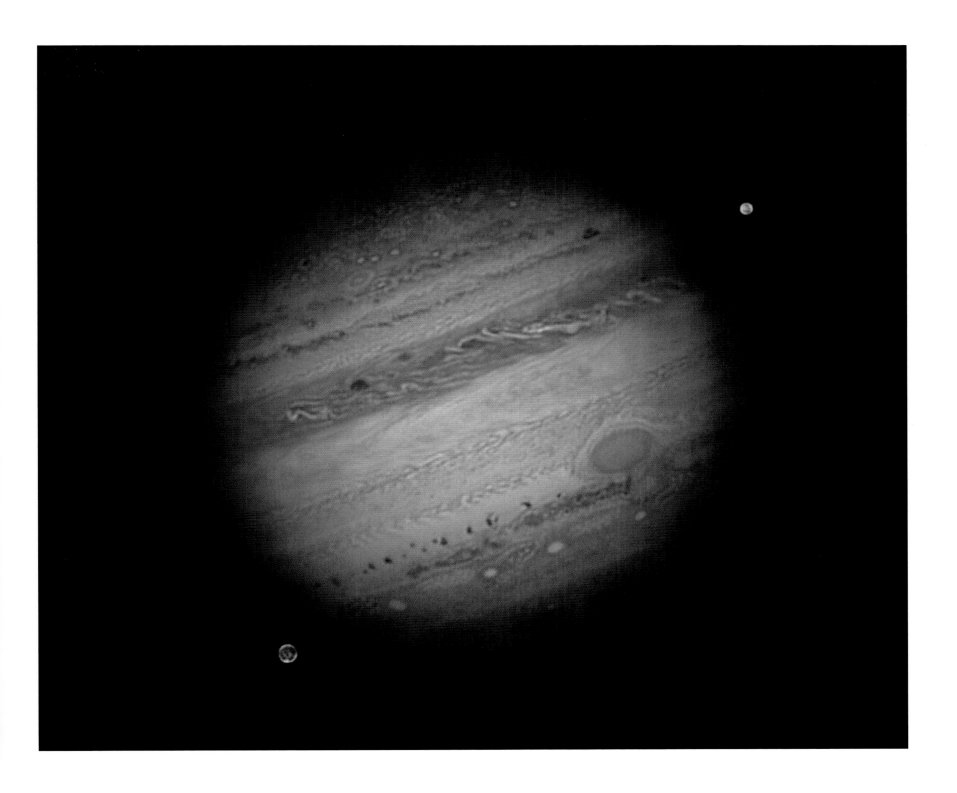

## MARTIN PUGH (UK/Australia)     *OVERALL WINNER 2012*

### M51 – The Whirlpool Galaxy
[19 June 2012]

**MARTIN PUGH:** I was always going to be excited about this image given the exceptional seeing conditions M51 was photographed under, and the addition of several hours of H-alpha data has really boosted the HII regions.

**BACKGROUND:** A typical spiral galaxy, the Whirlpool or M51, has been drawn and photographed many times, from the sketches of astronomer Lord Rosse in the 19th century to modern studies by the Hubble Space Telescope. This photograph is a worthy addition to that catalogue. It combines fine detail in the spiral arms with the faint tails of light that show how M51's small companion galaxy is being torn apart by the gravity of its giant neighbour.

**Planewave 17-inch CDK telescope; Software Bisque Paramount ME mount; Apogee U16M camera**

*"This is arguably one of the finest images of M51 ever taken by an amateur astronomer. It's not just the detail in the spiral arms of the Galaxy that's remarkable – look closely and you'll see many very distant galaxies in the background too."*

WILL GATER

*"The depth and clarity of this photograph makes me want to go into deep space myself! A breathtaking look at the Whirlpool Galaxy."*

MELANIE GRANT

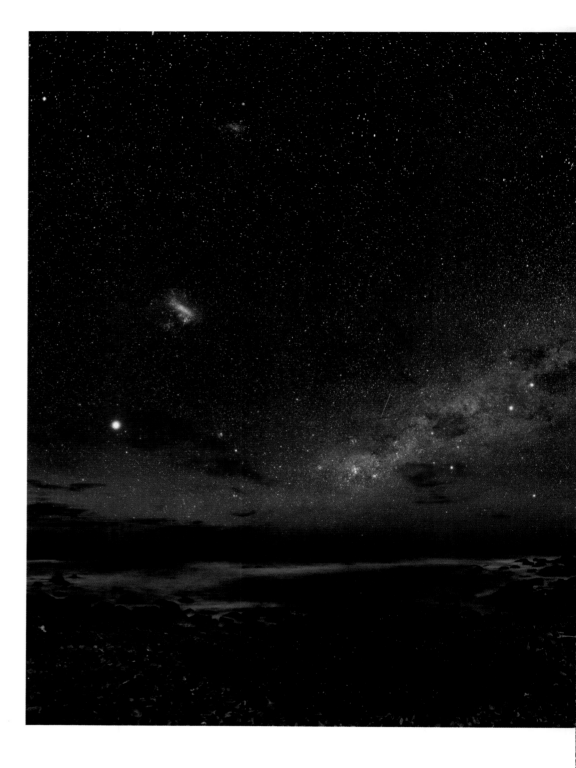

# MARK GEE (Australia)    *OVERALL WINNER 2013*

## Guiding Light to the Stars
[*8 June 2013*]

**MARK GEE:** I recently spent a night out at Cape Palliser on the North Island of New Zealand photographing the night sky. I woke after a few hours sleep at 5am to see the Milky Way low in the sky above the Cape. The only problem was my camera gear was at the top of the lighthouse, seen to the right of this image, so I had to climb the 250-plus steps to retrieve it before I could take this photo. By the time I got back the sky was beginning to get lighter, with sunrise only two hours away. I took a wide panorama made up of 20 individual images to get this shot. Stitching the images together was a challenge, but the result was worth it!

**BACKGROUND:** The skies of the Southern Hemisphere offer a rich variety of astronomical highlights. Here, the central regions of the Milky Way Galaxy, 26,000 light years away, appear as a tangle of dust and stars in the central part of the image. Two even more distant objects are visible as smudges of light in the upper left of the picture. These are the Magellanic Clouds, two small satellite galaxies in orbit around the Milky Way.

**Canon 5D Mark III camera; 24mm f/2.8 lens; ISO 3200; 30-second exposure**

*"One of the best landscapes I have seen in my five years as a judge. Much photographed as an area but overwhelming in scale and texture. Breathtaking!"*

MELANIE GRANT

*"This is a great composition. I love the way that the Milky Way appears to emanate from the lighthouse – really cementing the connection between the stars and the landscape. I also love the way the Milky Way drags your view out to sea, inviting you to go out and explore the unknown."*

PETE LAWRENCE

*"Some images have a real ability to evoke a real emotional response. This image gives me a feeling of pure peace. Cape Palliser in New Zealand is now on my list of places to visit."*

MAGGIE ADERIN-POCOCK

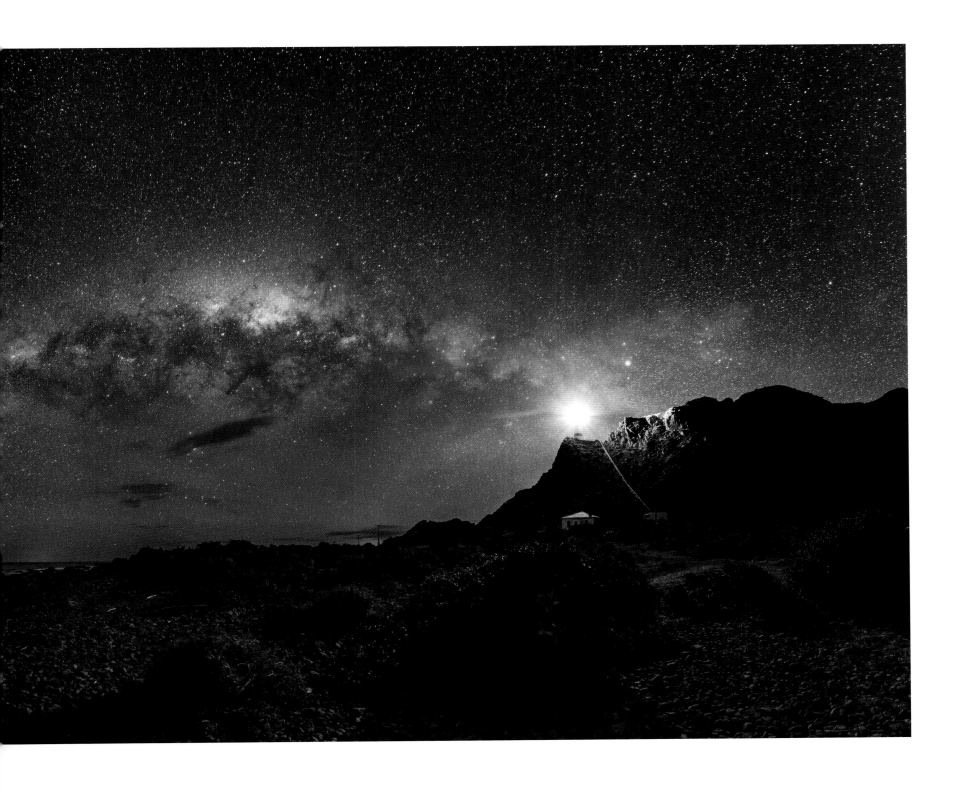

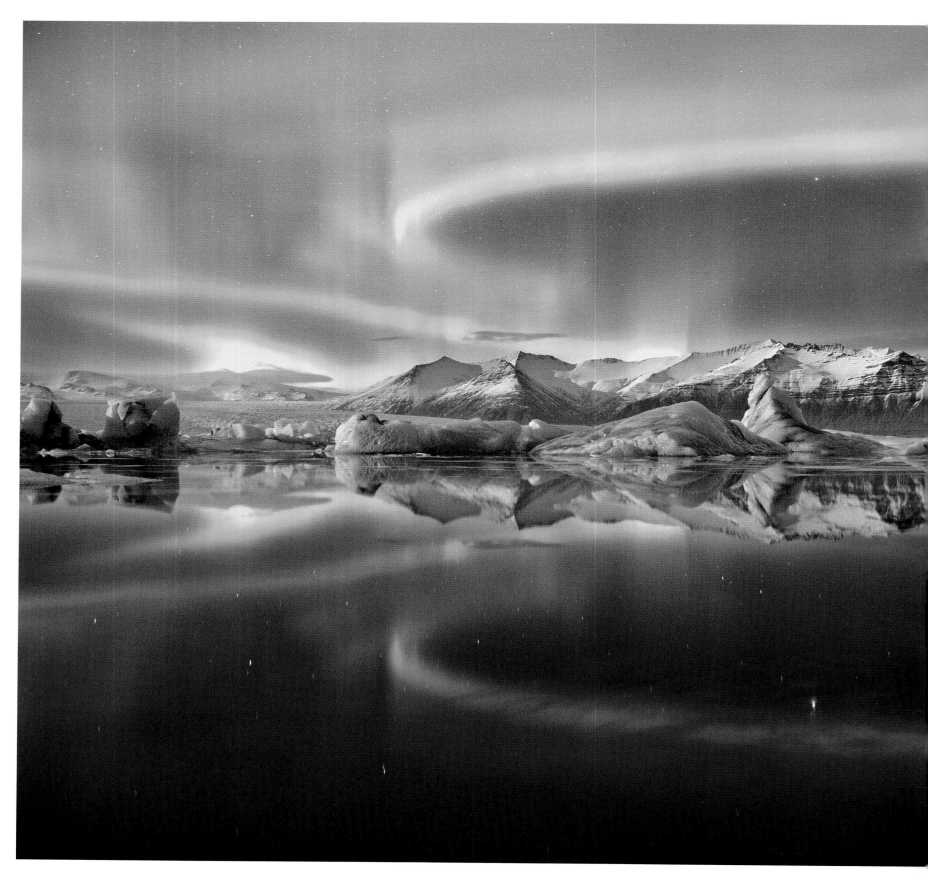

## JAMES WOODEND (UK)

### Aurora over a Glacier Lagoon
[9 January 2014]

**JAMES WOODEND:** Jökulsárlón Glacier lagoon with an overhead aurora reflected in the water. Although it is not a strong aurora, sometimes these make the best reflection shots. The water was very still – you can see the icebergs floating in the lagoon and their reflections. In the background is the Vatnajökull Glacier.

*Jökulsárlón, Vatnajökull National Park, Iceland*

**BACKGROUND:** A total lack of wind and current combine in this sheltered lagoon to produce a striking mirror effect, giving the scene a feeling of utter stillness. Even here, however, there is motion on a surprising scale: the loops and arcs of the aurora are shaped by the slowly shifting forces of the Earth's enveloping magnetic field.

**Canon 5D Mk III camera; 33mm f/3.2 lens; ISO 1000; 10-second exposure**

*"Beautiful curves and symmetry! A wonderful, icy picture – I love the combination of whites and blue in the glacier with the chilly green of the aurora."*

MAREK KUKULA

*"I absolutely love the colours and auroral symmetry in this image as well as the contrast between the serene floating ice and the dramatic light display above. The blue ice is exquisite and the overall composition is mesmerizing. If you described this image on paper it would sound very alien indeed but the photographer has recorded the scene in a way that looks totally natural. The true beauty of planet Earth captured by camera: a worthy winner of the competition!"*

PETE LAWRENCE

*"Breathtaking shot! With its surreal colours and majestic aura it could be the landscape of a fairy-tale. I love the sense of depth, the sharpness of the turquoise ice, the structured symmetry, but, above all, its ethereal feel."*

MELANIE VANDENBROUCK

*"The lime greens and ice blues of this arctic landscape literally bounce off the page. A scenic dream of epic proportions."*

MELANIE GRANT

*"This beautiful image captures what it's really like to see a good aurora – the landscape, with the reflections which seem almost sharper than the shapes in the sky, is a terrific bonus, too! This is the first time an aurora image has won the overall prize; I think what captivated the judges was that it really looked like the aurora was right in front of the viewer – there's no need for exaggerated or stretched colour."*

CHRIS LINTOTT

*"This image is wonderful; it's a really natural portrayal of the aurora as diffuse and veil-like over the sparkling white landscape below."*

CHRIS BRAMLEY

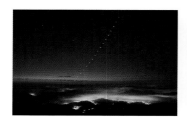

**18**
**O CHUL KWON** (*South Korea*)
Venus-Lunar Occultation

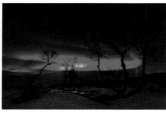

**20**
**RUNE JOHAN ENGEBOE**
(*Norway*)
Flow

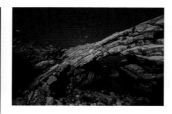

**21**
**CHRIS MURPHY** (*New Zealand*)
Sky Bridge

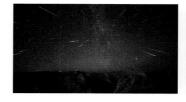

**22**
**RICK WHITACRE** (*USA*)
'Warp Factor 9, Mr Sulu' – 2013
Perseid Meteor Shower

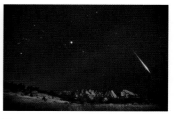

**24**
**PATRICK CULLIS** (*USA*)
Geminid Fireball

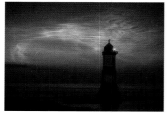

**25**
**KRIS WILLIAMS** (*UK*)
Shimmer – Black Point, Anglesey

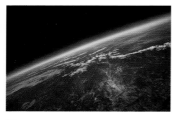

**26**
**PATRICK CULLIS** (*USA*)
Moon Balloon

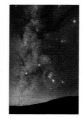

**28**
**CHAP HIM WONG** (*Hong Kong*)
Winter Constellations

**29**
**MAARTEN VAN HAEREN**
(*Canada*)
Mount Wilson

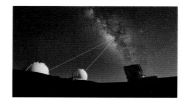

**30**
**SEAN GOEBEL** (*USA*)
Peering into the Milky Way

**31**
**GRAHAM GREEN** (*UK*)
Wistman's Wood

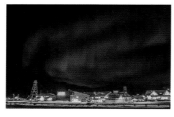

**32**
**DAVID WRANGBORG** (*Norway*)
Longyearbyen by Night

**33**
**ALEX CONU** (*Romania*)
Majestic Milky Way

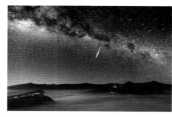

**34**
**JUSTIN NG** (*Singapore*)
Eta Aquarid Meteor Shower
over Mount Bromo

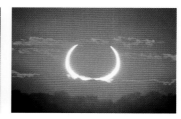

**36**
**FABRIZIO MELANDRI** (*Italy*)
Horns of Fire Sunrise

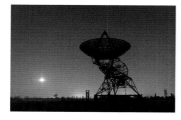

**37**
**JAMES MILLS** (*UK*)
Celestial Interactions

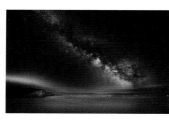

**38**
**CHAP HIM WONG** (*Hong Kong*)
The Seven Sisters and
the Milky Way

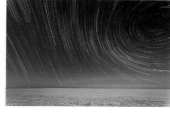

**40**
**SEBASTIÁN GUILLERMAZ**
(*Argentina*)
Star Trails on the Beach

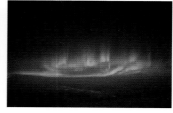

**41**
**PAUL WILLIAMS** (*UK*)
In-flight Entertainment

**42**
**ANDREW CALDWELL**
(*New Zealand*)
Falling to Earth

**43**
**CATALIN BELDEA** (*Romania*)
Totality from above the Clouds

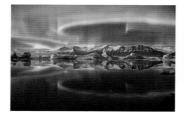

**44 and 192**
**JAMES WOODEND** (*UK*)
Aurora over a Glacier Lagoon

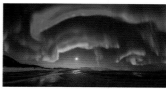

**46**
**TOMMY RICHARDSEN** (*Norway*)
What the … !

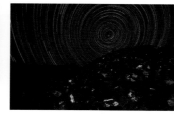

**47**
**GRANT KAYE** (*USA*)
Fluorescent Mine Tailings
in the Tungsten Hills

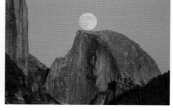

**48**
**JEFF SULLIVAN** (*USA*)
Moonrise Behind Half Dome

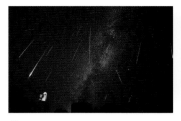

**49**
**SERGIO GARCIA RILL** (USA)
Perseids Composite

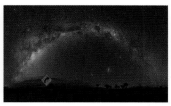

**50**
**CARLOS ORUE** (Australia)
Right Turn Ahead

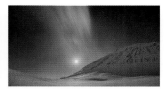

**52**
**TOMMY RICHARDSEN** (Norway)
Arctic Night

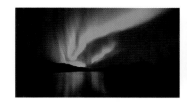

**53**
**KOLBEIN SVENSSON** (Norway)
Aurora

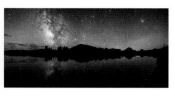

**54**
**DAVID KINGHAM** (USA)
Oxbow Bend Reflections

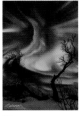

**56**
**OLE CHRISTIAN SALOMONSEN**
(Norway)
Creature

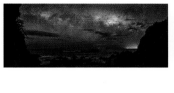

**57**
**MARK GEE** (New Zealand)
A Night at Devil's Gate

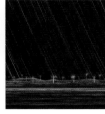

**58**
**MATT JAMES** (Australia)
Wind Farm Star Trails

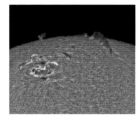

**62**
**ALEXANDRA HART** (UK)
Ripples in a Pond

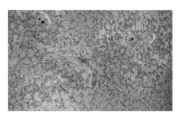

**64**
**LEVENTE BARATÉ** (Hungary)
Sun Whirlpools

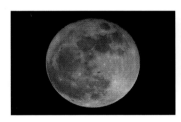

**65**
**DANI CAXETE** (Spain)
ISS Lunar Transit

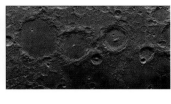

**66**
**GEORGE TARSOUDIS** (Greece)
Area of the Crater Ptolemaeus

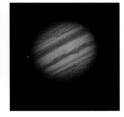

**67**
**PETER RICHARDSON** (UK)
Jupiter and Europa from
Somerset, December 2013

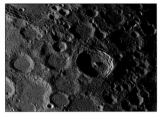

**68**
**GEORGE TARSOUDIS** (Greece)
Best of the Craters

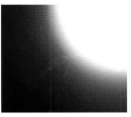

**70**
**STEPHEN RAMSDEN** (USA)
Calcium K Eruption

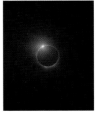

**71**
**TUNÇ TEZEL** (Turkey)
Diamond and Rubies

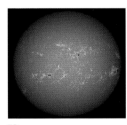

**72**
**MICHAEL BORMAN** (USA)
Solar Disc in Calcium K,
January 2014

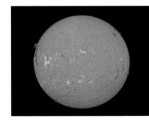

**73**
**ALEXANDRA HART** (UK)
Majesty

**74**
**ALEXANDRA HART** (UK)
Solar Nexus

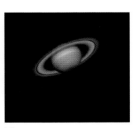

**76**
**PETER RICHARDSON** (UK)
Saturn from Somerset, April 2014

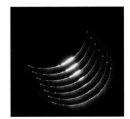

**77**
**PHIL HART** (Australia)
Close-up with Second Contact

**78**
**CHAP HIM WONG** (Hong Kong)
Comet Panstarrs –
Six Consecutive Days

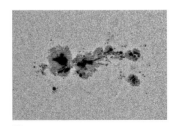

**80**
**ALEXANDRA HART** (UK)
Surfing the Sun

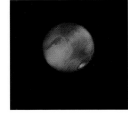

**81**
**PETER RICHARDSON** (UK)
Mars from Somerset, April 2014

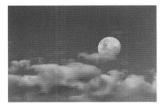

**82**
**SEBASTIÁN GUILLERMAZ**
(Argentina)
Occultation of Jupiter

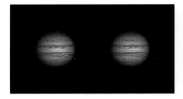

**84**
**TOM HOWARD** (*UK*)
Thirty Minutes

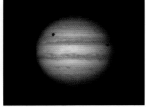

**85**
**KEV WILDGOOSE** (*UK*)
Jupiter and the Shadows of
Io and Ganymede

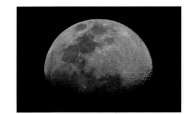

**86**
**IGNACIO DIAZ BOBILLO**
(*Argentina*)
Zenithal Colour Moon

**90**
**BILL SNYDER** (*USA*)
Horsehead Nebula (IC 434)

**92**
**ADAM BLOCK** (*USA*)
Rapt with Spiral Arms

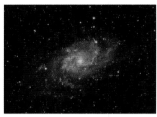

**93**
**MATTHEW FOYLE** (*UK*)
The Triangulum Galaxy (M33)

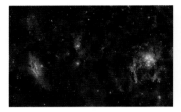

**94**
**ROGELIO BERNAL ANDREO**
(*USA*)
California vs Pleiades

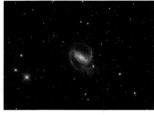

**96**
**MICHAEL SIDONIO** (*Australia*)
The Jets of NGC 1097

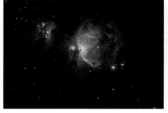

**97**
**TANJA SUND** (*South Africa*)
Star Factory, the Orion Nebula

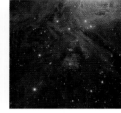

**98**
**MARCO LORENZI** (*Italy*)
At the Feet of Orion
(NGC 1999) – Full Field

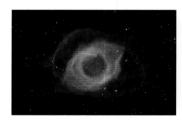

**100**
**DAVID FITZ-HENRY** (*Australia*)
The Helix Nebula (NGC 7293)

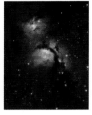

**101**
**OLEG BRYZGALOV** (*Ukraine*)
M78: Stardust and Starlight

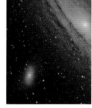

**102**
**OLEG BRYZGALOV** (*Ukraine*)
Dwarf Elliptical Galaxy
NGC 205 (M110) in the Local Group

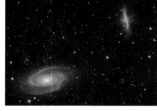

**103**
**ANDRÉ VAN DER HOEVEN, MICHAEL
VAN DOORN, NEIL FLEMING**
(*Netherlands*) M81/M82 with SN2014J

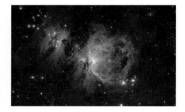

**104**
**ANNA MORRIS** (*USA*)
Orion Nebula

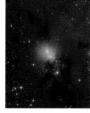

**106**
**OLEG BRYZGALOV** (*Ukraine*)
NGC 1333 Stardust

**107**
**ADAM BLOCK** (*USA*)
The Red Rectangle

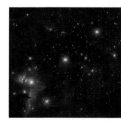

**108**
**MAURICE TOET** (*Netherlands*)
Orion's Belt

**110**
**PAUL HAESE** (*Australia*)
The Meat Hook (NGC 2442)

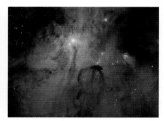

**111**
**ROLF WAHL OLSEN** (*New Zealand*)
The Turbulent Heart
of the Scorpion

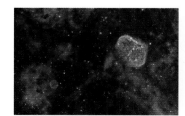

**112**
**IVAN EDER** (*Hungary*)
Soap Bubble and
Crescent Nebula

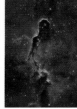

**113**
**IVAN EDER** (*Hungary*)
Elephant Trunk Nebula (IC 1396)

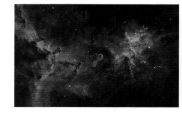

**114**
**IVAN EDER** (*Hungary*)
Centre of the Heart Nebula

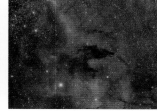

**115**
**PAUL HAESE** (*Australia*)
The Wolf

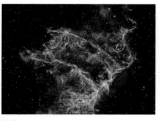

**116**
**J.P. METSÄVAINIO** (*Finland*)
Veil Nebula Detail (IC 1340)

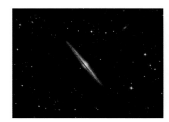

**118**
**ANTONIS FARMAKOPOULOS**
*(Greece)*
**NGS 4565 Galaxy**

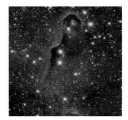

**119**
**LEONARDO ORAZI** *(Italy)*
**VDB 142**

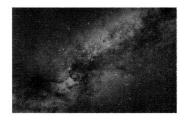

**120**
**LEONARDO ORAZI** *(Italy)*
**Zenith of the Northern
Summer Sky**

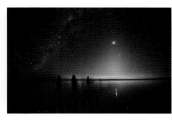

**124**
**JULIE FLETCHER** *(Australia)*
**Lost Souls**

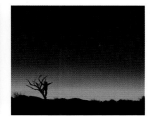

**126**
**LÓRÁND FÉNYES** *(Hungary)*
**Three Planets in Conjunction**

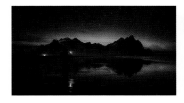

**127**
**PHILIP EAGLESFIELD** *(UK)*
**Chasing the Dragon**

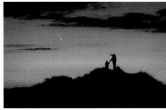

**128**
**CHRIS COOK** *(USA)*
**Father and Son Observe
Comet Panstarrs**

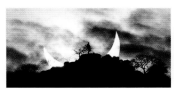

**129**
**EUGEN KAMENEW** *(Germany)*
**Hybrid Solar Eclipse 1**

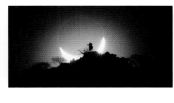

**130**
**EUGEN KAMENEW** *(Germany)*
**Hybrid Solar Eclipse 2**

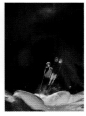

**132**
**MIKKO LAITINEN** *(Finland)*
**Aurora Skiing**

**133**
**INGÓLFUR BJARGMUNDSSON**
*(Iceland)*
**Cave with Aurora Skylight**

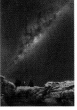

**134**
**CARLOS ORUE** *(Australia)*
**Observing the Milky Way**

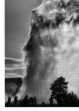

**135**
**ROBERT HOWELL** *(USA)*
**Eclipse and Old Faithful**

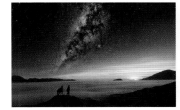

**136**
**JUSTIN NG** *(Singapore)*
**Good Morning Horses!**

**140**
**MARK HANSON** *(USA)*
**NGC 3718**

**142**
**LÁSZLÓ FRANCSICS** *(Hungary)*
**Queen of the Reflection Nebulae**

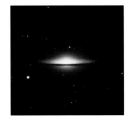

**143**
**BLAIRGOWRIE HIGH SCHOOL,
S2 CLASS** *(UK)*
**The Sombrero Galaxy (M104)**

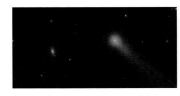

**144**
**DAMIAN PEACH** *(UK)*
**Comet Lovejoy with M63**

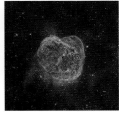

**145**
**MARK HANSON** *(USA)*
**NGC 6888**

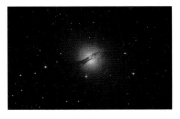

**146**
**LÁSZLÓ FRANCSICS** *(Hungary)*
**Centaurus A and Relativistic Jet**

**147**
**BLAIRGOWRIE HIGH SCHOOL,
S6 CLASS** *(UK)* **Supernova SN2014J
in the Cigar Galaxy (M82)**

**148**
**LÁSZLÓ FRANCSICS** *(Hungary)*
**The Morphology of the
Lagoon Nebula**

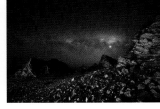

**152**
**CHRIS MURPHY** *(New Zealand)*
**Coastal Stairways**

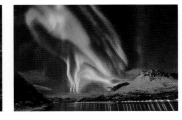

**154**
**CLAUS POSSBERG** *(Germany)*
**Celestial Dance**

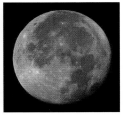

**155**
**ALEXANDRE BOUDET** *(France)*
**99%**

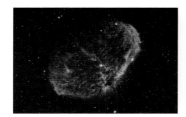

**156**
DANIELE MALLEO *(USA)*
The Crescent Nebula in H-alpha
and OIII (NGC 6888)

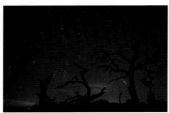

**158**
MARK EZELL *(USA)*
Raining Perseid Meteors

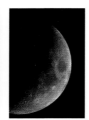

**159**
MICHAEL SCHMIDT *(Austria)*
Moon Mosaic

**160**
PAUL MOORE *(UK)*
Orion's Constellation
over Kilbeacanty

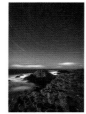

**161**
ROB OLIVER *(UK)*
A Giant's Star Trail

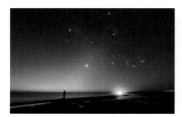

**162**
YANNAN ZHOU *(China)*
Qinghai Lake Before Dawn

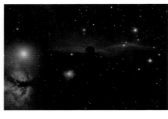

**166**
SHISHIR & SHASHANK
DHOLAKIA *(USA)*
The Horsehead Nebula (IC 434)

**168**
EMILY JEREMY *(UK)*
Moon Behind the Trees

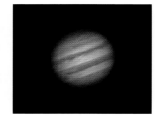

**169**
GABRIEL TAVARES *(Brazil)*
Jupiter from my Back Yard

**170**
EMMETT SPARLING *(Canada)*
Milky Way over Bowen Island

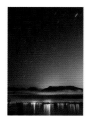

**171**
EMMETT SPARLING *(Canada)*
New Year over Cypress Mountain

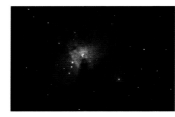

**172**
JACOB MARCHIO *(USA)*
Nebulous Beauty

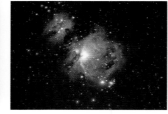

**173**
GRAY OLSON *(USA)*
The Great Orion Nebula

**174**
HARRY ASPREY *(UK)*
The Line Between Day and Night

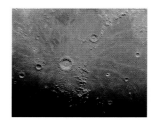

**175**
JACOB MARCHIO *(USA)*
Crater Copernicus

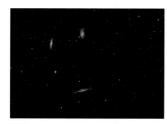

**176**
SHISHIR & SHASHANK
DHOLAKIA *(USA)*
The Leo Triplet

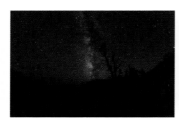

**177**
TOM OLIVER *(UK)*
Midnight Sky

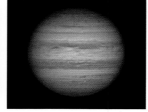

**178**
OLIVIA WILLIAMSON *(UK)*
The Plain Face of Jupiter

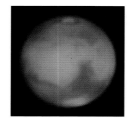

**179**
OLIVIA WILLIAMSON *(UK)*
The Martian Territory

**180**
SHISHIR & SHASHANK
DHOLAKIA *(USA)*
The Heart Nebula (IC 1805)